The Painted Word
BRITISH HISTORY PAINTING: 1750–1830

The Painted Word

BRITISH HISTORY PAINTING: 1750–1830

Edited by Peter Cannon–Brookes

With contributions by:

PETER CANNON–BROOKES
MARTIN BUTLIN · DAVID ALEXANDER
GEOFFREY ASHTON · MARTIN POSTLE
and MICHAEL BELLAMY

THE BOYDELL PRESS

Catalogue edited by Peter Cannon-Brookes, co-ordinated by Michael Bellamy and produced by Hugh Tempest-Radford

First published 1991 for the Heim Gallery by The Boydell Press, Woodbridge

The Boydell Press is an imprint of Boydell & Brewer Ltd
PO Box 9, Woodbridge, Suffolk IP12 3DF
and of Boydell & Brewer Inc.
PO Box 41026, Rochester, NY 14604, USA

ISBN 0 85115 290 2

Printed in Great Britain by The Five Castles Press Limited, Ipswich, Suffolk

The cover illustration is a detail from *The Battle of Maida* by
Phillipe Jacques De Loutherbourg
(Catalogue No. 134)

CONTENTS

FOREWORD

MICHAEL BELLAMY

CONSIDERING the great amount of ink which was spilled over the subject of History painting in the eighteenth and early nineteenth centuries, it is amazing how little has been written about it since. There are honourable exceptions in the form of monographs on individual painters, and articles and theses dealing with specific aspects of the subject, but no attempt at an overall survey of what exactly was meant by the frequently incanted phrase 'History Painting', covering both the paintings and the engravings made from them, appears to have been undertaken. The interrelationship between painters, engravers, and the publishers and sellers of prints changed drastically during the late eighteenth century, and throughout the heyday of Boydell, Macklin, Bowyer and others, a booming export trade for English prints, engendered great prosperity, and this in turn led to unprecedented patronage for painters.

This exhibition and its catalogue cannot hope to overcome such neglect at one bound, but the paintings and prints should give some insight into a fascinating and under-appreciated area of British art. The catalogue is arranged, as far as possible, in the chronological order in which any particular image became known. This may have been public display in Vauxhall Gardens or in the exhibitions of the Society of Artists, Royal Academy and others.

Collectors of eighteenth-century British prints often, understandably, have a better knowledge of the field than their counterparts who are only interested in paintings. The great West End picture galleries created by Boydell, Macklin, Bowyer, Fuseli and Woodmason were all intended to pay their way by the sale of prints made after the paintings displayed, as well as by admission charges, and the export of these engravings to mainland Europe and America helped to spread the influence of British art in unlikely places. Names such as Reynolds and Fuseli have long been acknowledged, but all too many others from the ranks of the great founding generation of Royal Academicians have been largely ignored. Benjamin West, the second President, was, until relatively recently, overlooked, while Northcote, Westall, Smirke, et al, are personalities better known from the pages of Farington's diaries.

The paintings themselves have often languished unrecognised in country house collections, occasionally passing through the sale rooms, and then usually obscured by discoloured varnish. Over the last ten years the pictures exhibited here have been assembled and restored. Fortuitous neglect has often meant that they have not suffered harsh Victorian cleaning. The ghouls of many a sale of British paintings, they now emerge in their restored state as both more dramatic and more subtle than previously believed possible and, in many cases, positively beautiful.

Of course, there is some risk in mounting a commercial show centred on images dealing with subjects like classical literature, the Bible, Shakespeare, and medieval and later history. The Fine Arts can appear sufficiently circumscribed by the scholarship associated with the problems of attribution and connoisseurship, without throwing in half of the school curriculum! In mitigation, it should be pointed out that in many cases the immediate subject matter is the starting point from which the creative artist develops his own pictorial ideas. In others, where the artist stays closer to the text, the pictures give a clear insight into how people in the eighteenth and early nineteenth centuries saw their history and their literature, and what degree of reverence (or irreverence) they accorded to it.

Thanks should go to Richard Herner, who nurtured the idea of an exhibition devoted to this subject over a number of years. The authors of the introductory essays — Martin Butlin, Martin Postle, Peter Cannon-Brookes, David Alexander and Geoffrey Ashton — have all contributed recondite scholarship and great enthusiasm, none more so than Peter Cannon-Brookes whose feat in pulling together all the many threads into a cogently edited whole within a limited period took quite some doing.

I should also like to thank Hugh Tempest-Radford and Caroline Winstanley for their patient help and the many colleagues and friends who have generously contributed information and advice.

5

INTRODUCTION

WHEN one looks at the great names of later eighteenth-century and early nineteenth-century painting in England — Reynolds, Gainsborough, Wilson, Lawrence, Turner and Constable — one thinks of portraits and landscapes. Compare this with the great schools of painting in Italy, the Low Countries, France and Spain, where subject pictures are the rule rather than the exception. A glance through the catalogues of the annual exhibitions of the Royal Academy and other exhibiting bodies in London shows a low proportion, often only a little above a tenth, of subjects taken from sacred and profane history or literature (but then a large proportion of these exhibitions was taken up by architectural drawings, miniatures and the work of amateurs). Nevertheless, the depiction of such subjects was felt to be the most important purpose of art; it was not just William Blake who felt that all art worthy of attention should have a moral purpose. In particular, history painting, as it was called, ranked at the top of the academic hierarchy of genres which still governed the theory and teaching of art in England in the eighteenth century; landscape and portraiture ranked well below history painting and only just above still-life. Portrait painters such as Reynolds sought to aspire to the higher reaches of their craft by basing their portraits on the great models of antiquity, and landscape painters, such as Wilson and Turner, sought to 'elevate' their views with classical or historical subjects.

This was no mere concession to taste, let alone to the market. For those who concentrated on history painting this was, with rare exceptions, a sure road to financial disaster, as witness Barry, Blake and Haydon; only West and Copley were more or less successful in this genre, the first upheld by royal patronage, the other by a thoroughly up-to-date attitude to marketing. Indeed, marketing was a deliberate element in the propagation of the elevated art of history painting, and manifested itself in two interlinked ways, the spreading of the image through engravings and the 'galleries' or semi-permanent exhibitions devoted to an author or subject. Boydell's Shakespeare Gallery, Macklin's Bible, and Fuseli's Milton Gallery all combined de-luxe illustrated editions of the text with an exhibition of the paintings on which the illustrations were based, together, usually, with the publication of separate prints. In the absence of dealers' galleries, of touring exhibitions, and of today's widespread distribution of art books, it was through prints that the aspirants to high art reached the general public. Hence the importance of prints in this exhibition, strengthened with examples of the paintings which in themselves would have brought their creators neither a wide public nor a living wage.

The position of history painting in England was particularly difficult in relation to that on the continent of Europe. In Catholic Italy, France and Spain there was an unbroken tradition of religious art; in England, apart from George III's commission to West to decorate the Royal Chapel at Windsor Castle, religious subjects took their place on the walls of the Royal Academy as just another branch of subject painting. Nor was there much opening for the grand decorative schemes in palaces, churches and other public buildings that characterize the continent; the great campaigns of the end of the seventeenth and early eighteenth centuries had filled the available wall space at Hampton Court; St Paul's Cathedral; the Royal Hospital, Greenwich; and the great country houses. Patrons and their homes were now more modest.

Another factor was at work , the great English virtue of self-deprecation. If a patron did want a large subject picture to grace his walls the Old Masters had done it better. In the period under review, the great sales resulting from the French Revolution and its aftermath ensured a plentiful supply of works by acknowledged Old Masters and exacerbated the situation. The more self-assertive of English artists fought back. Hogarth, annoyed by the high price realised by a so-called Correggio, riposted with his *Sigismunda mourning over the Heart of Guiscardo*. Reynolds embodied the forms of the antique, Raphael and Titian in his portraits, and sought to recover the 'Venetian Secret' in disastrous experiments in technique. Turner saw himself challenged by the Old Masters and returned the challenge with a series of large canvases designed to show that he could outdo the works of Claude and Poussin, and

of Rembrandt and the artists of seventeenth-century Holland.

Difficulties over individual patronage were to a certain extent overcome. The dissemination of one's compositions through prints was one method. The development of exhibiting bodies was another, often linked with teaching institutions that not only taught the practice of art but also traditional academic theories. Hogarth played a substantial part in the earliest teaching academy, developing that established in 1711 by Sir Godfrey Kneller and taken over in 1716 by Hogarth's father-in-law, Sir James Thornhill. At the same time he led the way, through charitable gifts to the Foundling Hospital, established in 1739, in establishing a place where contemporary artists could show their wares. In 1760 the Society of Artists, solely an exhibiting body, held its first exhibition in the Great Room of the Society for the Encouragement of Arts, Manufacture and Commerce. Finally, in 1768, with its first exhibition the following year, came the Royal Academy significantly under royal patronage; this was both school and exhibiting body. Membership gave its leading figures additional kudos and, as reflected in Farington's diary, all the intrigues of a semi-political body. In addition, the sale rooms became part of the battlefield, with Turner buying back certain of his works, partly to keep up his prices, partly to establish that final apogee, the public gallery devoted to a single artist, a gallery already adumbrated in his private exhibition gallery, an asset also realised with varying degrees of permanency by such artists as Fuseli and West. A new patronage was actively encouraged, and was helped by the spread of wealth to a new, non-hereditary *nouveau riche*, relatively untrammelled by traditional tastes.

Paradoxically, despite all the difficulties, it was two British artists who re-established the great tradition of history painting in the second half of the eighteenth century, first in Rome and then in England. The Neo-Classicism of David in France was heralded by the work of the Scot Gavin Hamilton and the American Benjamin West. Gavin Hamilton stayed in Rome, sending works to the Royal Academy and also supporting himself by dealing in antiquities. West came to London and eventually succeeded Reynolds as President of the Royal Academy. While Reynolds could be criticised by Blake for not practising what he preached, West dignified his position by practising the most academically exalted genre of painting. A somewhat watered down form of his Neo-Classicism was continued by the next generation in the work of such artists as William Hamilton, Richard Westall and Thomas Stothard. Further infusions from abroad came with the artists G. B. Cipriani and Angelica Kauffmann, while Fuseli brought a more outlandish proto-romantic imagination. Artists such as Smirke represented the more home-grown, everyday style established by Hogarth, with a greater sense of everyday behaviour often akin to a caricature.

One great advantage making for the richness of English narrative painting was the wealth of English literature; to the Bible, in the King James translation, was added the inspiration afforded by Milton and Shakespeare. But perhaps the greatest achievement was the elevation of landscape in the hands first of Richard Wilson and subsequently, above all, in those of Turner. The romantic landscape, one of the greatest achievements of painting in England, owed much of its strength to that same belief, embodied in academic tradition, that art to be truly worthy of attention should deal with significant subjects. This was true not only of paintings of classical subjects such as *Ulysses deriding Polyphemus,* and of contemporary subjects such as *The Fighting 'Temeraire' tugged to her Last Berth to be broken up,* but also in landscapes and seascapes that concentrated solely on the great forces of nature. What had begun as perhaps an aberration, an anachronistic emphasis on high art, was finally transformed into a completely new expressive form.

NARRATIVE PAINTING: HOGARTH TO REYNOLDS

MARTIN POSTLE

WHEN Hogarth, in 1725, produced twelve engravings based on Samuel Butler's satirical poem, *Hudibras*, his intention was two-fold. First, he wished to demonstrate his ability to produce a sustained narrative which acted as a convincing visual parallel to Butler's text. Secondly, he wanted to provide an alternative to what he saw as the vacuous tradition of high art in England, which was concerned with meaningless myths rather than with issues which touched on the lives of ordinary people. Over the next thirty years this aim became a crusade for Hogarth, who strove to provide narratives which were relevant to current concerns. The text remained an important touchstone for Hogarth throughout his life, although even in his earliest works he was never content to be a mere illustrator of other people's ideas.

In, for example, *The Beggar's Opera*, Hogarth's translation of John Gay's immensely successful burlesque on high-flown Italian opera, the artist produced, between 1728 and 1730, no less than six different versions of the trial-scene, as he explored the relationship between the world of the actors and their audience. Indeed, Hogarth was continually aware, whether he was illustrating a poem by Butler, an opera by Gay, or a play by Shakespeare, that the text only came alive through the subjective response of the individual. This was particularly true of the plays of Shakespeare which during the early eighteenth century were cut and reshaped constantly to gain maximum dramatic force, irrespective of the purity of the text. *Macbeth*, for example, as one can see in John Wootton's painting in the present exhibition (cat. no. 1), was synonymous with the witches, whose presence on stage often completely overshadowed the rest of the characters.

One of the principal issues which coloured the career of Hogarth was the degree to which he could be described as a history painter rather than simply a painter of genre. In a sense Hogarth made the question irrelevant, for, as he widened the scope of narrative painting to include even his own inventions, 'modern moral subjects' such as *The Rake's Progress* and *Marriage à la Mode*, he effectively gave a franchise to future artists to explore a whole range of subject matter — the only proviso being that it was re-

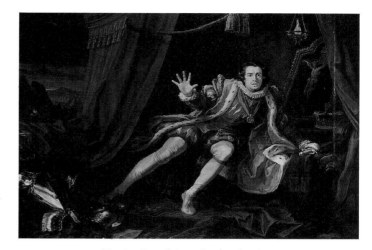

Fig. 1 David Garrick as Richard III

lated to contemporary values. In theatrical portraits, too, notably that of *David Garrick as Richard III* (Fig. 1), Hogarth also inaugurated a kind of narrative picture which Sir Joshua Reynolds, in particular, was to exploit to great effect later in the century. Here, Hogarth produced on a grand scale a portrayal of Garrick's stage-performance of *Richard III*, which the actor was keen to promote as the first demonstration of a whole new phase of naturalism in British acting. Hogarth, for his part, endorsed Garrick's claim by concentrating on the gestures and expression of Garrick/Richard as he stares at the spectre. Reynolds's subsequent elevation of his portrait sitters by the introduction of narrative, as one can see in his *Portrait of Lady Blake as Juno* in the present exhibition (cat. no. 13), relied on much the same devices.

The promotion of the subject picture, other than through the medium of engraving, was a long-standing problem for Hogarth and the generation of artists who practised prior to the establishment, in 1760, of the first public exhibition space, at the Society of Arts. Patronage

was on the whole not forthcoming and many of Hogarth's most ambitious works — such as his biblical cycle on the stairway of St Bartholomew's Hospital, or his depiction of *Moses brought to Pharoah's Daughter* — were produced as acts of philanthropy. The Foundling Hospital, where the latter painting still hangs — albeit in a reconstruction of the original setting — was, historically speaking, of seminal importance in the promotion of narrative painting in the mid-eighteenth century, for it provided a forum for British artists to demonstrate their commitment to the traditions of high art. Here Hogarth, Hayman and Highmore, arguably the most important narrative painters of the period, hung history paintings which acted as symbols of their aspirations.

Francis Hayman (1708–76), whose real importance has only emerged in recent years (principally through the researches of Dr Brian Allen), was, next to Hogarth, the most important figure in the development of a native narrative tradition in British art. Hayman, like Hogarth, was steeped in the theatre, having worked as a scene painter at Goodman's Fields and at Drury Lane during the 1730s, and he was, as one might expect, also a good friend of Hogarth. Although, it is tempting to dismiss scene-painting as an ephemeral activity, it is important to remember that the type of ceiling decorations produced by Hayman and others in the theatre were often permanent fixtures, and as such would have been constantly on view to a great number of people. Indeed, it was ultimately through Hayman's work in the theatre that he received his most celebrated commission, in the early 1740s, to decorate the supper boxes at Vauxhall Gardens.

Although most of these paintings have long since been destroyed, surviving drawings and engravings provide a good indication of the range of subject matter addressed by Hayman and his studio. Among the subjects were scenes from plays by Shakespeare, as well as modern dramatists such as Fielding and Dodsley, novels (notably Samuel Richardson's *Pamela*), and illustrations of popular childrens' games. As has previously been observed, the subjects chosen by Hayman mirrored closely the literary interests and social pastimes of the burgeoning middle-class clientele of Vauxhall, and as such provide a fascinating parallel to the themes which emerge at the same time in contemporary literature.

By the 1740s, owing in part to the pioneering work of Hogarth, and to the general interest in allying theatrical traditions to the traditions of high art, Hayman was encouraged to embark on a series of illustrations to the edition of Shakespeare published by.Sir Thomas Hanmer between 1741 and 1742. Hayman's work in this area opened the flood-gates to similar illustrated editions throughout the late eighteenth century. In addition to the illustration of plays, Hayman also undertook a number of other commissions, based on literary sources, which were of seminal importance in the development of a British narrative tradition. These included a series of engravings for Richardson's *Pamela,* designs for an edition of the works of Congreve, and three designs for a proposed series of engravings illustrating English history. Although this last scheme, entitled *English History Delineated,* was not completed, Hayman's plates, which included *The Conversion of the Britons to Christianity* and *The Battle of Hastings,* were among the first attempts to illustrate British historical themes.

Before leaving Hayman, a word needs to be said about his religious commissions, for the work he executed here also anticipates developments later in the century. In 1752 Hayman painted *The Good Samaritan* for the Chapel of Cusworth Hall, near Doncaster. As Brian Allen has pointed out, by the mid–1750s Hayman, whose reputation was then at its peak, practically had the field of history painting to himself. And yet, ten years later, the situation was transformed as a younger generation of artists who had been trained on the Continent began to snap up commissions. Hayman survived long enough to become a founder member of the Royal Academy in 1768, but his demise was already apparent by the death of Hogarth in 1764.

The 1760s mark a watershed in eighteenth-century British narrative painting. It was during this decade that native artists such as John Hamilton Mortimer, Robert Edge Pine, Nathaniel Dance and Joseph Wright (of Derby), carved out their careers, and foreigners, notably Giovanni Battista Cipriani, Angelica Kauffmann and Johann Zoffany, brought a new sophistication to figurative art in England. It is to this generation I now wish to turn.

Wright's importance as a painter of narrative subjects lies chiefly in the 1770s, and the 1780s when he produced several works for Boydell's Shakespeare Gallery. And yet his highly original nocturnes of the 1760s, such as *An Experiment on a Bird with an Airpump* (Tate Gallery), demonstrate — even though they are not based on a text — the ability of British artists (other than Hogarth) to produce powerful visual narratives in their own right. Mortimer, too, although he failed to fulfil the promise of his youth and never made the Grand Tour, is representative of the highly imaginative strain in British narrative painting around this time, and was very conscious of the impact of continental approaches to subject painting. A

Fig. 2 Lear

Richard III (Stratford-upon-Avon Town Council), is of further significance in that he was among the first British artists who adapted an Italianate, Neo-Classical painting style to British literary subject matter — notably in *Timon of Athens* (Her Majesty the Queen) which he showed at the Society of Artists in 1767. Although Dance's composition is reminiscent of Hayman's illustration of the same subject for Hanmers 1774 edition of Shakespeare, the artist did not treat the subject as a visual representation of a piece of theatre, but as a classical frieze in the manner of Gavin Hamilton.

It is not possible here to enumerate all those artists who during the late eighteenth century contributed to the development of a narrative tradition in British art, but it is important, nonetheless, to dispel the popular myth (and indeed this is one of the aims of the present exhibition) that narrative painting was the beleaguered activity of a handful of individuals. On the contrary, even though portraiture remained the staple of many British artists, by the late 1760s there was a lively interest in art which explored literary subject matter, from the Bible to the popular novel, though until then no one — except Hogarth — had attempted to codify the way in which British artists should approach narrative painting. In 1769, however, following the foundation of the Royal Academy of Arts, Sir Joshua Reynolds, in a series of lectures, published as his *Discourses*, set out to provide some ground-rules.

Reynolds, although we are accustomed to think of him primarily as a portrait painter, played a seminal role in the way in which the narrative tradition in a British art emerged after 1770. In the *Discourses*, which Reynolds read to the Royal Academy between 1769 and 1790, Reynolds spoke a great deal about history painting. In 1771, in his *Fourth Discourse*, Reynolds discussed the choice of subject matter open to the artist. "No subject", he stated, "can be proper that is not generally interesting, it ought to be either some eminent instance of heroic action, or heroic suffering. There must be something either in the action, or the object, in which men are universally concerned, and which powerfully strikes upon the publick sympathy". In this respect he was echoing Hogarth's earlier views — at least in so far as he wished to engage the public interest. On other issues they differed. The subject of the painting, he advised, should concentrate on one principal group, and the figures should be idealised and based on poetic rather than historical truth. Local costume should be eschewed in favour of a more generalised garb, and facial expressions should, he stated, exhibit a single, unambiguous emotion. Reynolds demonstrated his ideas in a picture which he

talented draughtsman, Mortimer was encouraged in his studies by Cipriani, who had arrived in England in 1756. By the mid–1760s, Mortimer had decided to embark on a career as a history painter, winning a premium from the Society of Arts in 1764 for his painting *St Paul preaching to the Britons* (Town Hall, High Wycombe). Although he continued to paint portraits, he was at his best when he had ample scope to use his fertile imagination, and amongst the subjects from literature which he tackled were illustrations to Chaucer's *Canterbury Tales, Don Quixote*, the frontispieces to Bell's *Poets of Great Britain* (1777–9) and, most striking, twelve etchings of characters from Shakespeare, based on his own drawings. The latter include *Lear* (Fig. 2), a wild, windswept figure which demonstrates a close affinity to the same figure in James Barry's *Lear in the Storm*, the first version of which he produced in 1774 (private collection).

Neither Pine (*c*.1730–88) nor Dance (1735–1811) were possessed of the imaginative gifts of Mortimer, or the versatility of Wright, although they both made significant contributions to the growing confidence of British artists in addressing narrative subjects. Pine's importance in the present context lies in his innovative series of depictions of actors in character (a genre also explored by Zoffany) whilst he anticipated Boydell by some years in mounting an exhibition of his Shakespearean history paintings in London in 1782 (destroyed by fire in Boston in the early nineteenth century). Dance, who also exploited the character-actor portrait, as in his 1771 *Portrait of Garrick as*

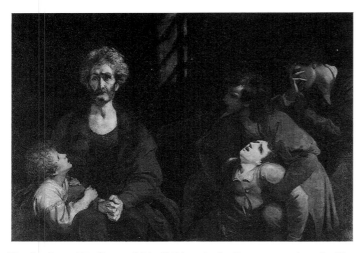

Fig. 3 Count Ugolino and his Children in the Dungeon as described by Dante.

exhibited at the Royal Academy in 1773, *Ugolino and his Children in the Dungeon* (Fig. 3), the subject of which he took from Dante's *Divine Comedy*.

Today, *Ugolino* seems more of an heroic failure than a successful vindication of Reynolds's theories, but at the time it was lauded among intellectual circles as an example of true pathos — notwithstanding vicious attacks by certain sections of the press. The important point was that Reynolds had not merely painted a narrative painting but had allied it to a particular intellectual viewpoint. As the 1770s progressed, notions about what constituted the best manner of approaching narrative painting tended to polarize around Reynolds's ideas.

In 1773 Reynolds, and several other British artists, including West, Barry, Cipriani, Dance and Angelica Kauffmann, embarked on a plan to decorate the interior of St Paul's Cathedral, under the auspices of the Royal Academy. Although the idea was eventually abandoned, it had a number of important repercussions. First, it accelerated the already worsening relations between Reynolds and his one-time protégé, James Barry, who believed that Reynolds had deliberately scuppered the scheme for personal reasons. Secondly, and on a more positive note, it set a precedent for subsequent collaborations in narrative painting between British artists. Thirdly, it marked a resurgence in interest in the promotion of religious painting in general.

Thus by the late 1770s, even before his ill-fated, but Herculean designs for St George's Chapel, Windsor, Benjamin West, an American who settled permanently in London in 1763, had produced altarpieces for Rochester Cathedral; Trinity College Chapel, Cambridge; and St Stephen Walbrook, London. Other artists too were beginning to secure the patronage of the clergy, and in 1776 Mortimer was commissioned to make designs for painted glass as Brasenose College, Oxford, while Cipriani painted an altarpiece for Clare College, Cambridge. At the Royal Academy, too, religious subject matter gained in popularity. In 1777 John Singleton Copley exhibited a *Nativity*, with Stothard showing in 1778 a *Holy Family*, and in 1779 Reynolds unveiled his own version of the *Nativity* (see cat. no. 33), which formed the central design of his scheme for the West Window of New College, Oxford.

While Reynolds created a forum for debate, through his *Discourses* and his even more controversial subject pictures, Benjamin West must nonetheless be regarded as the most successful exponent of narrative painting in late eighteenth-century England. West, who had since the 1760s secured the friendship and patronage of George III, was a prolific artist, and one who, although the quality of his work varies widely, was capable of great innovation — most notably in his *Death of General Wolfe*, which established new standards for the adaption of modern subject

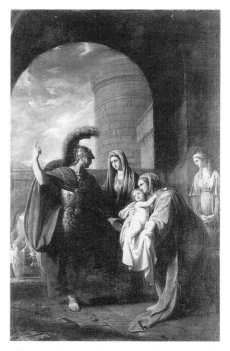

Fig. 4 Hector taking leave of Andromache

12

matter to the iconography of high art. The range of West's art was unusually broad. In the 1760s and 1770s he began to produce historical subjects based on classical history, such as *The Oath of Hannibal* of 1771 (Her Majesty the Queen). By the 1770s he was also producing works based on episodes from English history, from *Alfred the Great* (cat. no. 32) to *The Battle of the Boyne* (cat. no. 34). Furthermore, West had a wide-ranging interest in classical and modern literature and produced numerous illustrations from Homer (Fig. 4), as well as episodes from Euripides, Virgil, Ariosto, Boccaccio and British authors such as Shakespeare, Spenser, Gray and Sterne. West, although his art shows a number of stylistic changes over the years, continued to exploit a brand of narrative painting which made its impact through a Poussinesque frieze-like structure. By the 1780s, however, an alternative form of narrative, which concentrated on the psychological impact of dramatic events on key characters, was evolving. Reynolds who, as we have seen, had promoted such an approach, continued to turn out occasional *grandes machines* in this vein. In 1781, for example, he exhibited *The Death of Dido* (Her Majesty the Queen) at the Royal Academy. One artist who was present in Reynolds's studio when he worked on the painting was Henry Fuseli, and in the same year Fuseli exhibited his most celebrated picture, *The Nightmare* (Detroit), which explored more explicitly the quasi-erotic ideas which were implicitly expressed in Reynolds's own painting of *Dido*.

Born in Zurich in 1741, Fuseli, after a sojourn in Italy in the 1770s, settled for good in London in 1780. Though lacking West's technical expertise as a painter, and Reynolds's cool-headed pragmatism, Fuseli was among the most genuinely intellectual artists working in England in the second half of the eighteenth century. As well as being a draughtsman of the highest order, Fuseli had a profound knowledge of European literature and philosophy, and greatly admiring English writers like Shakespeare and Milton, he was able to see their achievement within a broader European context. Fuseli's work was dramatic, but it did not simply seek to draw on, or re-enact theatrical traditions, as his treatment of the Witches from *Macbeth* (Fig. 5), for example, demonstrates. It was Fuseli, with his drive and sense of the epic, who was instrumental in promoting Boydell's Shakespeare Gallery in the late 1780s.

In 1786 the publisher, Thomas Macklin, conceived the idea of making prints from paintings by prominent British artists including Fuseli, Barry, West and Loutherbourg, based on the works of English poets. These paintings

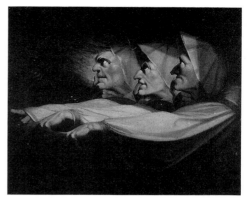

Fig. 5 The Three Witches

were exhibited in Pall Mall from 1787/88 at the Poet's Gallery, alongside the texts, while the prints, combining text and image, were sold separately. In November 1787 a similar scheme was hatched by John Boydell which concentrated solely upon episodes taken from the work of Shakespeare. Barry in particular, who had for many years despaired at the lack of patronage for high art in England, leapt at the opportunity afforded by Boydell and, among his best works, produced by 1787, is *King Lear weeping over the Body of Cordelia* (Tate Gallery). Romney, whose powers by this time were unfortunately in decline, also cooperated with the venture, as did West, but Reynolds was more reluctant about involving himself in a commercial enterprise over which he did not have ultimate control. He was, however, eventually persuaded to take part, and when in May 1789 the *Morning Post* declared that Boydell's Gallery was "a treasure of graphic excellence, in the highest degree creditable to BRITISH GENIUS", it is doubtful whether either Reynolds or Fuseli had conceived of it in quite such nationalistic terms.

Eventually Reynolds painted three works for the Shakespeare Gallery, *Puck (private collection)*, the *Death of Cardinal Beaufort* (Petworth), and *Macbeth and the Witches* (Petworth). In July 1789 Reynolds noted that his sight was failing. Nevertheless he continued to work on the picture, but in September the *Morning Post* reported: "Macbeth will probably remain for ever in its present *visionary* state". The painting, which is monumental in conception and scale, was ultimately too much for Reynolds, and yet, even today in its ravaged condition, it exerts a curious fascination. It also serves as a poignant reminder of the continual, although at times frustrated, ambition of British eighteenth-century artists to match in visual terms the nation's rich literary heritage.

FROM THE 'DEATH OF GENERAL WOLFE' TO THE 'DEATH OF LORD NELSON': BENJAMIN WEST AND THE EPIC COMPOSITION

PETER CANNON-BROOKES

WHEN, for early sixteenth century Verona, Riccio depicted the last life of the eminent local doctor, Girolamo della Torre, he showed della Torre, stark naked, being lifted onto a classical couch, whilst all around him friends and family have dressed for the occasion in togas and Roman tunics. This deliberate rejection of the real world stems from the earliest phase of the Italian Renaissance and for his tomb in S. Croce, Florence, by Bernardo Rossellino, Leonardo Bruni (died 1444) is laid out on his bier, wearing his poet's laurel wreath, as if his body had just been carried ceremoniously from exposure in the forum. Both Bruni and della Torre are depicted as heroes *al antica* and this Renaissance convention for heroic death scenes was retained with considerable tenacity for more than three centuries. The archaeological sophistication sought by Anton Raphael Mengs and Gavin Hamilton in Rome encouraged the maintenance of such an approach, but the practical problems of depicting heroic/epic events which had taken place outside Europe — in India or Canada for example — were increasingly formidable.

Earlier in the eighteenth century, the artists illustrating Paul de Rapin-Thoyras's *History of England* (1743–47) — Charles Grignion, Hubert François Gravelot and George Vertue (1684–1756; the leading engraver in England of the 2nd quarter of the 18th century) — were content with the picturesque historicist compositions in a Gothick-Rococo mode which made no attempt to reconstruct what actually took place or represent recognisable individuals. These volumes were to a considerable extent superseded from 1754 by David Hume's *History of England* and the growing strength of antiquarian researches. Meanwhile the representation of the victories achieved by the 1st Duke of Marlborough during the War of Spanish Succession remained without immediate successors until the War of Austrian Succession, from 1740, revived memories of the former. John Wootton's massive *Siege of Lille* and *Siege of Tournai* (captured 1708 and 1709) in the Royal Collection were completed in 1742.

The Seven Years War (1756–63) brought British successes in India, through the agency of the East India

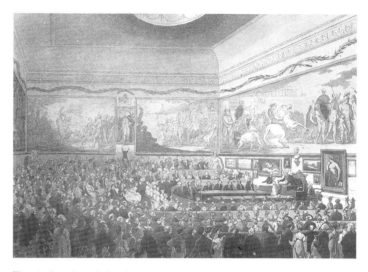

Fig. 1 Interior of the Great Room of the Society of Arts in 1809, from Ackermann's *Microcosm of London*, showing James Barry's cycle of paintings depicting *The Progress of Culture* (1777–83).

Company, with the Battle of Plassey and capture of Chandergore in 1757, the siege of Arcot in 1759 and the Battle of Wandewash concluding the major hostilities there in 1760. By the Peace of Paris (1763) Britain secured Canada, Nova Scotia, Granada, St. Vincent, Dominica, Tobago and Minorca. 1760 also saw the accession of George III and the military and naval successes encouraged the outbreak of patriotic fervour which fostered a new interest in history painting by native British artists. The first public exhibition of contemporary British art open to "all the Present Artists" (as against the more limited ranks of those around Hogarth and Hayman whose works were already to be seen on public display at Vauxhall Gardens and the foundling Hospital) opened in the Strand Great Room of the Society of Arts, 21 April 1760. 130 exhibits were on display and by the time it closed, 8 May 1760, 6,582 catalogues had been sold at 6d and over 1,000 visitors crowded in during the busier days.

15

Premiums for the best paintings of history and of landscape were offered by the Society of Arts that year, and the paintings exhibited there and subsequently at the Free Society of Artists (1762) reveal a widening of history painting from the classical subjects preferred by the Italian masters to include themes from Shakespeare and British history. One of his earliest works, George Romney submitted *King Lear in the Tempest* (Kendal), whilst Robert Edge Pine won the first premium of 100 guineas for "the best historical picture painted in oil colours, the figures to be as large as life, and the subject to be taken from the English history" with *The Surrender of Calais to Edward III* (engraved by F. Aliamet and published in 1762). The 2nd premium went to Andrea Casali for his *Story of Gunilda*. In the same exhibition William Dawes exhibited *A Scene from Macbeth, Act IV, Scene 1* (19) and *Mortimer taken prisoner by Edward the Third in Nottingham Castle* (20), and Samuel Wale contributed *The Widow of Sir John Grey petitioning King Edward the Fourth to restore her Husband's Lands, forfeited in the Cause of the House of Lancaster.*

As a result of dissension, a substantial group of those exhibiting moved on and in 1761 exhibited instead in the Great Room, Spring Gardens, as the Society of Artists of Great Britain, and thus, from 1761, a second series of exhibitions was provided for the London visiting public. However, Vauxhall did not immediately lose its significance as a showcase for contemporary English painting and that year was unveiled in the Saloon the large *Surrender of Montreal to General Amherst,* by Francis Hayman. Captured 8 September 1760, the event was still fresh in the public mind and the portrayal of contemporary history served to focus attention on the limitations imposed by the conventions of the day. Paintings of military operations, to be intelligible, demand clearly identifiable dress in order to differentiate between the opposing sides and Wootton had followed the tradition established by Adam Frans van der Meulen for Louis XIV. *The Surrender of Montreal to General Amherst,* and Hayman's painting of *Lord Clive meeting Mir Jafar, Nawab of Murshidabad, after the Battle of Plassey* (Bayly, 1990, pp. 99-100, no. 107) unveiled in the Saloon in 1762, were extensions of that tradition of military painting. From 1762 Richard Wright exhibited a series of paintings of recent naval engagements, at the Society of Artists, treated realistically, but the death of a national hero such as General Wolfe at Quebec, was quite a different matter and when Romney, in 1763, entered his *Death of Wolfe* for the premium of 100 guineas offered by the Society of Arts (183), it was much criticised as "a coat and waistcoat piece". Robert Edge Pine won the first premium that year with his *Canute reproving his Courtiers for their Flattery* (engraved by Aliamet and published 1772) in which the problems of sartorial propriety were minimal, whilst the second premium was won by John Hamilton Mortimer with his *Edward the Confessor spoiling his Mother at Winchester.*

Benjamin West arrived from America in Rome in 1760 and with stays in Florence, Bologna, Parma and Venice studied there until June 1763 when he travelled via Florence, Livorno, Parma, Genoa, Turin and Paris to London. During that brief time he had shaken off his provincial beginnings and had been deeply impressed by the archaeological correctness sought by Anton Raphael Mengs and Gavin Hamilton in their paintings of classical subjects undertaken in Rome. His *Paetus and Arria* (Yale Center for British Art, signed and dated 1766) and *Pylades and Orestes* (signed and dated 1766, Tate Gallery, exhibited at the Society of Artists (180)) reveal the impact of their ideas and occupy a parallel position to the paintings of Angelica Kauffmann and Nathaniel Dance who both arrived in England that year. West's full maturity as a Neo-Classical painter was demonstrated by his *Leonidas and Cleombrutus* and *Agrippina Landing at Brundisium with the Ashes of Germanicus* (both signed and dated 1768 and exhibited that year at the Society of Arts) and on the strength of these Archbishop Drummond presented West to the King. George III commissioned from him *The Departure of Regulus from Rome* (signed and dated 1769, Royal Collection) which was by his express wish included in the first exhibition of the newly-founded Royal Academy. The patronage of George III thereby established continued until 1801 and included some 60 paintings costing a total of £34,987, and from 1772 West enjoyed the position of Historical Painter to the King.

At the Society of Artists in 1764 West had exhibited *Angelica and Medoro, an historical picture* and *Cymon and Iphigenia,* both admirable essays in his Neo-Classical style, whilst Edward Penny (1714–91) sent in his *Death of Wolfe* (1763 version, given by the artist to the University of Oxford in 1787). The latter was carefully researched as to the precise details concerning the exact location of the event and those present, and the death of General Wolfe is depicted with uncompromising realism in contemporary dress. Penny's painting, now in the Ashmolean Museum, attracted only limited attention when exhibited, as did his *Marquis of Granby relieving a sick soldier* in the same vein exhibited at the Society of Arts (96) the following year (Yale Center for British Art), although both were subsequently extremely popular in engravings. Thus when West let it be known that he was intending to paint

The Death of General Wolfe in contemporary dress considerable pressure was brought to bear by both the King and Archbishop Drummond. On the face of it, West's position in 1769/70 was not sufficently secure for him to take any risks, least of all with a major painting of a subject with which other artists had recently experienced difficulties, and Archbishop Drummond was nervous that his protégé would, by depicting the scene in contemporary military dress, risk losing the reputation he had so recently established as the leading Neo-Classical painter in Britain. George III had been told that "modern military costume impaired the dignity of the subject and that it was thought very ridiculous to exhibit heroes in coats, breeches, and cock'd hats" (Erffa & Staley, 1986, p. 55). To a certain extent this intervention can be explained on the basis of the unsympathetic public response to Romney and Penny's earlier representations, as well as the belief in the moral superiority of classical antiquity which was embodied in the desire to depict a hero *al antica*. On the other hand West understood well the intellectual basis of the approach of Mengs and Hamilton to classical antiquity, and he could not see why the same discipline and intellectual rigour could not be applied to the depiction of contemporary history.

For the composition of his *Death of General Wolfe,* West adopted a *Lamentation over the Dead Christ* composition and set it as a *tableau vivant* in an extensive landscape. Erffa & Staley, and others, have noted this derivation, but without drawing attention to the strongly sculptural character of the solution achieved by West. Comparisons with Anthony van Dyck's *Lamentation* reveal generic similarities, but the differences are more significant and other sources of inspiration must be sought for this combination of great immediacy and strong sculptural forms. The middle decades of the 18th century saw the climax of the tradition of realism in Italian sculpture with the flowering of the famous *presepe* of Naples and Genoa and the *sacri monti* of Piedmont and Lombardy. West would have seen the Renaissance forerunners of these sculptural complexes in the life-size painted terracotta *Lamentation over the Dead Christ* groups in S. Anna dei Lombardi, Naples (Guido Mazzoni, 1492), S. Maria della Vita, Bolgna (Niccolò dell' Arca, 1490s?) and, probably, S. Giovanni della Buona Morte, Modena (Mazzoni, 1477–80). In the *sacri monti* such terracotta sculptures, life size painted in naturalistic colours with glass eyes and real hair, were, from the early 16th century, assembled by Gaudenzio Ferrari and his successors into ever more ambitious *tableaux vivants* within chapels whose frescoed interiors completed the illusion.

West's *Death of General Wolfe,* with the extremely realistic figures arranged in sculptural groups, clearly separated from the landscape and scenes of battle wrapped around it, is a translation into painting of the Italian devotional complexes, reinforced by the intellectual discipline which West had learnt from Mengs and Hamilton. Winckelmann had recognised the importance of colour in classical sculpture — an element subsequently ignored by later generations of Neo-Classical artists, until Alma Tadema — and thus West's *Death of General Wolfe* displays in principle the same correctness and rationalism with respect to its chosen subject matter as that sought by his mentors. Furthermore, West exploits with great skill Renaissance illusionistic devices — learnt no doubt from his close study of Correggio in Parma, as well as Raphael in Rome — whereby the observer of the painting completes the ring of figures around the dying General. This psychological involvement of the spectator in the action is strong, but not spelt out, and the implicit breaking down of the barrier between the real world and the painted space must have made many contemporary observers uneasy without their being able to identify the precise reason for their disquiet.

Just as Mengs and Hamilton had, in Rome, demanded of West absolute archaeological accuracy in the depiction of classical scenes, verisimilitude was equally essential in the depiction of contemporary uniforms and other military equipment, and apart from Wolfe himself six of the figures are portraits of officers who were present (or would like posterity to think that they had been present!) In his *Death of General Wolfe* Benjamin West achieved the synthesis which was to revolutionise British history painting, and it was, perhaps, not entirely a coincidence that John Singleton Copley and John Trumbull, his fellow Americans in London, most fully understood the intellectual discipline which made *The Death of General Wolfe* such a triumphal success.

The revival of British history painting was, from the initiative of the Society of Arts in 1760, gathering its own momentum long before *The Death of General Wolfe* was first exhibited, in West's studio in 1770. An entry charge was made then, which provided a welcome addition to West's income, and in consequence the painting was already well-known in artistic circles long before it was exhibited at the Royal Academy in 1771 (210). Indeed, West had written to the American painter, Charles Willson Peale, 21 June 1770, that the picture had already "procured me great honour". George III at first declined to purchase it, though both Archbishop Drummond and Sir Joshua Reynolds underwent a dramatic change of heart,

because of the unsuitability of modern dress for the depiction of heroes. The painting was purchased by Lord Grosvenor who subsequently ordered four pictures, with subjects from English history, the same size, to hang with it in a room in Grosvenor House, London (see cat. nos. 34, 35 & 41).

West's *Departure of Regulus from Rome* had been delivered to George III in 1769 and to this the King added a further six paintings between 1770 and 1773 to decorate the Warm Room in Buckingham House. Amongst these was the first replica of *The Death of General Wolfe* (1771) and this slightly ad hoc scheme may have suggested the Grosvenor House paintings which were delivered in pairs in 1780 and 1783 after exhibition at the Royal Academy. A further series of history paintings were commissioned from West at this moment (*c*.1771) by Lord Clive for the Eating Room at Claremont, and were to depict major evernts of his career in India, but only one — *Lord Clive receiving from the Mogul the Grant of the Duanney* appears to have been almost completed by Clive's suicide in 1774. Finished later and exhibited at the Royal Academy in 1795 (28; by descent to the Earl of Plymouth) this successfully applied the criteria evolved for *The Death of General Wolfe*. Again West looks to the Italian High Renaissance, but more specifically the Raphael Cartoons, then installed in Buckingham House. Edward Penny's painting of Lord *Clive receiving from the Nabob of Bengal (sic) the grant later used to establish 'Lord Clive's Fund'* (commissioned by the East India Company, 1772) provides a revealing contrast.

Engraved by William Woollett and published by the consortium of Woollett, Boydell and Ryland, 1 January 1776, the print of *The Death of General Wolfe* was a huge commercial success and John Boydell was by 1790 able to claim to have earned a clear profit of £15,000 from sales of the print, having paid Woollett £2/300 for the plate. Nevertheless Woollett made his reputation with this plate and both painters and engravers recognised for the first time since the heyday of Hogarth that the scale of the financial profits to be made from exhibiting and engraving a successful painting could be vastly greater than the price to be gained from selling it. Much of the motivation of painters, engravers and print publishers for the rest of the century was provided by a relentless search for the magic combination of artist and subject matter which could repeat the profits reaped from *The Death of General Wolfe*. Thus the fundamental changes in the relationship between painters and their public, the rise of exhibitions charging for entry (directly or indirectly), the vast increase in the dissemination of reproductive prints (above all stipple engravings), and the evolution of modern marketing techniques, all owe their greatest impetus to *The Death of General Wolfe* and the inspiration provided by its example.

The Boston Tea Party in 1775 and the outbreak of the American War of Independence created considerable difficulties for Americans suspected of harbouring democratic tendencies, and West himself was not above suspicion. In the same year, John Singleton Copley, whose parents were recent immigrants from Ireland to Boston, from where he had been contributing portraits to the exhibitions of the Society of Arts (1766–72), settled in London after a year travelling in Europe. His early career parallels that of West to a remarkable extent, and they were in correspondence long before Copley came to Europe, so that Copley was well aware of West's artistic aims and ambitions for history painting some years before they met in London. Indeed, their aspirations were remarkably close and Copley determined to make his mark as a history painter with a painting which would capture the imagination of the public in a manner similar to *The Death of Wolfe*. This he achieved with the remarkable *Watson and the Shark* which represented in brutally dramatic terms an incident which had taken place in Havana harbour almost 30 years before. Exhibited at the Royal Academy in 1778 (65) the mezzotint by Valentine Green made from it was published 1 May 1779 and ensured, by its rapid dissemination, public awareness of Copley and his sensational paintings. From the beginning the marketing techniques of Copley were remarkably modern.

The relationship between Copley and West at this stage remained friendly and for *The Death of the Earl of Chatham* (see cat. no 37) it must be assumed that West allowed him access to his oil sketch of the same subject (*c*.1778–79; Kimbell Art Museum, Fort Worth). The resulting painting, completed in 1781, is an artistic *tour-de-force* with 55 identified portraits which contribute greatly to the overwhelming immediacy and presence of the figures in their peers' robes. Unlike Reynolds, Copley was acutely aware of the commercial possibilities of such a work and hired in summer 1781 the Great Room in Spring Gardens. Some 20,000 paid one shilling each for admission and the large engraving, executed by Francesco Bartolozzi for Copley at a cost of £2,000, and published in 1794, generated a profit in excess of £5,000.

With *The Death of Major Pierson* Copley effectively took over the leadership of contemporary history painting from West and the *tableau vivant* quality of this intensely dramatic and minutely observed scene is very striking, with the main action arranged as a frieze. The commercial aspects were to the fore, not least because the painting

had been commissioned by John Boydell, for £800, and together with *The Death of Chatham* they were exhibited from 22 May 1784 in the Great Room at 28 Haymarket. One shilling admission was again charged and in August the exhibition was transferred to the large gallery in Boydell's house, Cheapside. Subscriptions were taken for the line engraving by James Heath (see cat. no. 44) but much of the commercial profit to be made from it was lost when Heath failed to complete the plate until 1796, in contrast to Valentine Green's mezzotint of *Watson and the Shark* which was on sale within relatively few months of the display of the painting.

In many respects the only real competitor to the Americans was Philip Jacques de Loutherbourg whose *Mock Attack before George III*, exhibited at the Royal Academy in 1779 (182) and *Review of Warley Camp before George III* (R.A., 1780 (15); both Royal Collection), reveal a quite extraordinary vitality and realism which stem from minute observation and a wonderful characterisation of light effects. A brilliant stage designer working with both Garrick and Sheridan, Loutherbourg brought together these skills in his *Eidophusikon* which opened 26 February 1781. Its performances combined elements of both theatre and painting, and counted Gainsborough and Reynolds amongst its enthusiastic supporters. In 1782 new scenes included *The Cataract of Niagara* and *Satan arraying his Troops on the Banks of the Fiery Lake, with the raising of the Place of Pandemonium; from Milton*, thereby anticipating the Romantic conceptions of John Martin some forty years later. Loutherbourg also exhibited, at the Royal Academy in 1783, the year before *The Death of Major Pierson* was completed, his *Battle between Turks and Russians under their General Ptomkin near Bender* for which Catherine the Great sent him armour and weapons to ensure great accuracy.

Robert Edge Pine was unable to compete and after the failure of his 1782 exhibition of Shakespearan history paintings he sold the engraved plates to Boydell and took the paintings with him when he emigrated to the United States in 1783. He did, however, leave behind him his last essay in contemporary history — *Lord Rodney in Action, aboard the 'Formidable', attended by his principal Officers* (Royal Academy 1784 (378)) — which anticipate some of the great epic compositions of the Napoleonic Wars.

The third American history painter, John Trumbull, had a revolutionary background and effectively took over the subjects which were politically too dangerous for either West or Copley to handle. Shortly after his arrival in London, West employed Trumbull to make full-size copies of his *Battle of La Hogue* and *Death of General Wolfe*. Trumbull welcomed the opportunity and wrote to his father:

> West's pictures are almost the only examples in Art of that particular style which is necessary to me — pictures of modern times and manners. In almost every other instance the art has been confined to the History, Dresses, Customs of Antiquity (Jaffé, 1975, p. 69).

The precise reasons for ignoring Copley here are uncertain, since Copley appears to have encouraged him generously until 1787, but the arduous task was completed in four months and Trumbull gained fast a vast amount of valuable experience of West's ideas and working methods. Trumbull's cycle of eight monumental paintings of the American War of Independence was begun in West's studio after the latter had wisely abandoned, unfinished, in 1784, his painting of *The Peace Commissioners in 1782*. *The Death of General Warren at the Battle of Bunker's Hill, 17 June 1775* was finished by March 1786, and *The Death of General Montgomery in the Attack on Quebec, 31 December 1775* soon afterwards, but these subjects could not be exhibited in London and British engravers refused to engrave them. Continental engravers were eventually found, but the engravings were not ready for publication until 1798.

After breaking with the Royal Academy, Wright of Derby organised a one-man exhibition in London at Robins's Rooms in Covent Garden in 1785, with contributions in the catalogue from the poet, Hayley. The centrepiece was his enormous canvas depicting *A View of Gibraltar during the Destruction of the Spanish Floating Batteries* (missing since the mid-19th century). This action had taken place in September 1782, but the subject soon became popular with painters and George Carter exhibited earlier in 1785, in a room in Pall Mall, his *Siege of Gibraltar* and *Floating Batteries* with 34 other history paintings which Edward Edwards reported was profitable. Trumbull made three versions of his *Sortie Made by the Garrison of Gibraltar, 26–27 November 1781* by which he chose a slightly earlier incident in the campaign, and he exhibited the third, large version, completed early in 1789, in the auction rooms of Thomas Hammesby in Spring Gardens, 11 April–4 July 1789, following the pattern established by Copley. However, it was largely ignored by both public and press, mostly due to competition from the annual exhibition of the Royal Academy and Boydell's recently opened Shakespeare Gallery in Pall Mall. William Sharp was engaged to engrave the picture but this too was delayed and not ready for publication until the end of 1789.

Additional competition for these epic compositions and the special exhibitions organised to market them, was

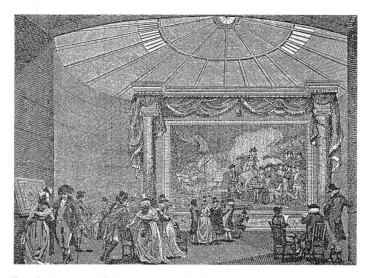

Fig. 2 J. S. Copley's *Siege of Gibraltar* displayed in a tent near Buckingham House in 1791. This engraving, which decorated the admission ticket, both provided a souvenir and additional advertising.

offered from March 1789 by the Panorama which opened in a room behind No. 28 Haymarket and proved such a success that it moved soon afterwards to purpose-built accommodation in Cranbourne Street, behind Leicester Fields. This accommodated two panoramas simultaneously on different levels and counted both Reynolds and West amongst those who praised it. Copley began work on his huge *Siege of Gibraltar*, commissioned by the City of London, in 1783 and the subscription list for engravings was opened in 1788 although the painting was not finished and put on exhibition until 1791. In the meantime Copley had been sent to Germany by George III to take the portraits of four Hanoverians who had been present at the siege by the Spaniards and French, and, displayed in a vast tent which bore a marked resemblance to a panorama building, it attracted immense crowds, over 60,000 paid a shilling each to view it.

Meanwhile, Benjamin West's antiquarian interests, reinforced by the researches of Joseph Strutt which provided reliable sources for increasingly accurate historic dress from the Middle Ages, took on a new lease of life with his *Alexander III of Scotland saved from a Stag . . .* which was exhibited at the Royal Academy in 1786 (148; see cat. no. 52). This may have been the immediate inspiration for the cycle of eight paintings dedicated to events in the reign of Edward III which was commissioned from West by George III for the Audience Chamber of Windsor Castle

(1786–89). These remarkably accurate reconstructions of medieval scenes are one of the major antecedents for 19th century English historical narrative painting (Strong, 1978), but belong to another story, and West did not return again to contemporary history until his *Death of Lord Nelson*.

The outbreak of war with revolutionary France, in 1793, spelt rapid disaster for the previously flourishing export trade of engravings on which the fortunes of Boydell, Macklin, Bowyer and other depended, and under acute financial pressures these print publishers were unable to respond to the changing market. Stipple engraving, which from the early 1770s become the most important medium for rapid, inexpensive reproduction of paintings, and was the technique chosen by Boydell for his Shakespeare Gallery, tended in less skilled hands working under pressure to be unacceptably coarse and during the 1790s ceased to be the preferred medium. By the time lithography became established in the 1820s it was virtually dead, and with it the main outlets for the paintings of a considerable group of second and third rate artists. However, the new generation of print publishers — above all the Ormes — were able to seize the initiative and satisfy the demand for military and naval subjects appropriate to a nation at war.

Loutherbourg too responded to the challenge with a series of brilliant war compositions commencing with *The Battle of Valenciennes* commissioned in 1793, whilst a flurry of Anglo-Indian contemporary history paintings inspired in part by the Anglo-Mysore Wars, included Arthur William Devis's *Lord Cornwallis receiving the Sons of Tippoo* begun in India in 1793 and that of the same subject by Robert Home (National Army Museum) who actually witnessed the scene at Seringapatam in February 1792 (Bayly, 1990, p. 35 & pp. 154-55, no. 157), whilst Home was also responsible for one of the most dramatic pieces of reportage from India at this date, *The Death of Colonel Moorhouse at Bangalore* (1793-94; National Army Museum). Tippoo Sahib was killed at the storming of Seringapatam (4 May 1799), by which time he had become in British folk mythology something of a hero. Arthur William Devis painted *Major General Baird and other British Officers finding the Body of Tippoo Sahib . . .* (1799–1802; National Museums of Scotland) and Henry Singleton the spirited and decidedly romanticised *Last Effort of Tippoo Sultann in the Defence of the Fortress of Seringapatam* (painted c.1800; stipple engraving published 1802). Slightly later in date is the much more restrained interior scene by Thomas Daniell of *Sir Charles Warre Malet, Bt., the British Resident at the Court of Poona, in 1790 concluding a*

treaty in Durbar with Souae Madarow, the Peshwa of the Maratha Empire (C.1800–05); cat. no. 125). Robert Bowyer first exhibited Loutherbourg's *Battle of Valenciennes* in his Historic Gallery in 1794 and Loutherbourg contracted that year to produce for Bowyer, over a twelve-year period, five large-scale paintings of historic scenes, of which *The Defeat of the Spanish Armada* is in the National Maritime Museum and *The Great Fire of London* (signed and dated 1797, Lord Northbrook) was aquatinted in colour (1799) and line engraved (1805) for Bowyer's edition of Hume's *History of England. The Battle of Valenciennes* was exhibited again from 1795 together with its spectacular companion painting, *Lord Howe's Victory, or, The Battle of the Glorious First of June 1794,* until 1799 when both paintings were auctioned at Christies. Purchased by Mr. T. Vernon of Liverpool, they formed a travelling exhibition which was shown in the Assembly Rooms, Edinburgh, during the summer of 1800. However, the market was already coming close to being flooded with an ever growing number of such attractions in the late 1790s, apart from the long-running galleries of Boydell, Macklin and Bowyer.

Robert Dodd's panorama of *The Fleet at Spithead in 1795* proved a great attraction in 1796 when exhibited in the Great Room at Spring Gardens. On the other hand, Copley's immense and pedantic painting of *Charles I Demanding in the House of Commons the five Impeached Members,* begun in 1782, was finally finished in 1795 and exhibited in Spring Gardens. Including no less than 58 portraits laboriously copied from reliable sources and then adapted, the result of this immense research programme is more an historical document than a work of art and constitutes the *reductio ad absurdum* of the approach originally advocated by Mengs and Hamilton. An artistic cul-de-sac and, appropriately, now housed in the Boston Public Library, Copley reluctantly recognised from the response to his 1799 retrospective exhibition the futility of such mammoth programmes, and the last phase of contemporary history painting is characterised by a less rigid approach.

The central attraction of the Royal Academy exhibition of 1798, for example, was William Beechey's immense grop portrait of *George III and the Prince of Wales reviewing the Tenth Hussars and Third Dragoons* (Royal Collection) where the subject has been interpreted in terms of a dramatic battle scene. Drama did not, however, always ensure popular success, and although Fuseli's Milton Gallery opened in 1799 in the old Royal Academy Rooms in Pall Mall, and again, with additions, in the summer of 1800, the venture was financially unsuccessful despite

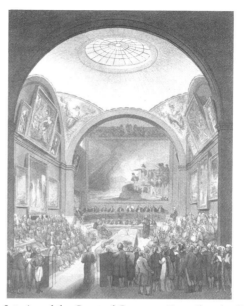

Fig. 3 Interior of the Court of Common Council at the Guildhall, from Ackermann's *Microcosm of London* (1808–10), hung with J. S. Copley's *Siege of Gibraltar* and some of the paintings presented by Alderman Boydell in 1793.

purchases made by collectors of the stature of Thomas Lawrence and John Julius Angerstein, after its closure. Public support was increasingly for the great dioramas and Robert Ker Porter opened his vast *Storming of Seringapatam* at the Lyceum in April 1800 (engraved in three sections by John Vendramini and published 1802–03) , whilst Samuel James Arnold's panorama of *The Battle of Alexandria,* 108 feet long, was displayed at Wigley's Great Room, Spring Gardens, from late 1801 until replaced by Girtin's *Great Picture of London (Eidometropolis)* in August 1802. Henry Aston Barker's panorama of *The Attack on Copenhagen* opened in Leicester Fields in 1802 and received the fulsome approval of Nelson for its accuracy. William Heath's panorama of *The Battle of Trafalgar* exhibited in 1806 at Leicester Square was, not surprisingly, a tremendous popular success and inspired a large number of imitations.

This was in sharp contrast to the failure of Fuseli's Milton Gallery and Woodmason's New Shakespeare Gallery, and the rapid disappearance of Macklin's Poet's Gallery after his death in 1800, followed shortly afterwards by Bowyer's Historic Gallery (auctioned 1807). Boydell was allowed by Act of Parliament in 1804 to dispose of his property by lottery to avoid bankruptcy, and

by his death, aged 85, 12 December 1804, all 22,000 lottery tickets had been sold. Nevertheless the sum raised was derisory compared to the £350,000 he had proudly claimed to have laid out "in promoting the commerce of the fine arts in this country". William Tassie purchased the winning ticket and the paintings from the Shakespeare Gallery were auctioned by Christies, 17–20 May 1805, for a total of £6,181-18-6. The lease of the Shakespeare Gallery was purchased by the newly-founded British Institution and its first exhibition was held there in 1806.

However, as one of his last commercial ventures, Boydell offered a prize of £500 for a painting of *The Death of Nelson*, to be engraved and the painting then to be presented to the Admiralty or some other public body. West had promised Nelson to execute a painting of his death scene to be a companion piece to his *Death of General Wolfe* which Nelson so greatly admired. West's immense painting (Walker Art Gallery, Liverpool) was able to be displayed in his studio, like that of *Wolfe*, from May 1806, but he justified his blatant manipulation of history on the grounds that: "there is no other way of representing the death of a Hero but by an Epic representation of it" (see cat. no. 126).

In contrast the much more accurate representation of this scene, by Arthur William Devis in his *Death of Nelson* (National Maritime Museum), completed the following year and exhibited at the British Institution in 1809, was almost ignored by the public. By comparison to both West and Devis, at this late date, Loutherbourg's *Battle of Maida* (cat. no. 134), executed in 1807, has a directness and clarity which is both true to the subject and refreshingly lacking in didactic purpose.

Benjamin West would have made an excellent television producer, with his unerring eye for good marketable television rather than historical truth, but like the pedantry of Copley's *Charles I*, his justification for the "Epic Composition" carried within it the seeds of its own destruction.

FOOTNOTES

1. For main sources utilized see Bibliography, but more specific sources are quoted in the text, the footnotes below, or the relevant catalogue entries.
 The relationship between Benjamin West and his engravers is discussed by David Alexander in 'Benjamin West and the Market for Prints after History Paintings', in Alexander & Godfrey, 1980, p.32, which is prefaced by J. T. Smith's comment that: "Mr. West may justly be considered the founder of Historical Engraving in England". The examples set by Rubens, and before him, Dürer, were highly relevant in that both sought to increase the currency of their respective styles as a means of generating immediate income as well as future commissions, in contrast to Sir Joshua Reynolds who saw in prints after his paintings only *gloire*. The sheer scale of the publishing of engravings after West alone ensured his dominance as a history painter, even before the popular successes of *William Penn's Treaty with the Indians* (engraved by John Hall, published June 1775) and *The Death of General Wolfe* (engraved by William Woollett, published January 1776). The marketing strategy being employed by Gavin Hamilton out of Rome, using the plates privately engraved for him by Cunego after his paintings, did not go unnoticed by West.
2. See David Alexander, 'The Painter and the Search for the Best Selling Print 1775–1800', in Alexander & Godfrey, 1980, pp.51-52, not least for Copley's disastrous relationships with engravers.
3. Op. cit., pp.52 & 54, no. 109. Trumbull took the cycle back to the United States with him in 1816, at the conclusion of his second period of diplomatic service in Europe. Yale College accepted them as a gift in 1831 and erected a handsome Neo-Classical gallery in which to display them.
4. Nicolson, 1968(a), pp.15-16.
5. See Richard Godfrey, 'The Ambitions of the Print Publishers', in Alexander & Godfrey, 1980, pp.60-62.

PRINT MAKERS AND PRINT SELLERS
IN ENGLAND, 1770–1830

DAVID ALEXANDER

IN 1770 the English print market was on the eve of great change and expansion[1]. The engraved portrait still reigned supreme, principally in the form of the mezzotint, but the Irish-born mezzotint engravers, upon whom Joshua Reynolds had relied almost exclusively for twenty years, were about to give way to younger English engravers[2]. At the same time the pre-eminence of mezzotint was under threat, and the quality of English line engraving was rapidly improving. Until the 1760s this had been dominated by those who were either French-born, such as François Vivares (1709–80) and S. F. Ravenet (1706–74) (cat. no. 4), or trained in Paris, such as Thomas Major (1720–90) and Robert Strange (1721–92). These men produced excellent plates, principally silvery plates after the Old Masters, and were as well regarded abroad as in Britain. However, it was the success of the engraving of Richard Wilson's *Destruction of the Children of Niobe* by William Woollett (1735–85), with a style that relied on much greater contrasts, that gave collectors confidence that English line engravers could be in the same class as the leaders of the foreign schools. Woollett became something of a legend in his lifetime, hailed as the leader of his profession and depicted as a man totally dedicated to his work[3] (Fig. 1).

Woollett's success could not have been possible without the exhibitions of the Society of Artists, which had given publicity to Wilson's picture in the initial exhibition in 1760 and to Woollett's print the following year. For the first time prints could be seen on public display, visible to the polite world as a whole, not simply to the few who frequented engravers' or printsellers' premises. Exhibitions encouraged the increasing ambitions of artists to paint a wider range of subject matter and to break with the tyranny of portraiture. Thus there were to be seen an exciting new range of historical pictures, from the Neo-Classicism of Benjamin West (1738–1820) or Nathaniel Dance (1735–1811) to the *luministe* conceptions of Wright of Derby (1734–97) and the animal paintings of George Stubbs (1724–1806) and Sawrey Gilpin (1733–1807)[4]. All these genres were engraved in mezzotint, notably by Valentine Green (1739–1813), the most ambitious of the

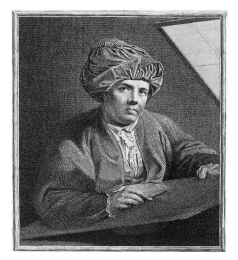

Fig. 1 *William Woollett* (1735–85), line engraving drawn, engraved and published by J. K. Sherwin, 12 August 1784.

younger English engravers[5]. Wright's paintings provided the inspiration for some of the most marvellous of all prints in that medium[6]. It was, however, the line engravers who in the end gained most; their technique was not only that which was seen to stand highest in the hierarchy of printmaking and was considered to be the appropriate medium for history, but it was also more capable of producing the larger printings which the market could absorb.

Although mezzotint plates had the disadvantage of wearing quickly, they could be engraved more quickly. This explains why most of the paintings which were engraved in the late 1760s and early 1770s continued to be mezzotints. A good many of these were published by John Boydell (1719–1804), whose skill at self-advertisement was rapidly making him the best known of print publishers[7]. There were, for example, some forty-six prints published after West's works between 1768 and 1780; thirty of these were mezzotints, twenty-one of them

by Green[8]. Of the forty-six prints, Boydell published twenty-nine, and all but five of these were mezzotints, with almost all either by Green or by Richard Earlom (1743–1822), who was almost constantly in Boydell's employment as engraver and draughtsman[9]. Boydell did not necessarily commission all these plates; some are likely to have been initiated by Green, who obviously had good relations with West, and sold after completion to Boydell. Green published three mezzotints after West before 1780 but it was not until later that he followed the example of the successful Irish-born engravers and published himself the majority of his plates. As the majority of his early prints were issued by Boydell he must have appeared very much that publisher's dependent.

The high profile which engravers assumed in the Society of Artists and the Free Society; the former gave publicity to Wilson's picture in the initial exhibition in 1760, and the latter to Woollett's print in 1762, with some acting as Directors and some exhibiting prints which were then published by printsellers, was probably one of the factors which influenced the 'architects' of the Royal Academy to exclude them on its inception in 1768. Painters set on raising the status of their profession did not want the agents of print publishers to have any say in their affairs. At that point Boydell was only one of several leading publishers: Robert Sayer, François Vivares, William Darling, Thomas Bradford and Thomas Major were all prominent figures in 1770, catering both for collectors of fine prints and for those simply looking for prints for decoration; some of them issued catalogues of their stock and generally advertised new plates in the newspapers[10]. In addition John Smith of Cheapside, Matthew Darly and Carington Bowles (d.1793) were publishers of satires and humorous prints whose turnovers must have been comparable to the other publishers.

Although Boydell's business may not have been pre-eminent his ambitions were very different and marked him out from the others. In the late 1760s he launched a series of large line engravings *Sculptura Britannica: A Collection of Prints, Engraved after the Most Capital Paintings in England*. One of his intentions was to show how many important Old Master pictures there were in the country and provide volumes of prints of them for gentlemen's libraries. By 1769, when the first volume of fifty plates was complete, he claimed that "his principal View, which was the Improvement of the Art . . ." of engraving "has, in a great Measure, been answered". He announced that the second volume would, unlike the first, contain prints after living British painters, not least because they could help the engravers to get better results, but in the event he only

Fig. 2 John Boydell (1719–1804), mezzotint by Valentine Green after Josiah Boydell (1750–1817), published by John Boydell, 1772, as No. 61 of his second volume of Boydell's *Collection of Prints*.

included three plates after West, and his own portrait [11] (Fig. 2).

In 1769 the Royal Academy relented towards engravers to the extent of creating six positions as 'Associate Engraver', an honour which most of the leading engravers seem to have considered insulting and therefore declined. West was apparently the only Academician who had opposed the exclusion of engravers from full membership[12]. West was no less conscious than Reynolds of the importance of engraving to a painter's fame, but he had none of Reynolds's anxiety to distance himself from the business of print publishing, and on several occasions he was sole or joint publisher of plates, several of which were in his possession at his death.

The market did not develop in the way which Boydell had hoped. It did not sustain the taste for 'serious' prints, and he had to abandon the original intention of the *Sculptura* after the first two volumes, although some of his ambition to reproduce a corpus of Old Masters in English hands was channelled into the *Houghton Gallery*[13]. Subsequent volumes of his *receuil* were made up principally of re-issued plates, orginally published either by other publishers — such as Bradford or Arthur Pond — engravers such as Bernard Baron (1700–66) or painters such as Thomas Smith (d.1767), Richard Wilson or Robert

Edge Pine (c.1730–88). Many of the latter had published prints after their paintings by subscription, as William Hogarth had done, thus by-passing the print publishers[14].

The changes in the print market were a direct response to the growing popularity of prints. Aquatint, a form of tonal etching, caught on because it produced what were almost facsimiles of wash drawings. These could be engraved rapidly and also be effectively hand-coloured — something which could no longer be done on line engravings in a way which satisfied the more demanding aesthetic standards of the day. The speed at which prints could be produced was demonstrated daily by the stream of etched satires, but reproductive prints could not be produced so rapidly for a variety of reasons. On some occasions topicality was very important, for example, in the case of the prints which followed Margaret Nicholson's attempt to kill George III on 2nd August 1786 (cat. no. 53). In a little over two months a drawing had been made by Robert Smirke (1753–1854), etched by Robert Pollard (1755–1838), aquatint added by Francis Jukes (1747–1812) and sufficient copies printed to meet the initial demand on publication. Sometimes the printing of large plates could take a very long time; nine months was allowed for printing 1,500 copies of the *Death of Major Pierson* (cat. no. 44)[15]. Distinguished work was produced in aquatint, in particular by its English pioneer, Paul Sandby (1730–1809), but it was usually employed to reproduce topographical watercolours rather than oil paintings. It was not really until the end of the century, with the increased popularity of watercolours and the vogue for colour plate books, that aquatint came into its own[16].

The important new technique of the 1770s was stipple, a development from the French crayon manner, which was used to great effect in Charles Rogers's *Collection of Prints in Imitation of Drawings*, begun in 1763 and finally completed in 1778. A tonal effect was created by groups of etched or engraved dots, enabling the texture of a drawing to be exactly reproduced, though the technique was soon being used to engrave paintings. It had a very rapid impact, and this can be seen with prints after Angelica Kauffmann. Several mezzotints appeared of her paintings in the early 1770s, mostly published by Robert Sayer or by William Wynne Ryland (1733–83), a line engraver turned publisher who employed the Irish-born Thomas Burke (1749–1815).

The first stipple after her work — *Phoenissa*, engraved by Jonathan Spilsbury, probably with Angelica's cooperation since he had earlier engraved *Princess Augusta* for her — appeared on 1st January 1774. On 10th May 1774 Ryland published *The Pensive Muse*, the first of his impressive series of stipples after Angelica, who apparently helped him and corrected, or 'touched', several proofs of his prints. In 1780 Ryland held an exhibition of *Original Pictures, Historical and Emblematical, Painted by Angelica Kaufman On Purpose for Engravings in various Manners exhibiting with the above, coloured and plain*[17]. The exhibition contained eighteen pictures by Angelica, some thirty-one prints by Ryland and seventy or so prints by other engravers, not all after Kauffmann. Among Ryland's prints shown was a pair of *Telemachus*, published in 1778, of which one is shown here (cat. no. 21). This is interesting in probably being the earliest exhibition of prints put on by a printseller. Ryland was, however, in very serious debt owing to earlier speculations: his success as a print publisher was not sufficient to extricate him and he forged an India Bill, for which he was executed in 1783.

Ryland had trained as a line engraver, and it was another line engraver, Francesco Bartolozzi (1727–1815) who was to become the most famous stipple engraver of the British school. He was brought to London in 1764 to etch drawings by Guercino in the Royal Collection and, much to the surprise and indignation of other engravers, was among the founder members of the Royal Academy in 1768.[18] As well as many fine line engravings, Bartolozzi put his name to a vast array of stipples after most of the painters of the day, and was employed by most of the publishers at one time or another, seldom publishing prints himself.[19] He had a constantly changing team assisting him and his supervision was not always as conscientious as his employers would have wished. Excessive alterations to *The Death of Chatham* after John Singleton Copley (1737–1815), a line engraving published in 1788 (cat. no. 37), weakened the plate and only two-and-a-half thousand impressions could be printed. West was so dissatisfied with the plate of *Alexander III*, engraved in 1788 (after the large painting recently acquired by the National Gallery of Scotland), that although the plate cost him 500 guineas he was not able to publish it[20] (proof, cat. no. 52).

Other line engravers, for example James Heath (1757–1834) and John Keyse Sherwin (1751–90), turned their hands to stipple on occasion. Sherwin, an able draughtsman in his own right who succeeded Woollett as Historical Engraver to the King, was an elegant figure who is shown in a self-portrait as something of a man of fashion, sporting on his buttons the feathers of the Prince of Wales, whose Historical Engraver he had become (Fig. 3). Most recruits to the new method were, however, from the ranks of the mezzotint engravers. Several engravers represented here who had trained in mezzotint — Thomas Burke (1749–1815) (cat. nos. 22, 31), George

Fig. 3 John Keyse Sherwin (1751–90), stipple engraving by Charles Sherwin after a self-portrait, *c.*1790.

Keating (1762–1842) (cat. no. 83, 111 & 112), William Dickinson (1746–1823) (cat. no. 42, 47) and John Raphael Smith (1752–1812) (cat. no. 43), also engraved stipples[21].

In addition to these experienced engravers, many novices, several of whom had improved their draughtsmanship at the Royal Academy Schools, were attracted to stipple. Among those who worked almost exclusively in the technique were Edmund Scott (*c.*1746–*c.*1810)[22], James Hogg (active late 18 Cent.) (cat. nos. 54, 55, 61 & 98) and Thomas Ryder (1746–1810) (cat. no. 51). London also attracted a number of foreign engravers, several of whom studied with Bartolozzi. Some returned home after mastering the new method, but a few, such as Luigi Schiavonetti (1765–1810) and his brother Nicholas, and the brothers G. S. and I. G. Facius, who were German, made England their home. The latter did not publish on their own account until the end of their careers and initially seem to have worked exclusively for Boydell, who employed them in the late 1770s and early 1780s, principally on plates after Kauffmann. One of their last jobs for Boydell was engraving *The Ascension,* one of the pictures painted by West for the Royal Chapel at Windsor (cat. no. 38). Some impressions of this print are dated 2nd January 1797, but it was far from finished then.

West had a good reputation among engravers for understanding their problems, but a plaintive note dated 14th September 1801 from the two engravers to Boydell gives a different picture.

Amongst the many Delays which have occur'd with the engraving of the Assention there is now an Other, which is Mr. West's retuching on it. Fourteen Days are past allready and it is not done yet. If you could promote it by any means, we shall be verry thanckfull, as it is verry much against us to loos any further Time in finishing it, particularly if no addition should be granted to the Prize of 110 guineas[23].

During the 1780s at least twenty important new publishers began to publish stipples; these included a number of engravers such as J. R. Smith (1752–1812) and William Dickinson (1746–1823), who for a time largely abandoned engraving for printselling; he issued many stipples, particularly after the humorous drawings of the fashionable amateur Henry Bunbury (1750–1811)[24]. Other publishers included James Birchall (17xx – 1794) who traded from 473 Strand from 1778 until his death in 1794. Some of the publishers of stipples were carvers and gilders; a high proportion of stipples were bought as 'furniture' prints, framed close to the image, often in gilt ovals or circles. There was an additional demand for impressions printed in colours. This was done *à la poupée,* by dabbing colours onto the plate before each printing, and such impressions were often sold for double that of uncoloured prints.[25]

In part because of the boom in illustrated books — elegant illustration was becoming recognised as an effective way of selling new editions of the classics — and in part because of the fashion for furniture prints, by the mid 1780s the print trade had become an important source of employment for English artists[26]. The market was hungry for affecting depictions of history or literature of a kind which would appeal to the fashionable, who were widely influenced by the rather self-indulgent cult of sensibility[27]. This was exemplified most typically perhaps by the response to scenes in the works of Laurence Sterne, one of the favourite literary sources of the time (cat. nos. 26-29, 50-69).[28]

The painters who benefitted most from this fashion were, in order of their birth: Matthew William Peters (1741/2–1814), Francis Wheatley (1747–1801), James Northcote (1746–1831), William Hamilton (1750–1801), Robert Smirke (1753–1845), William Redmore Bigg (1755–1828), George Morland (1762/3–1804) who painted many fancy pictures as well as the rustic genre pictures which became so well-known through mezzotints, Thomas Stothard (1755–1834), Henry Singleton

(1766–1839) and Richard Westall (1766–1836). Some of these painters, notably Bigg, a pioneer of the philanthropic genre picture in the early 1780s, published a number of stipples themselves, but most painters had not the time or the capital to involve themselves in the complications of print publishing. The single group which did attempt to publish their paintings was that of American history painters — West, Copley and John Trumbull (1756–1843) — who published expensive line engravings by subscription, with very mixed results, as is described below.

One neglected venture by a painter to publish a set of stipples after his own paintings was that of R. E. Pine, son of the engraver John Pine who had been an associate of Hogarth in securing the Engravers' Copyright Act of 1735. Pine announced in 1781[29] that he was painting a series of Shakespearian scenes of which he would publish prints in pairs "till a set is obtained, which will sufficiently illustrate the first of the Dramatic Poets". In advertisements headed 'Historical Painting' to emphasise the seriousness of his scheme he suggested that Shakespeare:

> of all writers, claims the attention of the Historic Painter. These subjects, having hitherto been unattended to, but for frontispieces to the plays; it may be proper to observe, that the pictures proposed, are not meant to be representations of stage scenes, but will be treated with the more unconfined liberty of painting, in order to bring those images to the eye, which the writer has given to the mind; and which, in some instances, is not within the power of the Theatre.

Pine exhibited six paintings in 1782 and a few of these were engraved by Caroline Watson (1760–1814), a professional engraver capable of very sensitive work whose father James was one of the Irish-born mezzotint engravers working in London. Pine was a radical out of sympathy with the fashionable world which determined the fates of ventures such as this, though the precise reasons for Pine's disappointment are not certain. Perhaps the paintings were simply not interesting enough. Pine left for America in 1784, taking his pictures and a large stock of the prints with him, but having sold the plates to Boydell who promptly reissued them with his own publication line (cat. nos. 45 & 46).

This was not the first series of prints of imaginative scenes from Shakespeare; the 'frontispieces' to which Pine referred were probably those being issued by the enterprising book publisher John Bell (1745–1831), who commissioned drawings and paintings from leading artists such as P. J. de Loutherbourg (1740–1812) and J. H. Mortimer (1740–1779) for his elegant little *British Poets*, which began to appear in 1778 and was followed up by further sets of *Shakespeare* and *British Theatre*. Pine's prints were, however, the first set of large singly issued prints of Shakespeare[30].

Pine's failure did not deter the publishers now determined to capitalise in a major way on public interest in paintings of literary scenes. Three ambitious projects soon followed: those of Macklin, Boydell and Bowyer. Whereas publishers had previously been content to obtain permission to engrave already painted pictures, occasionally buying a canvas for publicity purposes, these three followed Bell's example by commissioning paintings directly from the painters which they exhibited in their own galleries.

Thomas Macklin, who had been active as a publisher only since about 1779, was the first off the mark with a plan for publishing a hundred large prints illustrating English poetry announced in 1787[31]. He displayed a selection of lively and successful paintings by Reynolds, Gainsborough, W. Hamilton, Fuseli and others in his Poets' Gallery in Fleet Street, and secured the services of the best stipple engravers, notably Bartolozzi, who was paid between £250 and £350 for each plate he engraved for the series, which was generally far more than painters other than Reynolds and Gainsborough were paid[32]. Also much employed was Bartolozzi's former pupil P. W. Tomkins (1760–1840), engraver of *Amyntor and Theodora*, in which Stothard depicted the moment at which the hero of Mallett's poem sees his beloved, Theodora, whom he had given up for lost, being rescued from the sea (cat. no. 65). By 1799 Macklin was in financial difficulties, and the series of *British Poets* was suspended after only twenty-four prints, with the pictures put up for sale the following year. Macklin's second project, his illustrated *Bible*, fared better, being published in eight folio volumes in 1800, with twenty-two of the seventy-one plates based on paintings by de Loutherbourg (cat. no. 106)[33].

In 1788 Boydell launched his *Shakespeare Gallery*, which had its own gallery in Pall Mall. More than enough has been written about this venture;[34] the verdict of one of the painters, James Northcote, whose pictures of the *Murder of the Princes in the Tower* (cat. no. 49) and their *Burial*, were among the few which were generally admired, may be given:

> neither were there painters prepared to execute the necessary pictures, nor was the public prepared to appreciate them if ever so finely done. I knew it must prove his (Boydell's) ruin; but as he was determined at all events to make the attempt, and applied to me

to be one of the painters for the collection, I thought I might as well benefit by it as leave it to others to do so. Ah! but it didn't answer! With the exception of a few pictures by Sir Joshua and Opie, and — I hope I may add — myself, it was such a collection of slip-slop imbecilities as was dreadful to look at, and turned out, as I had expected it would, in the ruin of poor Boydell's affairs.[35].

Nowadays the paintings of Fuseli (cat. nos. 76-81) are also excepted from the general failure. It was not only that the paintings were disappointing; they were on the whole engraved in a heavy and unsatisfactory stipple. Although West insisted upon line, with William Sharp engraving his *King Lear*, 1793 there was neither the time nor the engraving talent available to have more than a handful engraved in line, and stipple was not suited to such a large scale in the hands of any but the ablest engravers. Such was the demand for their services that even second rank engravers could command large fees. Mather Brown was paid one hundred guineas for his painting of *Richard II* (cat. no. 91); the engraver Benjamin Smith (fl, from *c.*1786–d.1833) was paid three times as much[36].

While much of the failure of the Shakespeare Gallery can be blamed on its artistic weaknesses, it is certainly true that the print market contracted after the war with France began in 1793. Exports of prints, in particular decorative types, had been important to the trade and these were seriously disrupted. The third of the publishing projects, the illustrated edition of Hume's *History of England,* was launched by Robert Bowyer (1758–1834) in 1792. He took Gainsborough's old house in Pall Mall in which he opened his Historic Gallery to show the pictures, many of them by de Loutherbourg. Nine volumes of his folio edition had appeared by 1805, but like Boydell he too was forced to dispose of his paintings by lottery, at an enormous loss[37]. The contraction of the market led to the failure of many other publishers, in particular among the ranks of the publishers of stipples, and work for engravers was harder to find. Some of them, such as J. R. Smith and Edmund Scott, gave up engraving for portrait painting.

On the other hand there were certainly new opportunties. Publishers who specialised in prints of the war, notably the Ormes, prospered, as is noted subsequently. The demand for prints after George Morland's paintings never flagged, and publishers who were alert to new fashions did well. Colnaghi found best-sellers with Wheatley's *Cries of London*, published between 1793 and 1796, and new markets were opened up by the publishers of aquatints and colour-plate books, such as Ackermann[38]. Nevertheless it is true that it required a new style of painting — that of the Dutch inspired genre paintings of David Wilkie (1785–1841), who generally published his own plates and worked very closely with engravers such as John Burnet (1784–1868) and Abraham Raimbach (1776–1843) — to breathe new life into the market for singly issued prints and thereby restore to British engravers some of the prestige which they had held before the French Revolution.

FOOTNOTES

1: The best general survey is Godfrey, 1978. Alexander & Godfrey, 1980, examines changes in terms of the relationship between painters and the print market.

2: For mezzotints after Reynolds see Griffiths, 1978; for the Irish mezzotint engravers see Alexander, 1973.

3: For Woollett's prints see Fagan, 1885. The best discussion of line engraving during this time remains that of Godfrey in Alexander & Godfrey, 1980.

4: Prints after Stubbs have been exhaustively catalogued Lennox-Boyd, Dixon & Clayton, 1989.

5: For Green see Whitman, 1902; this includes many subject mezzotints which are not included in the standard work on English mezzotints, Chaloner Smith, 1878-1883.

6: Prints after Wright have been meticulously catalogued by Clayton, 1990.

7: For Boydell see Bruntjen, 1974.

8: Prints after West are listed in the catalogue entries of Erffa & Staley, 1986. The figures of prints after West are based on those in Erffa & Staley, with some additions.

9: Earlom engraved many subject prints, see Wesely, 1886.

10: Contemporary printsellers' catalogues have been listed by Antony Griffiths, *Print Quarterly* Vol 1, No. 1. Sayer and Bennett's Catalogue for 1775, which is 150 pages long, plus an appendix of 66 pages has been reprinted, Holland Press, London, 1970.

11: It is fair to add that a continental commentator singled out Boydell for special mention because of this publication (Heineken, 1771, p.102).

12: Strange, 1775, p.113.

13: For the Houghton Gallery see Rubinstein, 1991.

14: See John Boydell, *Catalogue Raisonné . . .,* 1779, for a full list of his prints, printed in French. An exaggerated idea of Boydell's activity as a publisher is given most explicitly by Algernon Graves in his articles on 'Boydell and His Engravers', *The Queen,* July-December 1904, which accepted uncritically that he was the original publisher of the many plates which he simply reissued.

15: Farington, 1978–1 p.267, entry for 16 Dec. 1794.

16: The best survey of colour plate books remains Prideaux, 1909. Many of the major books are catalogued in the catalogues of the Abbey Collection, now at the Yale Center for British Art, published 1952–1957 in 4 vols.

17: The copy of this catalogue which belonged to Charles Rogers is in the Cottonian Collection, Plymouth City Art Gallery; the catalogue is not dated but the time of the exhibition has been established from press announcements. The present author is currently studying the prints after Kauffmann and is contributing a chapter to the catalogue of the exhibition on the painter to be organised by Brighton Art Gallery in 1992.

18: The indignation of engravers was expressed most forcibly in Strange, 1775.

19: Bartolozzi's prints are catalogued in Vesme & Calabi, 1928.

20: Farington, 1978–, entry for 4 July, 1801.
21: For Smith see Frankau, 1902.
22: For Edmund Scott see *The Scott Family at Home,* exhibition catalogue Hove Art Gallery, 1988.
23: Letter in the John. Frederick Lewis Collection of Engravers' Letters, Rare Book Department, Free Library, Philadelphia; quoted by kind permission.
24: For Bunbury see Riely, 1983. Dr Riely is currently working on a fuller study of Bunbury, which will include a catalogue of prints after his designs, compiled with Tim Clayton.
25: For colour prints see Frankau, 1906.
26: The scale of commissions given to artists for book illustration can be seen in Hammelmann, 1975.
27: See Alexander, 1986.
28: Gordon, 1974.
29: Victoria and Albert Museum, National Art Library, Press Cuttings, cutting of 1781. For Pine see Sunderland, 1974; Stewart, 1979.
30: Boase, 1947. Another set of illustrations which pre-dates Boydell's Gallery is that published by Charles Taylor, mostly after Stothard and Smirke, as *The Beauties of Shakespeare,* 1784.
31: For Macklin see Boase, 1963.
32: For de Loutherbourg see Joppien, 1973.
33:
34: See Bruntjen, op, cit., and Friedman, 1973, and her Boydell's Shakespeare Gallery, PhD thesis, Harvard University (Friedman, 1976). All the prints in the Gallery have been reproduced in Santaniello, 1979. A rival Shakespeare Gallery was established by James Woodmason in Dublin in 1793 with paintings by some of Boydell's artists, including Fuseli and W. Hamilton, which moved to London in 1794; see Hamlyn, 1978.
35: Fletcher, 1901, pp. 113-114, cited by Alexander & Godfrey, 1980, p.62.
36: Evans, 1982, p.253; this excellent study shows the importance of the print market to Brown's career.
37: For Bowyer see Boase, 1963.
38: For Ackermann see the study by Ford, 1983.

PATRIOTISM AND CONTEMPORARY HISTORY, 1770–1830

DAVID ALEXANDER

ONE of the strongest sentiments behind the English penchant for portraiture was patriotism. There was, for example, an endless demand for royal portraits, both painted or engraved, as tokens of loyalty to the Hanoverians, who after all had been twice seriously threatened, in 1715 and 1745. It was largely through portraiture that the English learned about their national history, and 'Houbraken's Heads', originally engraved to accompany Thomas Birch's *Lives*, 1743–52, was undoubtedly one of the best selling series of engraved portraits and very widely known.

Fine prints such as these — which had to be engraved in Holland as there was no engraver equal to such a task in London — were relatively expensive. At the same time cheap woodcuts, which have now nearly all destroyed, were to be found in the humblest of homes. Writing in the 1820s, the wood engraver Thomas Bewick (1753–1828) remembered how these "were commonly illustrative of some memorable events — or perhaps the portraits emminent Men who had distinguished themselves in the service of their country . . .". He regretted their disappearance:

> Whatever can serve to instill morality & patriotism into the minds of the whole people, must tend greatly to promote their own happiness, & the good of the community, for all Men, however poor they may be, ought to feel that *this* is their Country[1].

Among the greatest of all popular heroes were the admirals, and it was primarily through the progress of the naval campaigns that ordinary people knew about the wars with France. The Seven Years War (1756–1763) produced a number of memorable victories under Boscawen, Hawke and Keppel. Typically one of the best known prints commemorating their success was after the absurd group portrait painted by Francis Hayman (*c.*1708–76) for Vauxhall Gardens, which was engraved by S. F. Ravenet and published by John Boydell in 1765[2]. A number of paintings based upon participants' accounts and sketches were painted; one active maritime painter was Richard Paton (1717–91) who between 1758 and 1761 himself published by subscription six large line engravings, and sub-

sequently showed some of the paintings at the Society of Artists, 1762–64[3]. Paton, a former sailor, worked in the Excise Office until two o'clock after which his working day was over and he was able to paint. Another marine painter, Dominick Serres (1722–93), was highly enough regarded to become one of the foundation members of the Royal Academy, but this may be due more to the skill displayed by his seascapes than his depictions of contemporary history.

During the early 1760s the public-spirited Society of Arts considered history painting to be one of the many areas of national life which could benefit from encouragement, and began to offer premiums for such paintings. These went at first to the veteran Italian, Andrea Casali (*c.*1700–84), whose paintings were published by Boydell, and to Robert Edge Pine, who himself published plates of his *Calais* and his *Canute* in the early 1760s. It was, however, the young American Benjamin West who really showed what could be done, with pictures such as his *Regulus,* a subject suggested by the serious young George III. Engraved by Valentine Green in 1771, it was both the largest and, at a guinea, the most expensive mezzotint to have been published in England (cat. no. 15). With his *Death of Wolfe,* West changed the general perceptions of history painting, showing that attitudes and groupings could be adapted from the Old Masters to elevate the depiction of recent events — just as Reynolds had demonstrated for portraiture — and, moreover, that such events could be depicted in contemporary clothes, not antique garb which had been demanded by Reynolds. After being exhibited at the Royal Academy in 1771 the picture was engraved in line by William Woollett and published in 1766, jointly by Woollett, Boydell and W. W. Ryland (1732–1783). The print was an immediate success and Woollett was appointed Historical Engraver to the King. Thirty years later Boydell was to claim that the plate had brought him £15,000.

The effect of this print was to make painters aware of the financial possibilities of the print market — something which they had largely ignored since Hogarth's day. Thousands of prints had been made of Reynolds's paint-

ings but he had not made any money out of this: it was enough that prints should spread his fame. But after 1776 few ambitious paintings of historical interest were undertaken without the hope that they would provide the subjects for best selling prints. West himself took the lead by producing further historical pictures and becoming joint publisher of a series, designed to hang beside the *Wolfe*, which included *The Battle of La Hogue*, 1781 (cat. no. 35), *The Battle of the Boyne*, 1781 (cat. no. 34) and *Oliver Cromwell Dissolving The Long Parliament*, 1789 (cat. no. 41). Much of West's later efforts went into religious paintings, and although some of these were engraved, such as *The Ascension* (cat. no. 38), published by Boydell, which was painted for the Royal Chapel at Windsor, they did not have the same general appeal. It was not for many years that West painted another contemporary event, *The Death of Nelson* (cat. no. 126).

It was generally to distant history that most painters continued to turn, and there were a relatively small number of favoured episodes, some heroic and some, like the story of *Lady Jane Grey* (cat. no. 56) affecting[4]. Relevant extracts from standard histories were often added to pictures or prints; thus there is a reference to the passage of Rapin de Thoyras on the stipple of *Agincourt* engraved by Thomas Burke after J. H. Mortimer and published by the artist's widow in November 1783 (cat. no. 31)[5].

The continuing wars with France provided renewed opportunties for certain painters. In about 1780 Robert Dodd (1748–1816) and his brother Ralph began their careers as specialist naval painters, producing hundreds of pictures over the following thirty years, many of which they engraved and published themselves[6]. About 1784 the first engraving appeared after a naval painting by Nicholas Pocock (1741–1821), who also published a number of his prints of naval engagements[7]. Other painters, often lacking the naval contacts which enabled these artists to produce pictures based on first-hand accounts, tried to enter the competition. One persistent, but second-rate, figure was George Carter (1737–94) who in October 1780 published a plate by James Caldwall (1739–post 1807) after his picture of *The Engagement between the Quebec Frigate and the Surveillante* in October 1779[8]. In 1785 Carter held a well-attended exhibition of thirty-five historical paintings, including The *Death of Captain Cook* (now in the National Library, Canberra), which was engraved by John Hall and others in 1783 and published, without permission, as a pendant to *Wolfe*. A rival depiction after John Webber, engraved by Bartolozzi and W. Byrne (1743–1805), appeared on 1st January 1784)[9].

Boydell became conscious of the market for prints of naval victories — one which he had virtually ignored since the beginning of his career some thirty years earlier — and in 1780 he brought out the first pair of a new series of prints after paintings by Paton, who had probably tired of publishing himself after the lukewarm reception of his prints after his paintings of the *Royal Dockyards of Deptford* and *Chatham* published in March 1775. The Boydell series culminated in three prints of the *Relief of Gibraltar in 1782*[10]. This siege inspired a number of paintings; among those which were turned into prints were pictures by William Hamilton (1750–1801), Robert John Cleveley (1747–1809), James Jefferys (1751–84), Thomas Luny (1759–1837), J. K. Sherwin — engraved by himself — and finally and most importantly by the American painters John Singleton Copley (1738–1815), who settled in England, and John Trumbull (1756–1843), who came to Europe primarily to learn about the market for prints and returned to America to fulfil his ambition of painting the main battles of the War of American Independence. Copley was commissioned in 1783 by the City of London to produce a huge painting of *The Destruction of the Floating Batteries*[11]. He had already followed West's example by launching in 1780 a subscription for his picture of *The Death of Lord Chatham* in 1778 (some dramatic licence was taken with the title: Chatham is shown at the moment when he collapsed during a debate in the House of Lords on the war with America; he did not die for another month). Largely because this was a group portrait as well as an historical picture, requiring considerable care with the engraving of the individual figures, which had to be recognisable if sales were to be made to the families and friends of those who were present, the engraver Bartolozzi had to be paid the very large sum of £2,000. In 1788 Copley opened a subscription list for the *Gibraltar*, planned as a pendant to the *Chatham* which finally came out that year. Copley had shown the *Chatham* picture in a special exhibition — much to the annoyance of the Academicians — and he exhibited his new picture in a large tent in Green Park in 1791. Copley dropped Bartolozzi as his engraver in favour of William Sharp (1749–1824), whose name had been made by his plate of West's *Alfred the Great* (cat. no. 32), published by Boydell in 1782. The fee was the same as for the earlier plate, but no advance payment was to be made. This was just as well for Copley since Sharp was to take on so many more pressing commissions that the print was not published until 1810, twenty-seven years after the original incident. Trumbull was more fortunate in that Sharp worked more rapidly on the plate of his *Sortie from Gibraltar*. This

painting, which he cynically wrote was "addressed to the Vanity and Nationality of John Bull", was painted in 1788 and the print, also sold by subscription, appeared in 1799[12].

The siege of Gibraltar did not produce any memorable deaths in action. However, while it was in progress, the young Lord Robert Manners, Captain of HMS Resolution, was killed in the West Indies, and the death of this young aristocrat aroused very powerful emotions as well as patriotic feelings. Sherwin's plate of Thomas Stothard's painting was published in August 1786 by Thomas Macklin, who paid the painter £200 for the picture and Sherwin £700 for engraving the plate[13]. Another moving death was that of Major Pierson, killed in 1781 when the French attacked St. Helier in Jersey. This inspired Copley's most successful picture, when he was able to combine a stirring battle scene and a dramatic death scene without having to include the large number of portraits of participants which were necessary in some of his other history paintings. Copley was too financially committed by his other ventures to have published this picture, painted in 1783, and the print commissioned by Boydell of The Death of Major Pierson (cat. no. 44) from James Heath (1757–1834) did not appear until 1799. It was clear that the leading line engravers were in such demand that prints were in danger of taking so long to appear that the public would have lost interest when they did appear. As a result many subject pictures continued to be engraved in stipple or mezzotint, despite the disadvantages.

During the years of peace in the 1780s there were, of course, fewer events making overt appeals to patriotism. Exceptions were such incidents as the attempt to kill the King in 1786 which inspired a number of pictures and prints (cat. no. 53). Other events were engraved which appealed to the sensitive, such as The Loss of the Halsewell East Indiaman off the Dorset coast in January 1786, which was painted by Robert Smirke (aquatint engraved and published by Pollard and Jukes, 1786) and Thomas Stothard (stipple by Edmund Scott, published January 1789). This was also the subject of a print after Thomas Rowlandson published by S. W. Foreso in August 1786.

One of the heroes of the Age of Sensibility was the philanthropist John Howard (c.1726–90), who was said never to have knowingly given a sitting for a portrait. This did not prevent Francis Wheatley from painting Howard Visiting and Relieving the Miseries of a Prison, a picture exhibited at the Royal Academy in 1787. It was presumably the sight of this picture which inspired James Gillray (1757–1815) to design and engrave a large stipple of Howard relieving an impoverished officer in prison —

very similar to Wheatley's picture — which was published with the title The Triumph of Benevolence in April 1788. A subscription for a print of Wheatley's painting was launched by Thomas Simpson, a very active publisher in the City, and the print by James Hogg appeared on 9th April 1790 (cat. no. 61). Significantly this was a line engraving, one of the few which Hogg engraved in line rather than stipple, but line undoubtedly gave such a design greater dignity.

Other events of the time which were the subject of prints included the large line engraving by and after J. K. Sherwin of The Knights of St Patrick, 1783. Such a large line engraving of an event of relatively little interest in England would not seem to have been a commercial proposition; indeed it probably received a large subsidy from the Marquis of Buckingham (1753–1813), an excessively vain man who was Lord Lieutenant of Ireland 1782–3. Sherwin did not finish the plate by his early death in 1790 and the plate was not published until 1803[14] (cat. no. 123).

The outbreak of the French Revolution in 1789 soon had an effect on the lives of English painters. First of all there were the stirring events taking place across the Channel, and several painters worked up pictures of the best known incidents. Henry Singleton, for example, painted The Destruction of the Bastille (engraved in stipple by William Nutter (1754–1802) and published 1st March 1792) in a favourable light, as did Gillray, who produced a pendant to the stipple of Howard. The English mood soon changed and there were many prints of the French Royal Family which showed considerable sympathy with their fate. In addition to the set engraved by L. Schiavonetti after Charles Benazech (1767–94) and William Miller (1740–1810), 1793–96 (cat. nos. 100-105), there was another series after D. Pellegrini (1759–1840), as well as numerous singly issued prints[15].

The longer term effect of the Revolution, with the outbreak of war with France in February 1793 and the disruption of trade with the Continent, was that the English print market soon contracted. Commissions for literary and historical paintings at generous prices came to an end, and painters were dependent once again upon selling pictures to private patrons, who were on the whole apprehensive about the future. Macklin, Boydell and Bowyer had all launched their projects before the full effect of the economic disruption was apparent and their schemes continued to provide work for the painters. It is worth pointing out that a few further projects, usually the result of optimism on the part of individual painters, were launched. For example, James Northcote joined with the

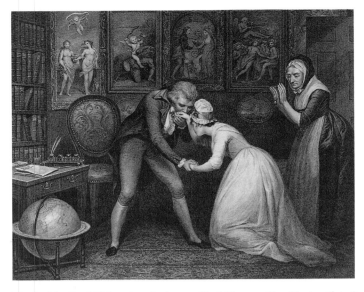

Fig. 1 The Good Girl receives the honourable Addresses of her Master, Plate 8 of Diligence & Dissipation, stipple engraving by Thomas Gaugain, after James Northcote, published by Gaugain, 1 May 1797.

engraver Thomas Gaugain (1748–1812), who had just been forced to sell his stock as a printseller because of the lack of trade, to issue an ambitious Hogarthian series of ten large stipple engravings, *Diligence and Dissipation,* 1797 (Fig. 1). Fuseli realised a long-cherished ambition by opening his *Milton Gallery* in 1799, and publishing a number of prints after his pictures, generally by his pupil Moses Haughton[16].

Much public interest, however, had inevitably shifted from imaginative works to depictions of the war. It was in Bowyer's Historic Gallery, in the fashionable area of St James's, that one of the first major pictures produced by the war was exhibited: Loutherbourg's *Grand Attack on Valenciennes,* commissioned for £500 by Valentine Green and the Basle publisher C. von Mechel, who subsequently commissioned a further picture of *Earl Howe's Victory on the first of June 1794.* Large line engravings by William Bromley (1769–1842) were sold by subscription and published in 1799 and 1798 respectively.

This was an isolated, successful speculation in print publishing and did not save Green from bankruptcy in 1799. However, the publisher who was to specialise most successfully in prints of current events based on paintings was Edward Orme, who is best known today for his book on transparencies (that is colouring prints and then illuminating them from behind). He was in partnership at

first with his brother Daniel (1767–post 1832), a miniature painter who was appointed Historical Engraver to the Prince of Wales in succession to Sherwin in the early 1790s. The brothers were in business in the early 1790s at 14 Old Bond Street and published several large prints after paintings by Mather Brown, including three of the *Defeat of Tipoo Sahib, The Relief of HRH Prince Adolphus* (mezzotint by S. W. Reynolds (1773–1835) published 7th June 1794), *Lord Howe on the . . .Queen Charlotte* (engraved by D. Orme, published 1st October 1795), and *The Attack on Famars* (engraved by D. Orme, published 1st February 1796).

By the end of the decade Edward had set up on his own in Conduit Street and was by 1st January 1799 calling himself Printseller to the King. Daniel for a time had a Gallery at 118 New Bond Street where he showed some of his own pictures, such as *Nelson boarding the two Spanish ships* (published 2nd June 1800) and *Lord Duncan's Victory* (published 20th August 1800; Fig. 2), both of which he published himself. In 1800 Edward moved to 59 New Bond Street and continued to issue a stream of patriotic prints as well as colour plate books. In 1814 a fullsome tribute was paid to Orme's activities by one of his authors, F. W. Blagdon, who commented on what he had done "in the good cause" by publishing so many prints of the war[17].

Another engraver-publisher who issued prints of contemporary history was James Daniell (active *c*.1800) who

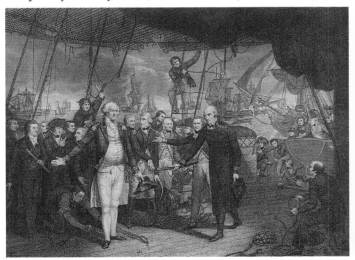

Fig. 2 Lord Viscount Duncan's Victory and Admiral Winter's Resignation . . . Oct. 11th 1797, stipple engraving by Daniel Orme after his painting, now in the National Maritime Museum, Greenwich, published by Daniel Orme, 20 August 1800.

engraved and published several large mezzotints after Henry Singleton of naval actions. These concentrate on figures on board, and for example, that of the action of *HMS Glatton*, published 15th June 1797 (the picture shown at the Royal Academy 1799), includes Captain Strangeways who was mortally wounded. Another mezzotint after Singleton depicts *Paul I granting Liberty to Genl. Kosciusko . . . painted under the immediate direction of Genl. Kosciusko when in London in the Months of May & June 1797*, a visit which incidentally inspired one of West's finest portraits, now at Oberlin University. Daniell also published Stothard's *Surrender of the Children of Tipoo Sultaun*, engraved by Charles Turner and published 15th August 1800.

Stothard painted other contemporary scenes, such as *The Death of General Abercromby at the Battle of Alexandria, 1801*, engraved in line by Francis Legat (1755–1809) and published 1st January 1805, a scene which was also painted by de Loutherbourg, engraved by Anthony Cardon (1772–1813) and published 1806. As with the death of Chatham, artistic licence was taken with this event, as the General did not die on the battlefield, but there was, however, evidently a premium on battlefield death scenes, because another successful print had been made of *The Death of General Fraser*, engraved by W. Nutter after the painting by his fellow Scot John Graham (1755–1817), published by J. Jefferys, 1794.

Other painters who tried to capitalise on interest in the course of the war included such unlikely figures as William Hamilton, best known for his fancy pictures, particularly of children, and painter of a picture of *Marie Antoinette in Captivity* which makes her look like a saint prior to martyrdom[18]. His *Defence of . . . Acre by Sir Sidney Smith* was exhibited by the engraver Anthony Fogg at 50 New Bond Street in 1800; a print by Fogg priced at a guinea for prints and two for proofs was advertised and eventually published on 7th April 1802.[19]

Although public attention was inevitably focussed on the war abroad the threat of invasion led to much military activity at home. A large volunteer army was raised, leading to a good deal of work for artists, since many of the volunteer officers wished to be recorded in their uniforms. There were also a number of provincial reviews, several of which were also recorded in prints. Thus Richard Livesay (d. *c*.1823), Drawing Master of the Royal Naval College at Portsmouth, published a set of four aquatints of reviews in the Isle of Wight in 1800, and one of *The Royal Review in Hatfield Park*, aquatint by J. C. Stadler published in 1802. Similarly William Alexander (1767–1808) a military drawing master at the time, drew,

engraved and published on 1st March 1800 an aquatint of *The Kentish Volunteers in the Presence of their Majesties*. This does not, however, show them engaged in military activities, for they are shown seated in the open enjoying a banquet provided by Lord Romney.[20]

The great number of prints of the war is testimony to their contemporary popularity, and they have largely been overlooked in recent times because many of the paintings have not survived and because the prints were not collected in Victorian times with the same fervour as accorded to mezzotint portraits, for example. The opportunities were there for the painters and publishers who were attuned to changed times. After Trafalgar, Boydell offered a prize of £500 for the best painting of the *Death of Nelson* which would be engraved. In the event it was not his picture, but one by West which proved most successful. The old painter, true to his promise to Nelson, came up with another *pietá*-like composition which was engraved by James Heath as a pendant to *The Death of Wolfe*, and which was eventually published after various tribulations in 1811 (cat. no. 126). It was then exactly forty years since he had originally exhibited *Wolfe*; and with another reverentially staged death scene, equally removed no doubt from what actually took place, he had a fine best-selling print.

FOOTNOTES

1: Bain, 1975 pp. 192–193.
2: For a discussion of this print see Allen, 1987, No. 79; Fig. 35.
3: The basic catalogue for naval prints remains Parker, 1911.
4: The choice of incidents depicted is discussed by Strong, 1978. This contains more discussion of earlier painters than the title suggests and has a valuable appendix which lists pictures of British history exhibited at the Royal Academy 1769–1904 arranged by subjects in their chronological order.
5: for Mortimer see Nicolson, 1968.
6: For the Dodds see Younger, 1925.
7: Pocock's career as a painter is discussed by Cordingley, 1988, but the importance of prints to his career is inadequately treated.
8: for Carter see the article by Lionel Cust in *The Dictionary of National Biography*.
9: Only two of Paton's projected series were engraved; five of the pictures were acquired for the Royal Collection; see Millar, 1969, Nos. 980–984.
10: Copies of Boydell's proposal for these three prints were printed at the end of the 1783 supplement to his 1779 catalogue.
11: For Copley see Prown, 1966.
12: For Trumball see Sizer, 1953
13: These figures are given in Whitley, 1928(2), p.10.
14: Sherwin's drawing for this print was in one of the sales held of the Duke of Buckingham's collection from Stowe, Leigh Sotheby, 7-8 August 1849, Lot 282.
15: For English prints of the French Revolution see Bindman, 1989 where most of those mentioned here are treated.
16: For the Milton Gallery see Weinglass, 1982. Professor Weinglass of the University of Missouri–Kansas City, is currently working on a comprehensive catalogue of prints after Fuseli.
17: Quoted Prideaux, 1909, p.243.
18: See Bindman, 1989, No. 136.
19: *Morning Chronicle* 31 May 1800.
20: Legouix, 1980, pl. 72.

THE BOYDELL SHAKESPEARE GALLERY: BEFORE AND AFTER

GEOFFREY ASHTON

PRIOR to the Boydell *Shakespeare Gallery* there were only seven complete illustrated editions of Shakespeare[1]. The first, Rowe's edition of 1709, was also the first octavo edition, the first edited edition and the first to include a life of the author. The illustrations, by François Boitard, are perhaps disappointing in their stilted references to stage productions, but the artist had no tradition of Shakespeare illustration on which to draw and to resort to his experience of the stage was the obvious solution. Boase, Merchant and Hammelmann all discuss the meagre prototypes for the Rowe illustrations. Sir John Medina's much more sophisticated designs for Milton's *Paradise Lost* in 1688 (a work to which Tonson, the publisher of the 1709 edition of Shakespeare, had the copyright) are the most important, but they are all agreed on the general and essential part played by contemporary stage production[2].

It is one of the most surprising aspects of Shakespeare illustration in the eighteenth century that as productions of his plays became more frequent and, presumably, more widely known, the engaved illustrations to the plays relied less and less on the inspiration of live performances. The second edition of Rowe, published in 1714, saw a smaller format and a number of new designs by Louis Du Geurnier[3]. Those designs by Boitard which were not interfered with were mostly re-engraved and the references to the stage removed or made less theatrical. The 1709 closet scene plate to *Hamlet,* for instance, showed the upturned chair that was a famous feature of Betterton's playing of the scene. The 1714 reworking of the plate removed the chair, presumably because it was felt that it upset the composition, and Hamlet and the Queen were given different and more formalised clothing. The later re-workings of the plates, those of 1728 and 1734 for instance[4], showed an eagerness to stiffen the figures and compositions that may have owed more to the inferiority of the engravers than to the anxiety to remove the images from the 'reality' of the stage.

Gravelot's designs for Theobald's second edition in 1740 are by an artist who might never have been to the theatre, and are in the full-flush tradition of early eighteenth cen-

tury French book illustrations[5]. Boitard cannot have seen productions of all the plays he illustrated, the vast majority were not performed in the early eighteenth century, but he felt that the connection with the stage was valid and important. He created the illusion that the design related to the theatre. Gravelot had no such aim. The works he illustrated he illustrated as literature to be read and not as plays to be visualised on stage.

His illustrations are decorations and it is the spirit of decoration that imbues Hayman's illustrations of 1743–44[6]. Five of the illustrations to Hanmer's edition were, of course, by Gravelot and the French artist also engraved all the Hayman designs, but Hayman was a man of the theatre and it would be reasonable to expect a real knowledge of Shakespeare in performance to illuminate his illustrations. Occasionally the stage is not far away; the plate of the play scene from *Hamlet* is a re-working of Hayman's painting of the same scene for Vauxhall Gardens which might relate to a stage performance, and Hayman played the priest on four occasions in productions of *Hamlet* at Covent Garden in the 1740s. Thomas Hanmer gave 'Instructions to Mr. Hayman for his Designs to Shakespeare's Plays'— the manuscript is in the Cottonian Library, Plymouth — and the description for the plate to *King Lear* gives a taste of the programme that Hayman was expected to follow:

> A naked barren heath, with a poor thatch'd weather-beaten hovel upon it. Edgar comes out of the hovel like a Tom o'Bedlam, all in rags, his hair ruffled and gnarl'd and mix'd with straws, and his gesture and action frantick. The King's fool having peep'd into the hovel runs back from the mad-man in a fright, the King bare-headed and in grey hairs stares with amazement at the flow and fixes great attention upon him. Kent habited like a serving-man waits upon the King. A very stormy sky with light'ning and rain.

This is a literary interpretation if only because the Fool had long disappeared from productions of *King Lear*, since Nahum Tate's 1681 version of the play, and would not reappear until Macready's 1838 production.

Strangely enough, David Garrrick in a letter to Hayman

also mentions the Fool when describing his vision of the ideal scene from *King Lear* although his references to particular gestures suggests that he is thinking of his own performance in the role. The letter, which dates from 1745, refers to a project Hayman had for six Shakespearean pictures, possibly for Garrick's friend William Windham. The scenes from *Lear* and *Othello* were evidently in hand by 1745 but they are now lost, along with the others. However, Hayman remembered Garrick's advice when he prepared the plate for *King Lear* in the later illustration of the heath scene produced for the incomplete Charles Jennens edition of 1770–4[7]:

> Suppose Lear Mad upon the Ground with Edgar by him; His Attitude Should be leaning upon one hand & pointing Wildly towards the Heavens with his Other, Kent & Fool attend him & Glocester comes to him with a Torch; the real Madness of Lear, the Frantick Affectation of Edgar, and the different looks of Concern in the three other Characters will have a fine Effect; Suppose you express Kent's particular Care & distress by putting him upon one Knee begging & entreating him to rise & go with Gloster; but I beg pardon for pretending to give You advice in these Affairs, You may thank Yourself for it, it is Your Flattery has made me Impertinent.

When the Hanmer edition appeared in 1743–4 Garrick was at the outset of his brilliant career as an actor, director, writer, stage manager and theatre licensee. He retired from the stage in 1776 and it is curious that during the reign of the greatest exponent of Shakespeare on the stage in the eighteenth century there was practically no activity in the field of Shakespeare illustration. The Hanmer edition appeared at the beginning of his career and no new complete illustrated edition of Shakespeare appeared until it was practically over. The first of Bell's two editions began to be published in 1773, using, in many cases, Garrick's own mangled acting texts and illustrated with plates that had possibly less to do with the stage than Hayman's of thirty years earlier[8]. Bell saw no point in having plates which related to performances, rather than the imaginary scenes that he commissioned, although he did issue a separate series of character plates which sometimes accompanied the texts of the play[9]. The same policy is pursued more methodically with Bell's second edition of 1785–8[10]. Each play is illustrated with a scene plate and a character plate. In the last edition, published before the Boydell scheme got under way, there were two scene plates to each play and no character plates. The Bellamy and Robarts edition of 1787–91 used the circular format of the later Bell illustrations, putting them underneath picturesque gothic arches[11].

Shakespearean character plates were, of course, immensely popular in the late eighteenth century and a glimpse at the *Harvard Catalogue of Engraved Theatrical Portraits* shows that a high percentage of engraved theatrical portraits from ca. 1770 were of actors and actresses playing Shakespearean roles[12]. However, it is inaccurate to see these theatrical portraits in the context of Shakespeare illustration. The two genres started life together with Rowe's edition of 1709, although there were a handful of seventeenth century theatrical portraits, but parted company fairly early in the eighteenth century. By the end of the century they were seen as parallel, and occasionally interchangeable, genres but not, most decidedly, one and the same thing. Henry Singleton's *Shakespeare Gallery* of 1792 was an attempt and a failure to combine the two[13].

Whilst Shakespeare book illustration tended to veer away from the stage, the painted image relied heavily on theatrical performance. The earliest and most monumental of Shakespearean scenes, Hogarth's *David Garrick as Richard III* and Van Bleeck's *Mrs. Cibber as Cordelia,* are also amongst the earliest and are certainly the most monumental theatrical portraits of the eighteenth century. The theatrical conversation piece was very largely the creation of David Garrick's insatiable appetite for publicity and his good fortune in finding, in Zoffany, an artist able to create the strong images that bolstered his position at the head of the British Theatre. Zoffany only painted Garrick in one Shakespeare scene, the dagger scene from *Macbeth,* but his whole frame of reference was taken from his teacher Benjamin Wilson's tomb scene from *Romeo and Juliet.* Whilst it is possible to see Wilson's painting at the head of one school of theatrical painting it is equally viable to put Hogarth's *David Garrick as Richard III* at the head of another. The large full-length theatrical portrait of the eighteenth century was not only more monumental but also more histrionic than the smaller type of portrait. The large portraits of J. P. Kemble by William Hamilton and Thomas Lawrence were the nearest that theatrical portraiture ever approached the grandiose historicism of the Boydell *Shakespeare Gallery.*

The Boydell *Shakespeare Gallery* was a business venture that was to mark the climax of Alderman John Boydell's outstandingly successful career. Gillray satirised the commercial aspect of the scheme, but it was something of which Boydell was justifiably proud. He had been the main force in converting the considerable debt to the continent, and especially France, in the trade of book illustration and other engravings, into an enormous annual profit

of £200,000. He had made British art a major export industry and the *Shakespeare Gallery* would crown the achievement. In the event, the French Revolution and the resultant chaos on the continent removed Boydell's entire foreign market and the *Shakespeare Gallery* swallowed up the whole of his considerable fortune. However, Boydell never would have embarked upon the scheme if he had not seen it as an attractive commercial proposition. Boydell's business acumen made him the most important patron of the arts in England in the late eighteenth century and it was entirely within his own interests to encourage painters and painterly schemes.

The first catalogue of the *Shakespeare Gallery,* of 1789, included Boydell's official declaration, "To advance the art towards maturity and establish an English School of Historical Painting, was the great object of the present design." The group of men who certainly felt this were those who gathered at Josiah Boydell's (Alderman John's nephew) dinner table in Hampstead towards the end of 1786 and formulated the idea of a lavishly illustrated edition of Shakespeare. Winifred Friedman gives a careful account of the internal mechanics needed to get the scheme off the ground; the gathering of subscribers, the commissioning of artists and engravers, the building of the gallery in Pall Mall, the first opening of the exhibition on 4 May, 1789, and the first issue of prints in 1791[14]. Although the plan of publication changed frequently on the road to Boydell's virtual bankruptcy, the final productions were much as had been originally envisaged. A nine volume folio edition was published in 1802, each play illustrated by the 'smaller' plates from the smaller pictures in the Shakespeare Gallery and the text edited by George Steevens[15]. The following year the larger plates were published in two elephant folio volumes[16]. The plates had been produced in parts over the previous twelve years but it is neither possible nor useful to decide on which came out when. The engravings are all dated but these dates do not seem to indicate the order in which the plates were sent to subscribers. Contemporaries blamed bad management for the series of events that forced Boydell to sell the Gallery and its contents by lottery in 1804–5 but the real reason was the absence of the continental subscriptions which would have made Boydell a millionaire and the *Shakespeare Gallery* a permanent feature of Pall Mall and a national memorial to Shakespeare.

Most of the 167 pictures were commissioned directly from the artists by Boydell, although he bought several pictures already painted. Before the scheme was announced Boydell had commissioned, fortuitously, from Northcote a couple of paintings of scenes from *Richard III,*

a coincidence that led the artist to claim responsibility for the whole idea. The painters' fees varied from fifty guineas to the thousand pounds that Reynolds received for his scene from *Macbeth*. Engravers were generally paid about twice the painter's fee, although their remuneration varied considerably, according to the size of the engraving, the importance of the engraver and the technique he used. Although a commercial failure the *Shakespeare Gallery* was not such an unmitigated artistic disaster. English artists were paid, for the first time outside the fields of decorative painting and the theatre, to work on the largest scale and on subjects that might reasonably be expected to fire their imaginations. They rose to the occasion and many of the artists — Northcote, West, Peters, Hamilton, Westall and Opie for instance — produced their best work for the scheme.

The *Shakespeare Gallery* engendered a number of similar projects including Fuseli's *Milton Gallery* and Woodmason's *Irish Shakespeare Gallery*. Fuseli first planned his *Milton Gallery* in 1790, although the actual exhibition of the paintings did not go on show at Christie's in Pall Mall, close to the Boydell Shakespeare Gallery, until May 1799. It closed July and reopened the following March, with seven additional paintings. It closed for good shortly afterwards. James Woodmason was self-appointed Stationer to the Royal Household in 1782, and Stationer to the King in Ireland in 1789. His *Shakespeare Gallery* was announced in the *Dublin Journal* in 1792 with Boydell's Gallery mentioned as a precedent. Woodmason commissioned Boydell artists to paint the pictures: Fuseli, Hamilton, Northcote, Opie, Peters and Wheatley. The scheme was supposed to promote Irish art but Peters was then the only artist with strong Irish connections.

The *Irish Shakespeare Gallery* was to consist of 72 paintings, two for each play (except *Pericles*), which were all to be engraved in line for a lavish new edition. The gallery opened in 1793 with eighteen paintings, four each by Fuseli and Peters, three by Wheatley and Opie, and two from Hamilton and Northcote. All the pictures were the same size ($65\frac{1}{2}$" x $52\frac{1}{2}$"). Five more pictures were added in June 1793, two by Hamilton, and one each by Fuseli, Northcote and Solomon Williams (fl.1792–1824), a local artist. The pictures were transferred to London and the *New Shakespeare Gallery*, opened at Schomberg House, Pall Mall, across the road from the Boydell *Shakespeare Gallery* in January 1794. Four pictures were added to the 23 on show in Dublin, with two each by Opie and Peters. The gallery closed in 1795, but Alfred Woodmason, James's youngest son, managed to persuade John Murray to publish seventeen engravings from the pictures in 1817. Six of

the prints bear Murray's name rather than that of Woodmason.

An astoundingly large proportion of nineteenth century editions of Shakespeare used the Boydell illustrations in one form or another, re-engraved, simplified, adorned with fancy borders and so on. That the same process was not followed with, for instance, Macklin's *Bible* in nineteenth century illustrated bibles, or Bowyer's *History* in nineteenth century histories of England, shows how much more successful the Boydell pictures were in attracting the public imagination. Despite Charles Lamb's dislike of the grandiose images of the Boydell Gallery, they eventually came to represent for many people the poetic force and heightened reality of Shakespeare's plays. In fact, Charles Lamb objected to the Boydell engravings on the grounds that they got in the way of his own interpretation of a scene. Most people were only too happy to have a scene visualised for them.

Ironically, despite the Boydell artists' disavowal of the influence of the stage, it was the influence of the stage that caused the Boydell engravings to retain there influence. The late eighteenth and early nineteenth centuries saw a nostalgia for the theatre of Garrick in the mid-eighteenth century with its flashier and quicker style of acting, smaller auditoria and more intimate relationship between actor and audience. The nostalgia is best exemplified in the cosy, small full-lengths of Samuel De Wilde which recall the similar conversation pieces of Johann Zoffany. Similarly, once the era of Kemble and Siddons was over, and a suitable time had lapsed, their noble profiles, rhetorical gestures and ponderous productions became a source of nostalgia if not actual emulation. The lapse ended in the mid-1820s when writers and critics, presented with the disintegration of their hero, the brilliant and demonic Kean, began to regret the passing of the older nobler style of acting. This publically expressed regret coincided with the first use of re-engraved Boydell plates as illustrations. After the death of Mrs. Siddons in 1830 the nostalgia increased as did the number of editions of Shakespeare using the Boydell illustrations. Both were seen as examples of a lost nobility and dignity of spirit; the acting of Siddons and Kemble developed into a legend of astringent unreality and the Boydell engravings were at hand to show what such inhuman dignity must have been like, regardless of the fact that the Boydell pictures owed very little indeed to stage productions.

The various re-issues of Boydell plates really only became an important force in Shakespeare illustration after the publication of the first Valpy edition in 1832–4[17]. Popular Shakespeare illustration of the previous three

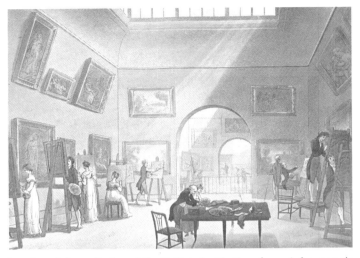

Interior of the galleries of the British Institution, from Ackermann's *Microcosm of London* (1808–10). Built by John Boydell as the Shakespeare Gallery and opened in 1789, the lease was purchased by the British Institution in 1805.

decades had been dominated by John Thurston. He was responsible for several complete sets of illustrations to Shakespeare, as well as contributing to editions illustrated by a number of artists. His most attractive and accomplished complete set was that engraved by Richard Rhodes and published by Thomas Tegg (1812–15), and the most popular those printed by C. Whittingham (1813–14) and D. S. Maurice (ca.1817[18]). The Whittingham illustrations were published fifteen times before 1850 and were much the most popular illustrations of the early nineteenth century[19]. Their appeal lay in their simplicity and their small size. From 1826 they were published separately, six illustrations to a page, and could almost be read as picture-book Shakespeare. Each play had a tiny frontispiece in which one might see the essence of the play, a skeleton within a hollow crown for *Richard II* for instance, and an illustration to each act. They were clear and concise, and perhaps provided a more useful introduction to Shakespeare for several generations of readers than Lamb's now sacrosanct *Tales from Shakespeare*.

For popular editions of Shakespeare in the early nineteenth century it is correct to emphasise the importance of Thurston and then the Boydell revival of the second quarter of the century, but other illustrated editions were produced during this period, often showing a very high level of artistic competence. Perhaps the best octavo book-illustrations to any author of the early nineteenth century

are Fuseli's for the Rivington *Shakespeare,* edited by Alexander Chalmers and published in 1805. The powerful images were produced by Fuseli simplifying and reducing his usually grandiose ideas and are much more impressive than any of the later early nineteenth century illustrations[20].

The most prolific book illustrators of the late eighteenth and early nineteenth centuries in general rather than purely Shakespearean terms, were Thomas Stothard and Robert Smirke. They appeared together at the beginning of their careers with the plates to *The Picturesque Beauties of Shakespeare,* published 1783–86[21]. Somewhat in the style of Hayman's illustrations of forty years earlier, these plates, four per play, were the first to give prolonged airing to each play. Issued as plates alone,and also with accompanying texts, they were perhaps the first Shakespeare illustrations to be seen as an alternative rather than as an adjunct to the text. Both Smirke and Stothard painted for the *Shakespeare Gallery* of course, Smirke being the most prolific contributor along with Richard Westall. Both produced series of *The Seven Ages of Man* and both produced intermittent Shakespeare illustrations in the early years of the nineteenth century.

Stothard was the most productive, with his sixteen plates to the incomplete Heath & Robinson edition of 1802–4, and his sixteen plates for the Kearsley edition of 1806[22]. However, both artists had a variously successful Shakespearean swan-song in the 1820s. Stothard produced 25 of the 39 engravings published by W. Pickering in 1826 and appended to a number of editions[23]. Their delicacy is matched and originality surpassed by the illustrations to an edition of Shakespeare published in 1826, most of which appear to be by Stothard. The publisher and printer, Charles Whittingham of Chiswick, commissioned Stothard to build Shakespearean scenes around the intials of his name and the title pages of the ten volumes read W H I TT I N G H A M[24].

Smirke's Shakespeare illustrations of the 1820s were not nearly so amusing. Like Thurston's popular illustrations, they were to consist of a frontispiece and one illustration to each act of all the plays. However, unlike the Thurston illustrations, Smirke's designs were issued in parts along with the text. This system, which had not been a great success with Boydell, was a positive disaster for Smirke's publishers. The edition began to be published by Rodwell and Martin in 1821 but the project fell into some difficulties and only eight plays were published. Only five were brought out by the original publisher[25], the last three being published by Hurst, Robinson and Jennings who, in 1825–6, published the illustrations on their own with a frontispiece by Smirke showing a bust of Shakespeare[26]. He also provided vignette frontispieces to the plays published. Dreams of a complete illustrated Shakespeare fizzled out in the *Shakespeare Portfolio,* a conglomerate collection of 96 plates including Smirke's existing 40 plates and the frontispieces[27].

The huge format of even the smaller Boydell illustrations was not one that was followed in the nineteenth century. The emphasis was on the creation of a large, popular market for Shakespeare and Shakespeare illustration rather than the retention of a small, exclusive one. Illustrations became smaller and smaller, and the editions larger and larger, as the commercial possibilities of wood-engraving and steel-engraving were realised. There were brave exceptions, such as the somewhat overdue publication in 1817 of seventeen engravings from Woodmason's *Irish Shakspeare Gallery*[28], which was not a success to judge from the rarity of the engravings, but the market for luxurious editions was sated and the war and post-war economic conditions of the early nineteenth century did not produce a vast new market for such things.

The market was not ripe until the late 1830s when two lavishly illustrated editions of Shakespeare appeared; Charles Knight's *Pictorial Edition,* 1838–43 and Robert Tyas's three-volume edition illustrated by Kenny Meadows, 1840–3[29]. In 1832, Moon, Boys & Graves had published a folio edition of the smaller Boydell plates, but the type-setting was rather shoddy with four pages of text to each folio page, and the ever-popular Thurston wood-engravings were thrown in as if the publishers were somewhat unsure of their market[30]. Both the Knight and Tyas editions were produced around their illustrations and because of their illustrations they were very successful. They were both reprinted several times before 1850 and appeared a number of times after that [31], with their illustrations pirated for editions published as far apart as New York and Leipzig, Paris and Philadelphia[32].

The large octavo format of both editions meant that they were easier to handle than their predecessor, the Boydell edition, where the massive folio pages had made any serious reading of the text an impossibility. the *Pictorial Edition* had, perhaps, an excessive dose of the didactic, but the reconstructions of Caesar's clock and Juliet's balcony were in keeping with the tenor of the time. The 'advance' in Shakespeare production that brought to bear Planche's frenzied researches, to make Charles Kemble's 1823 production of *King John* at Covent Garden an authentic reconstruction of the historical past also brought with it the *Pictorial Edition.* In the 1850s Charles Kean produced special editions of the text of his

Shakespeare productions and peppered them with details of his historical detective work. In order to approach closer to Shakespeare it was felt necessary to prosaicise the factual elements of the plays. The *Pictorial Edition* was the handbook of this school of thought which held almost total away in the British Theatre until the First World War. There were other aspects to the edition, however, and the polyglot frontispieces were amongst the most elaborate and, sometimes, the most attractive Shakespeare illustrations of the first half of the nineteenth century.

William Harvey was the major illustrator of the *Pictorial Edition,* but he was only one of many. Kenny Meadows was the sole illustrator of the Tyas edition and although he did not quite manage the 1,000 illustrations claimed for him on the earliest title page (the *Pictorial Edition* had *over* a thousand illustrations) he provided several hundred. His illustrations wind their way through the text and, although they are not always deeply sympathetic, they form a continuous comment on the text quite unlike any earlier edition. Kenny Meadows also produced separate series of full-plate illustrations to the plays, and whilst they were perhaps more carefully composed and considered, they were not nearly so effective as the energetic bursts of illumination that spring from the pages of the Tyas edition.

The Tallis edition of 1850 brings the story of Shakespeare illustration full-circle to the Rowe edition of 1709[33]. Like the very first Shakespeare illustrations, those to the Tallis edition take their inspiration straight from the stage. To the modern reader the evidence is conclusive; the illustrations are photographs of actors and actresses in costume. However, whereas François Boitard illustrated the Rowe edition with scenes inspired by stage performances because he couldn't really see any alternative, the Tallis illustrations deliberately rejected the tradition of Shakespeare illustration of nearly one hundred and fifty years. Even the new integrated format of the Tyas edition is rejected.

There are two main reasons for the break with the imaginative tradition. The daguerreotype was an exciting and relatively new invention of which any enterprising publisher would have been anxious to take advantage (Tallis was not a man to let tradition or good manners stand in the way of a good selling point; J. O. Halliwell, the most famous Shakespeare scholar of the day, was more or less named as editor on the title page although he had nothing at all to do with the edition), and the mid-nineteenth century saw an unbounded rush of self-confidence in theatrical productions of Shakespeare. To a large extent this was justified, as the original text of many of the plays was heard on stage for the first time since the early seventeenth century. The emphasis on historical accuracy gave the impression that Shakespeare was being served properly for the first time and the illustrations and editorial tone of the *Pictorial Edition* did nothing to disembarrass readers and play-goers of their opinion. Contemporary stage practice in 1850 was regarded, therefore, as the ultimate and absolutely correct way of producing Shakespeare. Why not, then, illustrate Shakespeare's texts with deadly accurate reproductions of stage performances? It was no accident that the occasional Boydell illustration was retained for comparison.

POSTSCRIPT — 'THE SEVEN AGES OF MAN'

The popularity of certain plays varied from one generation of artists to another, as did the depiction of favourite scenes. However, there was never any doubt that the most popular speech in Shakespeare was Jaques's soliloquy from *As You Like It,* Act II, scene vii, beginning "All the world's a stage . . ." and including his catalogue of the "Seven Ages of Man". The first series of plates illustrating the speech was a set of rather crude woodcuts published with the text in 1771. The most important of the early series were those by Smirke and Stothard, especially the Smirke series produced for the Boydell Shakespeare Gallery (cat. nos. 84-90). Smirke exhibited a set at the Royal Academy in 1798 (88), possibly the Boydell pictures. The debt to Hogarth and Dutch seventeenth century genre series is obvious.

However, although Smirke and Stothard's series are pleasantly anecdotal they are almost devoid of any form of visual wit. Later series often liven up the subject; Henry Alken's 1824 series, for instance, includes persistent and largely irrelevant references to sporting matters. Other artists, mostly later in the nineteenth century, saw the *Seven Ages* as an excuse to produce a series of comic illustrations. for instance, the anonymous publication of ca.1850 . . . *illustrations in jest and earnest. By a funny fellow,* and the *Progress of Pertinax Puzzle-wit* of twenty years later. Nevertheless, most nineteenth century literary interpretations of the speech were in profound earnest, taking it as the excuse for a diatribe, less poetic than Shakespeare's own, on the fleeting nature of life. John Evans's *Progress of human life: Shakespeare's 'Seven Ages of Man'* was first published in 1818 and had reached a fourth edition by 1834. This more serious attitude was reflected in the series published in 1840, with plates by a number of artists including Constable, Mulready, Wilkie and

Landseer and a series of triangular line engravings by Maclise.

Other series following, including one of ca.1850 that included some illustrations by Sir John Gilbert, a series published in Paris in 1852 with illustrations by Tony Johannot, and a series illustrated entirely by Gilbert in 1862. Smirke's Boydell series was expensively published as a collection of photographs in 1864, a venture that proved popular enough to support two further editions.

The speech was also used as an excuse for a number of extra-textual productions such as *The Seven Ages of Female Beauty*, published by Charles Tilt in 1838, which included nine, rather than seven, moments of female charm. This idea was developed later in the century by Miss Emma Stanley who devised a one-woman show, *The Seven Ages of Woman, A New Lyric Entertainment*. The show was in full swing by 1862 when the programme, with the words of the songs, was published, and *The Era*, for 26 November 1871, announced that Miss Stanley was still appearing in the same production at Weston-super-Mare Assembly Rooms nearly ten years later. Miss Stanley tended to dwell on the third age, not unnaturally, but she devised suitable sections for each age: 1. Infant; 2. Schoolgirl; 3. Lover; 4. Lady of a certain age; 5. Strong-minded woman; 6. Maturity and maternity; 7. last scene — Grandmother grey. Sir John Gielgud has brought the same format onto the stage of our own day but as early as 1807 George Cruikshank illustrated a broadside with *Paddy McShane's 'Seven Ages'* written by Major Downes and sung with unbounded applause by Mr. Johnstone at the Theatre Royal, Drury Lane.

However, the attraction of the subject as a basis for artistic creation was seen first by artists rather than actors. The evident success of the theme in the pictures of Smirke, Stothard and later artists encouraged the attempts at similar emphasis on the stage. The 'Seven Ages of Man' speech shows the importance of artists in creating a new approach to Shakespeare in the live theatre.

There is little evidence to suggest that any other body of Shakespearean painting had direct repercussions on the stage. Reynolds's *Portrait of Sarah Siddons as the Tragic Muse* was reproduced on stage almost as soon as it was finished, but there was no attempt to transpose the similarly grandiose images of the Boydell scenes onto the stage. The Boydell Shakespeare Gallery developed out of the tradition of Shakespeare illustration and, perhaps largely because of circumstance rather than design, that is where it remained.

FOOTNOTES

1: ASHTON WS Nos. 1,2,7, 8,18, 23, 24. ASHTON WS (or AWS) numbers refer to: Geoffrey ASHTON "A Catalogue of illustrated editions of Shakespeare and collections of Shakespeare illustrations 1709–1850" (212 editions included) Awaiting publication
2: HAMMELMANN, 1968; and MERCHANT, 1959
3: AWS 2
4: AWS 2 & 5
5: AWS 7
6: AWS 8
7: AWS 16
8: AWS 18 (plates only AWS 19)
9: AWS 20
10: AWS 23
11: AWS 24
12: HALL, 1930
13: AWS 28
14: FRIEDMAN, 1976
15: AWS 36 (18 parts, 9 vols. — original parts AWS 27)
16: AWS 40
17: AWS 123
18: AWS 63, 65, 69
19: AWS 65, 72, 87, 92, 93, 97, 106, 110, 111, 114, 117, 120, 121, 127, 154
20: AWS 44
21: AWS 22
22: AWS 38,46
23: AWS 91, 116, 132
24: AWS 94
25: AWS 77
26: AWS 89
27: AWS 107
28: AWS 68
29: AWS 146
30: AWS 121
31: KNIGHT: AWS 165, 178, 189, 190, 196; TYAS: AWS 170, 179, 191, 205
32: AWS 210

CATALOGUE

Authors of individual catalogue entries are identified
by their initials:

M.B. — Martin Butlin

M.J.B. — Michael Bellamy

M.P. — Martin Postle

P.C.-B. — Peter Cannon-Brookes

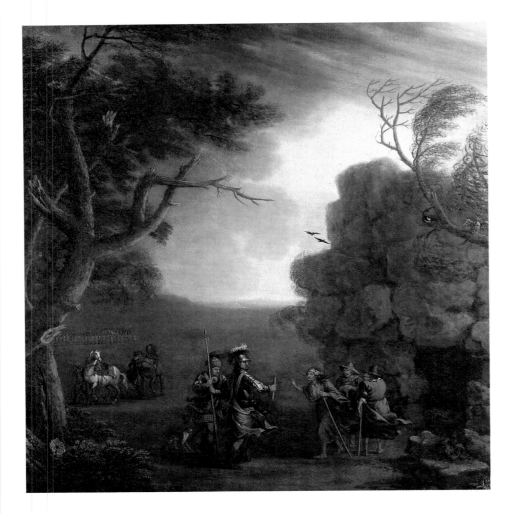

the blasted heath, while the surrounding gloom and autumnal evening sky increase the sense of foreboding.

John Wootton, who is often seen as the quintessential Early Georgian painter, in fact studied under Wyck and possibly Siberechts and visited Rome where he developed a style of painting indebted to Claude and Gaspard Dughet. By 1714 he had returned to England and was painting sporting pictures, especially horses. He collaborated with Dahl, Jervas and Richardson in equestrian portraits although his greatest artist friends were the architects Gibbs and Kent. Amongst artistic patrons he was well known to Edward Harley, 2nd Earl of Oxford, and became one of 'Harley's Virtuosi'. The literary dimension of this coterie included Prior, Pope, Gay and Swift, and we know that Prior, Pope and Gay all owned paintings by him, as did the poet Lyttleton. Indeed, the classical landscape painted for Pope contains several references to the poet's works which are more than merely flattering and show a sympathy with his thinking.

Wootton's representation of this Shakespearean subject, in 1750, employs the so-called Poussin size of figures and this format remained popular for narrative landscape paintings throughout the period 1750–1830, including those of the young J. M. W. Turner. The comparison between this composition and *Macbeth and the Witches*, by Francesco Zuccarelli (1702–88), signed and dated 1760, which was engraved by William Woollet in 1770, is intriguing.

M.J.B.

1. *Macbeth and Banquo meeting the Weird Sisters*

John Wootton
(Snitterfield 1622–1764 London)
Oil on canvas, 60 x 57½ inches
(152.5 x 146 cm)
Signed in Roman Script and dated 1750
BIBLIOGRAPHY: Cf. Meyer, 1984
PROVENANCE: The Rev. E. Thistlethwaite, Anfield Plain, Co. Durham

Taken from Shakespeare's *Macbeth,* Act I, Scene 3, the scene shows Macbeth and Banquo meeting the Weird Sisters — three witches — who prophesy that Macbeth, who is Thane of Glamis, will also become Thane of Cawdor and King in Scotland. Macbeth is confused and alarmed by this news which almost instantly proves to be in part true when Lord Ross enters and announces that the present king has awarded Macbeth the title Thane of Cawdor as reward for his courage in battle. Wootton shows Macbeth and Banquo, dressed in tartan, assailed by the witches before their cave. Around them lurk their familiars, the cat within the cave and the owl and magpie perched above their heads in the branches of a tree. In the background Macbeth's army stands marshalled upon

2. *The Destruction of the Children of Niobe*

William Woollett (1735–85)
after **Richard Wilson** (1714–82)
Etching and engraving, 5th State,
published by J. Boydell, London, 1761
(Fagan, 1885, XLII)

Painted by Richard Wilson *c.*1759–60, *The Destruction of the Children of Niobe* was the key picture of Wilson's career

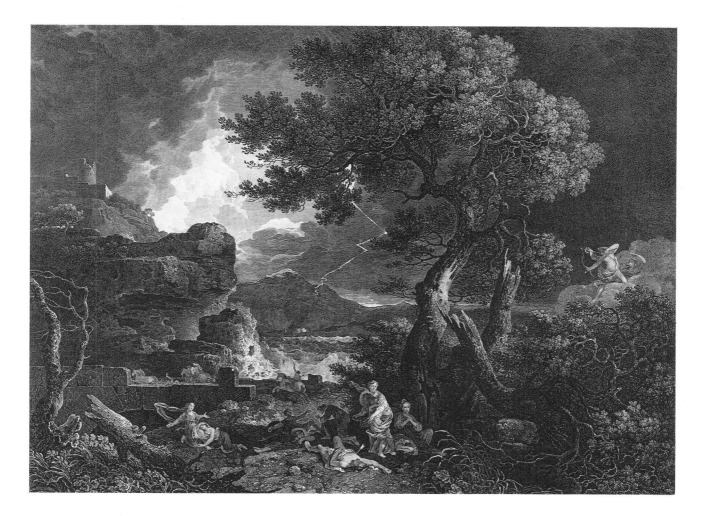

(Solkin, 1982, pp.200–202) and, exhibited at the Society of Arts, it immediately attracted very favourable attention. This exhibition, 21 April–8 May 1760, was held in the Strand Great Room of the Society of Arts and provided in London the first public exhibition of contemporary British art open to all 'the Present Artists'. A huge popular success, 6,582 catalogues were sold @ 6d and over 1,000 visitors attended per day to view the 130 exhibits, including works by Reynolds, Roubliliac, Hayman, Paul Sandy and Richard Wilson.

However, the Society of Arts had that year offered premiums for the best his-

tory and landscape paintings submitted to it and the paintings entered in competition for them remained hung together with the exhibition proper. This and the question of entry charges, led to controversy, and when the Society subsequently sought to impose additional restrictions, the more important artists withdrew in 1761, found themselves a large room in Spring Gardens and called themselves 'The Society of Artists of Great Britain'. Some of the 1760 exhibitors remained loyal to the Society of Arts and the Strand Great Room for 1761, calling themselves from 1762 'The Free Society of Artists'.

John Boydell commissioned William Woollett to engrave *Niobe*, and Woollett exhibited the finished engraving at the Free Society of Artists, 1762 (205). It too was a great success and obtained, for Boydell, a profit of c.£2,000. This was much larger than that earned before by any engraving after a landscape painted by a British artist, and points the way to the changed relationships between painters, engravers and print publishers developed during the second half of the eighteenth century. The economics are revealing in that Wilson sold *Niobe* for 80 guineas and Boydell paid Woollett £150 for the plate, but Boydell eventually

profited by some £2,000 from the print sales (see Smith, 1829, II, pp.251–53 for a detailed account).

P.C.-B.

3. *Solitude*

William Woollett (1735–85) and
William Ellis)1747–after 1800) after
Richard Wilson (1714–82)
Engraving with etching (in reverse), 6th State, published 4 June 1778 by William Woollett "From the original Picture in the possession of Mr. Robt. Ledger"

For the engraving Woollett has quoted lines from 'Summer' in Thomson's *Seasons* and the painting can probably be identified with the 'Landskip with Hermits' exhibited by Wilson at the Society of Artists in 1762 (132) (see Fagan, 1885, p.45, no. XCIX; Solkin, 1982, p.213)

P.C.-B.

4. *The Triumph of Britannia*

Simon François Ravenet
(1706–1774),
after **Francis Hayman** (*c.*1708–1776)
Etching and engraving, published by J. Boydell, London, 1 January 1765, when in the collection of Jonathan Tyers, at Vauxhall

One of the four large history paintings executed by Francis Hayman in the early 1760s for the Great Room in Vauxhall Gardens, this painting had been installed by mid-May 1762 and the history of the decoration of this room is provided by Allen, 1987, pp.66-68. The large frames were originally intended to house portraits of Frederick, Prince of Wales, and his family, but they were unfilled at his untimely death in 1751. Of the new set of paintings *The Surrender of Montreal to General Amherst* (8 September 1760) was unveiled by November 1761, whilst *Lord Clive Receiving The Homage of the Nabob* (Clive's victory at Plassey was won 23 June 1757) was placed in position late in

1762, and *Britannia Distributing Laurels to The Victorious Generals* would appear to have been installed shortly before June 1764.

In the background of *The Triumph of Britannia* is depicted Admiral Hawke's victory over the French at Quiberon Bay (20 November 1759). The Vauxhall decorations are important as the first cycle since Laguerre's decoration of the staircase as Marlborough House, London, with episodes from the War of Spanish Succession, in the manner of Van der Meulen, and the depiction of the scenes of *The Surrender of Montreal* and *Lord Clive* realistically, in contemporary dress provides an important prototype for West's *Death of General Wolfe*. Samuel Scott exhibited at the Society of Artists in 1761 (100) *The Taking of Quebec*, whilst George Romney won a consolation prize in 1763 from the Society of Arts for his *Death of General Wolfe* which was criticised as "a coat and waistcoat piece". Unsold, it was, according to William Hayley, sent to India.

Born in Paris and a pupil of Le Bas, Ravenet settled in London *c.*1750 and won a premium from the Society of Arts in 1761. He engraved the fourth and fifth plates of Hogarth's *Marriage à la Mode* and later worked for Boydell. Ravenet's engraving of *Britannia* was exhibited at the Society of Artists, 1765 (227).

P.C.-B.

5. *The Good Samaritan*

Benjamin West
(Springfield 1738–1820 London)
Black chalk, 15¾ x 20¼ inches
(40 x 51.5 cm)
Inscribed 'RL' in lower left corner
PROVENANCE: West family, London
Private collection, Philadelphia

A painting of *The Good Samaritan*, very close in composition to this drawing, but not identical, was offered by West's sons to the United States in 1826 (116) and sold by them, Robins, London, 22–25 May 1829 (136). This painting, present whereabouts unknown, was sold subsequently at Christies, London, 13 February 1925 (96) and again 8 February 1926 (38). Erffa & Staley, 1986 (p.338, No. 319), on the basis of a photograph, catalogue this painting cautiously as a very early work of Benjamin West, *c.* 1763–66, and they note that 'the clumsy details in conjunction with a sophisticated effect of light and a spacious Claudian landscape strongly suggest that the painting is a copy after an unidentified seventeenth-century work'. Furthermore they suggest that this drawing is not from the hand of West himself and that the initials may refer to Richard Livesay (1753–*c.*1823), West's student and assistant. However, to the Claudian qualities of the painting, the drawing adds a Rembrandtesque treatment of the figures which is not carried over into the painting. Livesay subsequently settled at Windsor where he painted copies for West, was patronised by George III and taught drawing to the Royal Family (1790–93), before being appointed drawing-master to the Royal Naval College at Portsea in 1796. He copied and engraved some of the works of William Hogarth, with whose widow he had lodged (1777–85), as well as engraving his own compositions, and it is curious that the painting sold at Christies in 1925/26 displays so many of the conventions of prints of *c.*1800.

P.C.-B.

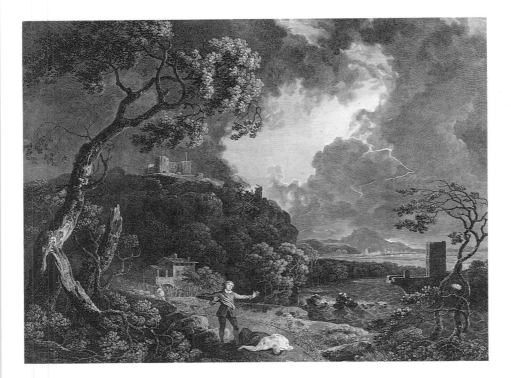

6. *Celadon and Amelia*

William Woollett (1735–85) and
John Browne (1741–1801), after
Richard Wilson (1714–82).
ETCHING AND ENGRAVING: 5th State,
before publication line [published by
William Woollett jointly with Ryland &
Bryer, London, 10 June 1766], when in
the collection of William Lock of
Norbury (Fagan, 1885, LVIII).

This narrative landscape painting, first
exhibited at the Society of Artists in 1765
(157), is inspired by the 'Summer' section
of James Thomson's *Seasons* and William
Woollett exhibited an impression of the
print at the Society of Artists, 1766 (290)
and again at its Special Exhibition in
1768 (215). The present location of the
painting is unknown, but in this compo-
sition Wilson found a "modern, English
and Christian equivalent to *The
Destruction of the Children of Niobe*" with
"the 'mysterious' hand of providence
acting on an innocent maid through the

agency of nature" (Solkin , 1982, p.221).
P.C.-B.

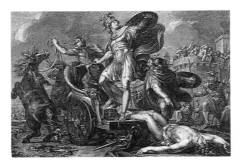

7. *Achilles vents his Rage on the Body of Hector*

Dominicus Cunego (1727–94), after
Gavin Hamilton (1723–98).
Line engraving with etching, "from the
Original Painting in the collection of his
Grace the Duke of Bedford", Rome 1766

Hamilton was educated at Glasgow

University (1738–42) before travelling to
Rome where he became a pupil of
Agostino Masucci, until 1748. After a
stay in London he settled in Rome in
1756 and executed there a very influen-
tial series of heroic history paintings. The
earliest of these, the *Anger of Achilles*, ex-
ecuted for the Duke of Bridgewater, is
lost, but, together with *Dawkins and
Woods discovering the Ruins of Palmyra*
(commissioned by Henry Dawkins in
1757), these were the first commissions
received by Hamilton in Italy.
Andromache morning the Death of Hector
may have been commissioned by Lord
Compton as early as 1756, but it was
completed in the summer of 1760, whilst
Achilles mourning Patroclus was commis-
sioned by James Grant of Grant in 1760
and completed in the summer of 1763.
Cunego engraved the painting in 1763
and it was exhibited at the Society of
Artists in 1765 (46).

Cunego's role was specific and he was
commissioned by Hamilton to engrave a
set of six prints after his *Iliad* paintings,
primarily in order to spread his reputa-
tion and Neo-Classical ideas (Alexander,
1983, p.13, but see also Macmillan, 1986).
*Achilles vents his Rage on the Body of
Hector* was commissioned in 1763 by the
Marquess of Tavistock and completed by
1766 when it was engraved by Cunego in
Rome, and much of Hamilton's influence
was exercised through the Cunego prints
rather than the paintings themselves.
P.C.-B.

8. *The Women at the Sepulchre*

Benjamin West, P.R.A.
(Springfield 1738–1820 London)
Oil on canvas, 29¾ x 23 inches
(74.3 x 58.4 cm)
Signed and dated 1768
PROVENANCE: Charles Price, 1768;
Possibly Samuel Dickenson, Esq., of East
Smithfield (Christie's, 11–12 March 1774,
lot 69); William Smith, M.P. (Christie's,
28 May 1824, lot 29; bought in at 15
guineas)

EXHIBITED: Royal Academy (various

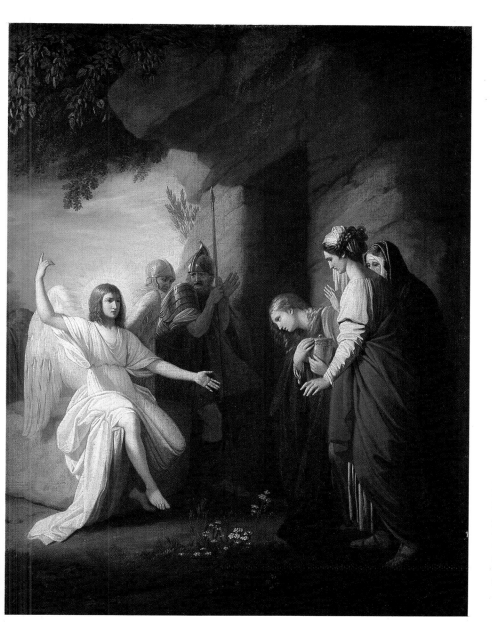

'A Correct List of the Works of Mr West', *Universal Magazine*, III 1805, p.529

J. Barlow, *The Columbiad. A Poem.* 1807, note 45, p.433 ('The Two Marys at the Sepulchre', under "Various Collections")

'A Correct Catalogue of the Works of Benjamin West, Esq'. *La Belle Assemblee or Bell's Court and Fashionable Magazine*, VI, 1808, supplement, p.15 ('The Mary's at the Sepulchre, W. Smith Esq., first painted forW. Locke Esq.')

J. Galt, *A Catalogue of the Works of West* in *The Life, Studies and Works of Benjamin West, Esq, President of the Royal Academy of London* 1820, Appendix II, p.233

J. Dillenberger, *Benjamin West: The Context of his Life's work*, 1977, p.159 (no 210)

H. von Erffa and A. Staley, *The Paintings of Benjamin West*, 1986, cat. no 371, (as whereabouts unknown)

West painted several versions of 'The Women at the Sepulchre', and there is some confusion as to which version was painted for whom and when, but this painting may be that painted for William Lock, of Norbury (1732–1810) who owned the *Celadon and Amelia*, by Richard Wilson (see cat. no. 6) before both belonged to William Smith, M.P. Not all versions were exhibited during West's lifetime, further confusing the picture. Until its recent appearance the present painting was known only from Pollock's and Smith's undated engravings. Related drawings are at Swarthmore and in the Butler Institute of American Art, Youngstown, Ohio. The latter drawing, signed and dated 1782, is a later reworking of the original composition.

The scene is taken from Matthew's Gospel chapter 28:

. . . in the end of the Sabbath, as it began to dawn towards the first day of the week, came Mary Magdalene and the other Mary to see the sepulchre.
And, behold, there was a great earthquake; for the angel of the Lord descended from heaven, and came and rolled back the stone from the door, and sat upon it.
His countenance was like lightning, and his raiment white as snow;

versions, in 1792, 1800, 1805 & 1818; see note below)

ENGRAVED: W. Nutter, 1803; T. Pollock; T. Smith

LITERATURE:
'A Correct Catalogue of the Works of Mr West', *Public Characters of 1805* 1804, p.563 ("The Marys at the Sepulchre, for Gen. Stibert")

And for fear of him the keepers did shake and became as dead men.

And the angel answered and said unto the women, "Fear not ye; for I know that ye seek Jesus, which was crucified.

He is not here: for he is risen, as he said. Come, see the place where the Lord lay."

M.J.B.

the 1760s, but neither was exhibited and the relationship between them may not be limited to the pairing of the engravings. However, the revival *c.*1800 of interest in this period of West's work, when major works by Annibale Carracci and the Bolognese classicists were reaching the London art market from the Orléans Collection and other sources, is revealing.

P.C.-B.

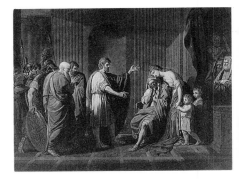

12. *Leonidas and Cleombrutus*

Charles Hodges (1764–1837), after **Benjamin West** (1738–1820)

Mezzotint, published 1 May 1789 by John and Josiah Boydell

The painting, signed and dated 1768, was exhibited by Benjamin West at the special two-day exhibition mounted at the Society of Artists in 1768, on the occasion of the visit to London of the King of Denmark, and again at the newly-founded Royal Academy in 1770 (197). Born in Springfield, Massachusetts, West had travelled in Italy, 1760–63, before settling in London, and he was very much aware of the Neo-Classical style of painting being evolved in Rome by Gavin Hamilton and others. His sympathies lay more with Nicolas Poussin and from his arrival in London in 1763 he executed a series of strongly Poussinesque classical history paintings until well after 1800. His Quaker background and sobre business-like approach to painting no doubt also encouraged him to avoid the meglomaniac tendencies of the Scottish artists in Rome.

Probably a pupil of John Raphael Smith, Charles Hodges was a leading engraver of Old Master paintings and he left England for Amsterdam in 1788, but he executed a number of mezzotints after English paintings subsequently.

P.C.-B.

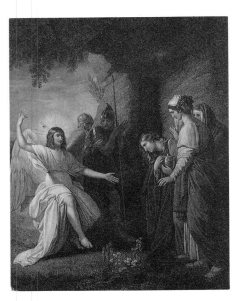

9. *The Women at the Sepulchre*

William Nutter (1754–1802) after **Benjamin West** (1738–1820)

Stipple engraving, Proof Before Title, published 1 January 1803 by Benjamin Beale Evans

The same painting is apparently the subject of a much smaller engraving by T. Pollock and that composition is identified by Erffa & Staley (1988, p. 370, no. 371) with a painting datable to *c.*1768. Erffa & Staley were unaware of this engraving by Nutter and that it is paired with *Jacob and Rachel*, after West, also by Nutter and published by Benjamin Beale Evans on the same day (cat. no. 64). The latter painting is also a relatively early work by West, dated by Erffa & Staley to

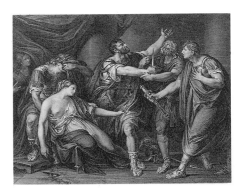

10. *The Oath of Brutus*

Dominicus Cunego (1727–94), after **Gavin Hamilton** (1723–98).

Line engraving with etching, "from the original painting in the possession of the Right Honble the Earl of Hopetoun", Rome 1768.

The painting (oil on canvas, 84 x 104 inches), now in the Yale Center for British Art, was commissioned by James Hope, later 3rd Earl of Hopetoun, in the summer of 1763, was engraved (according to Macmillan, 1986, p.41) in 1766. With his painting of *Agrippina with the Ashes of Germanicus* commissioned in 1765 by Earl Spencer and exhibited at the Royal Academy in 1772, these paintings are marginally smaller in size than the *Iliad* series, though close in style. The life-size classical figures painted by Hamilton exercised a powerful influence during the evolution of Neo-Classicism in Rome, not least on Jacques Louis David, but less in England where West preferred the Poussin-size and format.

P.C.-B.

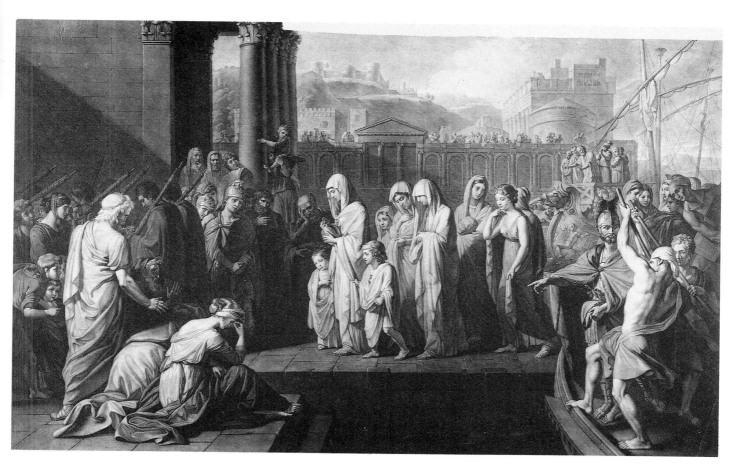

11. *Agrippina Landing at Brundisium with the Ashes of Germanicus*

Richard Earlom (1743–1822), after
Benjamin West (1738–1820)

Mezzotint, published 1 July 1776 by John
Boydell

Commissioned by West's first major patron, Robert Hay Drummond (1711–76), Archbishop of York, the passage from Tacitus was selected by him and West was given extensive guidance as to how he wished the subject to be treated. West told William Carey in 1818 that this was the first commission for an historical painting given to him after his arrival in England, and it was completed by February 1768 when the Archbishop arranged for West to show it to George III (Erffa & Staley, 1986, pp.179-80. no. 33). The painting (signed and dated 1768) was exhibited at the Society of Arts in 1768 (175), and again in the special exhibition later that year (120). Since 1947 it has been in the Yale University Art Gallery, New Haven.

Mezzotints after subject pictures were relatively common in late 17th century Holland and began to be published in England in greater numbers from the 1720s. Some fifty works by Philip Mercier were so engraved and the influence of the young Frederick, Prince of Wales, and his circle, was a significant factor in this development (see Ingamells & Raines, 1978).

Earlom was a pupil of Cipriani and one of the finest mezzotint engravers of the eighteenth century. He first worked for Boydell on the 200 plates for the *Liber Veritatis* after Claude Lorrain (published 1777) and subsequently engraved a wide range of Old Master and contemporary paintings.

P.C.-B.

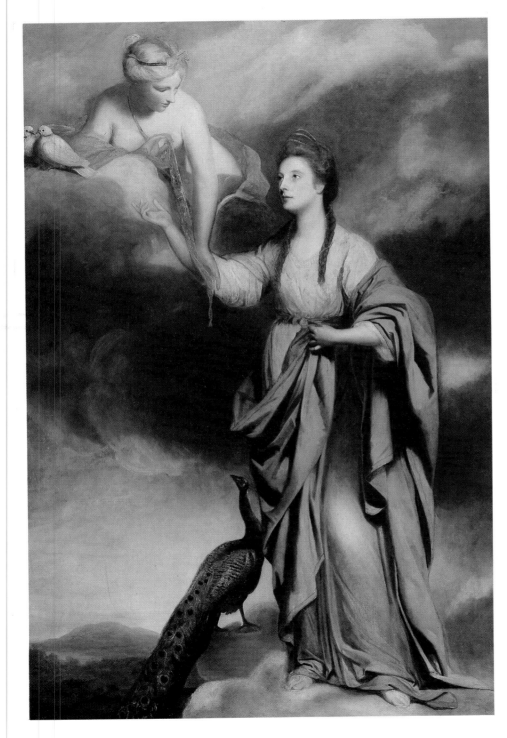

13. *Portrait of Annabella, Mrs Blake (later Lady Blake) as Juno receiving the Cestus from Venus*

Sir Joshua Reynolds P.R.A.
(Plympton 1723 – 92 London)
Oil on canvas, 93¼ x 57½ inches
(237 x 146 cm)
PROVENANCE: Sir Henry Bunbury, Barton Hall; Charles Wertheimer; Christie's 10th May 1912, lot 64; (52,000 gns to Sulley); Blakes sale, New York, 21–23 April 1915, lot 236; Mrs Hanbury Forbes, 1947
EXHIBITED: Royal Academy 1769 (90) Burlington House, 1908
ENGRAVED: John Dixon, 1771
S. W. Reynolds

LITERATURE: W. Cotton, *A Catalogue of the portraits painted by Sir Joshua Reynolds, P.R.A.,* London, 1857 p.9;
C. R. Leslie and Tom Taylor, *Life and Times of Sir Joshua Reynolds,* 2 vols., London, 1865, vol. 1, p. 323;
A. Graves and W. V. Cronin, *A History of the works of Sir Joshua Reynolds P.R.A.,* 4 vols., London, 1899, vol. 2, pl. 89;
W. Armstrong *Sir Joshua Reynolds,* London/New York, 1900, p. 194;
E. K. Waterhouse, *Reynolds,* London 1941, p. 60, illus. pl. 126;
N. Penny ed., *Reynolds* (exhibition catalogue, Royal Academy), London, 1986, pp. 27 and 29, illus. fig. 15

This magnificent full-length portrait, until very recently unlocated, was shown at the first Royal Academy exhibition in 1769. It is among the most important and most didactic works produced by Sir Joshua Reynolds during the early years of his Presidency. Exhibited by Reynolds as "A Portrait of a Lady in the character of Juno, receiving the Cestus from Venus", the portrait element was deliberately played down in contemporary notices of the work. The *Middlesex Chronicle,* for example, observed on 2 May 1769:

> The Pictures that have this Season chiefly attracted the Attention of the Connoisseurs at the Royal Academy in Pall-Mall, are three by Sir Joshua Reynolds, viz. Diana disarming

Cupid, Juno receiving the Cestus from Venus, and Hope Nursing Love . . .

The other two works mentioned were also portraits in character: *Diana* (Wimpole Hall) was the Duchess of Manchester, while *Hope* (Bowood) was a young actress named Miss Morris who had recently made an ill-fated debut as Juliet on the London stage. Reynolds had been producing paintings of this kind, which sought to elevate the portrait to the status of history painting, since the early 1760s. Two prominent forerunners to the present work are *Lady Sarah Bunbury Sacrificing to the Graces,* of 1765 (Art Institute, Chicago) which shared this picture's provenance until the Christie's sale of 1912, and *Mrs Hale as Euphrosyne,* exhibited at the Society of Arts in 1766 (which served not only as a portrait of the sitter but subsequently also as a decorative overmantel in the Music Room at Harewood House).

Annabella Bunbury, daughter of the Rev. Sir William Bunbury, Bt., was at the time the painting was exhibited, the wife of Patrick Blake, M.P., later Sir Patrick Blake, Bt., whom she had married in 1765. Sittings for Lady Blake, which may relate to the present painting, are recorded by Reynolds in 1766, 1767, 1768 and 1769. The narrative is drawn from Book XIV of Homer's *Iliad.* Here Juno, who seeks to attract the attention of Jupiter, borrows from Venus the 'cestus' — a girdle endowed with a magical power to enhance the beauty and feminine charms of the wearer. While Venus was traditionally associated with amorousness, Juno's attributes were of a more chaste nature — a fact which Reynolds underlines by the contrast between the scantily-clad figure of Venus (accompanied by a pair of billing doves) and the respectably berobed Juno, whose emblem, the peacock, is shown at her feet. According to Homer, Juno subsequently succeeded in becoming Jupiter's wife, although their marriage was stormy, and fraught with jealousy owing to her husband's numerous extra-marital affairs. Reynolds's intention, in employing the narrative in the present

work, was presumably to allude, by means of a quotation from Classical Antiquity, to Annabella Bunbury's success in capturing the heart of Sir Patrick Blake, although their subsequent divorce in 1778 adds an ironic twist to the tale.

This painting, engraved in 1771 by John Dixon, was probably a formative influence on Benjamin West's *Juno receiving the Cestus from Venus* (University of Virginia Art Museum, Charlottesville), which was exhibited at the Royal Academy in 1772. That painting, which was not a portrait, shows Venus, who wears a long, flowing robe, presenting the cestus to a naked figure of Juno — a conceit which Reynolds had, for obvious reasons, to show in reverse. The conservation of *Lady Blake as Juno* undertaken for the present exhibiion, has revealed once more the richness of Reynolds's impasto and his sensuous use of colour, for which the artist was so celebrated during his lifetime. Conservation has also uncovered the original landscaped background to the left of the figure, which had been overpainted with a nondescript seascape at some stage during the nineteenth century.

M.P.

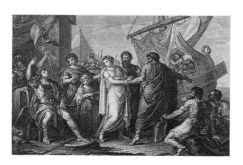

14. *The Anger of Achilles for the Loss of Briseis*

Dominicus Cunego (1727–94), after **Gavin Hamilton** (1723–98)
Line engraving with etching, "from the Original painting in the possession of the Right Honble Lord Viscount Palmerston", Rome 1769

Hamilton appears to have worked on *The Parting of Achilles and Briseis* (commissioned by Viscount Palmerston by 1766) concurrently with *The Anger of Achilles for the Loss of Briseis* (Macmillan, 1986, p.33) and the former was exhibited at the Royal Academy in 1770 (97). The last paintings in the series, *Priam pleading with Achilles for the Body of Hector,* for Lord Mountjoy, was engraved in 1775, and *Hector's Farewell to Andromache* was apparently commissioned by the Duke of Hamilton at late as 1777 (Hunterian Art Gallery, University of Glasgow) when Hamilton's monumental but increasingly two-dimensional Neo-Classical figures had lost their following in England.

After engraving a number of plates commissioned by Hamilton in Rome for his *Schola Italica* and *Iliad* series, Cunego came to England and was employed by John Boydell.

P.C.-B.

16. *Venus Lamenting the Death of Adonis*

Matthew Liart (1736–*c*.82), after **Benjamin West** (1738–1820)
ENGRAVING (in reverse): "From the Original Picture in the Collection of Sir William Young, Bart.", published 1 May 1783 by John Boydell

First published by Matthew Liart himself, 13 December 1771, his plates were acquired subsequently by John Boydell

and republished under his name. The painting, now in the Carnegie Institute, Pittsburgh, is signed and dated twice — 1768 and 1772 — as well as "Retouched 1819", and these changes are analysed in detail by Erffa & Staley (1986, p.228, no. 116). It was exhibited at the Royal Academy, 1769 (121) in its unaltered state and Liart paired the composition with *Cephalus lamenting the Death of Procris* (see cat. no. 20).

P.C.-B.

15. *The Departure of Regulus from Rome*

Valentine Green (1739–1813), after
Benjamin West (1738–1820)
Mezzotint, published 14 November 1771
by J. Boydell

In Rome, Benjamin West met Richard Dalton, George III's Librarian, and received from him an invitation to come to England, with the implied promise of royal patronage. West arrived in 1763 but it was George III's viewing of *Agrippina Landing at Brundisium with the Ashes of Germanicus,* in February 1768, and the presentation of the artist by Archbishop Drummond, which led to the commission for *Regulus.* This was the beginning of some thirty years of sustained patronage of West by George III (see Erffa & Staley, 1986, p.168, no. 10) and this large painting (88½ x 120 inches, signed and dated 1769) was displayed in the first exhibition of the Royal Academy, 1769 (120), before entering the Royal Collection. When in Rome West had been introduced to Cardinal Albani, and the painters Batoni, Mengs, Hamilton and David, and notwithstanding his preference for the Poussinesque model, West's early Classical history paintings executed during the late 1760s were in the forefront of this phase of the development of history painting in England.

An impression of Valentine Green's mezzotint was exhibited at the Society of Artists in 1772 (110). Green, from Halesowen, near Birmingham, came to London in 1765 and as a mezzotint engraver he was self-taught. However, he founded his reputation on his large plates after *Regulus* and *Hannibal Swearing Emnity to the Romans* (published 1773), before forming his very fruitful association with Reynolds from 1778. Alexander & Godfrey (1980, p.33, no. 57) observe that this is "One of the largest and most ambitious mezzotints of the 18th century, and must have presented considerable problems to the printer. Strong impressions are rarely found".

During the third quarter of the 18th century the Irish mezzotint engravers dominated the engraving of portraits, but this was challenged by the younger generation of English mezzotint engravers, above all Valentine Green, who achieved a great success with his *Experiment with an Airpump,* after Joseph Wright of Derby, published by Boydell in 1769. Later in his career Valentine Green obtained the rights to engrave the paintings in the Dusseldorf Gallery, but after the outbreak of war the scheme collapsed and he went bankrupt in 1799.

P.C.-B.

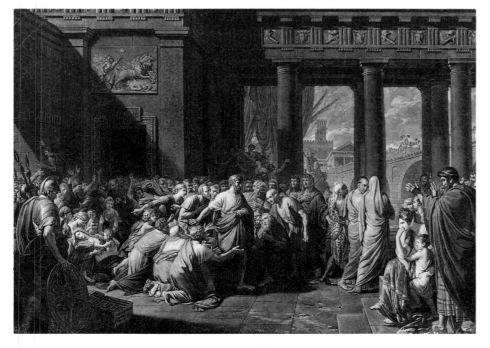

17. *The Departure for Canaan: Jacob and Rachel with the Infant Joseph*

Georger Romney
(Beckside 1734 – 1802 Kendal)
Oil on canvas, 50 x 40 inches
(12.7 x 101.5 cm)

This recently re-discovered work of George Romney is one of his rare fully-realised history pictures. We have the evidence of contemporary accounts of Romney, such as Flaxman's, that despite earning his living by portraiture, "his heart and soul were engaged in historical and ideal painting", but apart from his

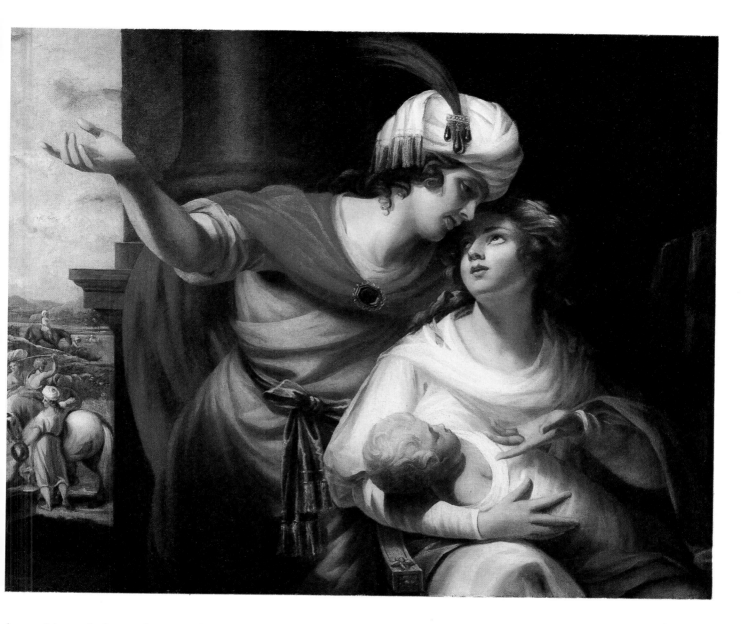

four later designs for Boydell's Shakespeare Gallery very few finished paintings survive, although a host of drawings outlining ambitious schemes do, many in the Fitzwilliam Museum, Cambridge. George Romney was born in Beckside, near Dalton-in-Furness, and received his early training from Christopher Steele in Kendal, York and Lancaster. He practised in Kendal, mainly as a portrait painter, 1757–62, but always had ambitions as a history painter, winning premiums from the Society of Arts in 1763 and 1765. The Neo-Classical elements in his style were strengthened by his visit to Italy in 1773–75 and soon after his return to London he consolidated his position as the third fashionable portrait painter, alongside Reynolds and Gainsborough. During the period 1781–91 he was besotted with Emma Hart (Lady Hamilton from 1791), painting her in an immense range of guises, but, suffering increas-

ingly from depression, he became something of a recluse with visions of a great cycle of Milton paintings.

The canvas shows Jacob, the twin brother of Esau, one of the Hebrew Patriarchs and seen by Christian theologians as a prefiguration for Christ. Jacob fell in love with Rachel, the beautiful daughter of Laban who made him work for seven years to win the hand of his kind but ugly daughter Leah and then another seven before he was allowed to marry Rachel. Their mariage was not initially fruitful and although Leah had six sons and a daughter by Jacob, and his other wives also produced offspring, it was only after a long while that a son, Joseph, was eventually born. Jacob stayed on in Laban's land in the meanwhile and was paid for husbanding his cattle by being given all of the speckled or partly-coloured sheep and cattle that were born amongst the herds. Jacob then encouraged them to breed by placing spotted branches in front of the healthier cattle whenever they went down to drink, thus encouraging by suggestion the birth of a very large number of speckled cattle. Laban's sons became so incensed at this that God told Jacob to return to his homeland, Canaan, which Jacob did, secretly, having first told his wives of his plan.

Jacob is shown in Romney's picture as a prosperous man, still young, dressed in the jewelled finery which has come from the cattle that his men are husbanding and to which he gestures while explaining their impending departure to his wife. Rachel, very much in the mould of Romney's beauties, points to their newly-born child who is still in swaddling clothes and not yet old enough to undertake a lengthy journey.

Similarities with Benjamin West's style are apparent; the vignette at left, the sweeping gesture and the confined foreground at right with its architectural backdrop are all reminiscent, whilst the brightly lit landscape at left has echoes of scenes by Jacopo Bassano.

M.J.B.

18. *The Death of General Wolfe*

William Woollett (1735–85), after
Benjamin West (1738–1820)
Line engraving with etching, 8th State with "Historical Painter to His Majesty" under West's name and "Engraver to His Majesty" under Woollett's name, published 1 January 1776 by Messrs. Woollett, Boydell and Ryland

At the Society of Artists in 1764 Edward Penny exhibited his carefully-researched *Death of General Wolfe* (1763, Ashmolean Museum, Oxford; the 1764 version is at Petworth) in which the three main protagonists are treated realistically and in a manner close to the truth, but it attracted little attention. However, the death of Major-General James Wolfe (1727–59) on the Plains of Abraham outside Quebec, at the turning point of the battle against the French which secured Canada for the British, fired imaginations, and George Romney had previously entered his *Death of Wolfe* in 1763 for the premium of 100 guineas offered by the Society of Arts for a British history painting. This was described disparagingly by a contemporary as "a coat and waistcoat piece" — i.e. the scene was depicted in contemporary dress — and the Premium was won by Robert Edge Pine with his *Canute reproving his Courtiers for their Flattery*.

Consequently much influence was brought to bear on West not to risk depicting the scene in contemporary dress, despite the success of Hayman's large contemporary history scenes at Vauxhall (see cat. no. xx), but he remained determined and by bringing together two separate strands he created a highly successful personal synthesis. Thus, compositionally, *The Death of General Wolfe* derives from traditional representations of the *Lamentation over the Dead Christ*, but by marrying a strong emphasis on realism with contemporary dress, clearly recognisable portraits and epic treatment, West was able to disregard narrow demands for verisimilitude and instead develop his personal concept of Epic Composition in which a certain

poetic licence is preferable to the dry reportage sought by Edward Penny. Nevertheless, West was clearly nervous about its reception by the public and the finished painting, signed and dated 1770, was first exhibited, that year, in his studio. The Abbé Barthélemy (*Voyage du jeune Anacharis en Grèce*, published in 1788) notes that there was an admission charge, and this precedent was subsequently cited by Jacques Louis David to justify his charging for entry to view his *Battle of the Romans and the Sabines* between 1799 and 1804 (Holt, 1979, p.6).

Exhibited at the Royal Academy in 1771 (210), George III declined to purchase it because "the dignity of the subject had been impaired by showing 'heroes in coats, breeches, and cock'd hats' " (Erffa & Staley, 1986, p.213), but the public thought otherwise and with *The Death of General Wolfe* a new chapter opens in British history painting. The composition was engraved by William Woollett and published 1 January 1776, and this proved to be enormously successful commercially, so that Boydell was later able to claim that by 1790 the profits from it had already reached £15,000. Thus, for the remainder of the century, both painters and engravers sought the magic combination of subject and treatment which would capture the imagination of the public and repeat the success of *The Death of General Wolfe*, preferably with vast profits to be earned from both entrance charges and the sale of engravings. Few achieved this goal and, with a fickle public always looking for new experiences, the synthesis achieved by West carried within it the seeds of its own destruction as public taste became increasingly jaded.

Lord Grosvenor purchased *The Death of General Wolfe* and subsequently purchased four more large paintings by West with subjects drawn from English history, which were hung together in Grosvenor House, London, until the 1820s:

1. *General Monk Receiving Charles II on the Beach at Dover* (signed and dated 1782, exhibited at Royal Academy 1783 (91), engraved by Woollett and Sharp

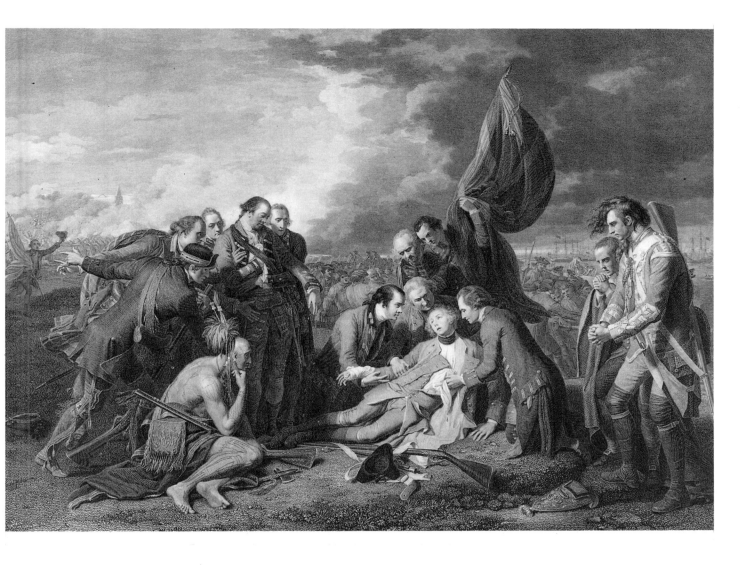

and published 5 April 1789);

2. *Oliver Cromwell Dissolving the Long Parliament* (see cat. no. 41);

3. *The Battle of the Boyne* (see cat. no. 34);

4. *The Battle of La Hogue* (see cat. no. 35).

All four canvases are of an unusual size for West and were very probably commissioned by Lord Grosvenor. Meanwhile, George III changed his mind and commissioned the first of the full-size replicas to be ordered from West.

P.C.-B.

19. *The Return of the Prodigal Son*

John Young (1755–1825) after
Benjamin West (1738–1820)
Mezzotint, trimmed inside plate mark
with loss of publication line at the
bottom [published 21 October 1789 by
John Young]

Best known as the author of the outline
engravings illustrating the catalogues of
the Stafford, Angerstein, Grosvenor,
Leicester and Miles collections, pub-
lished in the 1820s, John Young was also
a skilled mezzotint engraver and exhib-
ited a group of mezzotint portraits at the
Royal Academy in 1794. *The Return of the
Prodigal Son* is equated by Erffa & Staley
(1986, p.339, no. 321) with that exhibited
at the Royal Academy in 1771 (215) 'The
Prodigal Son Received by His Father'.
 One of three paintings made available
by West for reproduction by the
Polygraphic Society, he retained it in his
studio and the reproduction (16 x 16
inches including the frame) was exhib-
ited at the Polygraphic Society, 1788 (6).
 P.C.-B.

20. *Cephalus Lamenting the Death of Procris*

Matthew Liart (1736–*c*.1782) after
Benjamin West (1738–1820)
Engraving (in reverse), "From an
Original Picture the same size in the
Possession of B. West, Esq.", published 1
May 1783 by John Boydell

First published by Matthew Liart him-
self, 13 December 1771, this plate is taken
from the painting now in the Art
Institute of Chicago (oil on panel, 13⅜ x
16⅞ inches) which is signed and dated
1770 (Erffa & Staley, 1986, p. 242, no.
150). It may be that West intended to
make a larger version of this subject, but
the initiative in pairing this subject with
that of *Venus Lamenting the Death of
Adonis* (cat. no. 16) has to be attributed to
Liart.
 P.C.-B.

21. *Telemachus at the Court of Sparta discovered by his grief on the mention of his father's sufferings* (Odyssey, Bk. IV),

Studio of Angelica Kauffmann
(Chur 1740–1807 Rome)
(possibly **James Harvey**)

Oil on canvas, 25 x 32¼ inches
(63.5 x 82 cm)
ENGRAVED: See cat. no. 22 (W. W.
Ryland)

LITERATURE: Cf. Lady Victoria
Manners and Dr. G. C. Williamson,
*Angelica Kauffmann, R.A., Her Life and
Works,* London, 1924, pp.40 and 236

The scene shows Telemachus, the young
prince who has set out in search of his fa-
ther Odysseus. Although he has been ab-
sent for ten years and is believed by
many to be dead, Odysseus's wife,
Penelope, waits at home, unwilling to
believe the apparent truth, besieged by
an army of suitors who live off the fat of
Telemachus's inheritance. Athena visits
Telemachus, dressed as a traveller, and
tells him to go in search of his father who
is not dead, and suggests that he go and
visit Odysseus's old boon companions
who may be able to give him some clues
as to his father's whereabouts. He goes
firstly to Nestor and then, accompanied
by Nestor's son, Peisistratus, travels on
to Menelaus's court at Sparta. They are
shown into the king's hall where a ban-
quet is in progress and the two young
men marvel at the luxurious furnishings
and plate, but Menelaus tells them that
he would be happy with much less
wealth if only his dear old friends were
still alive around him, particularly
Odysseus whose memory he then
praises so eloquently that Telemachus
breaks down in tears and has to cover
his face with his cloak. At this,
Menelaus's wife, Helen, accompanied by
her ladies in waiting, guesses Tele-
machus's identity and tells her husband
who their unknown guest must be.
 Angelica Kauffmann shows the puz-
zled King Menelaus seated on this
throne at left while his queen and her at-
tendants stand at right, excited by their
discovery. The palace and its furniture
which Homer describes in careful detail
is here translated by Angelica Kauff-
mann into a Neo-Classical interior
worthy of Piranesi or Adam.
 The *Odyssey* was a favourite source for
Angelica Kauffmann who had come to
England in 1766 after considerable suc-

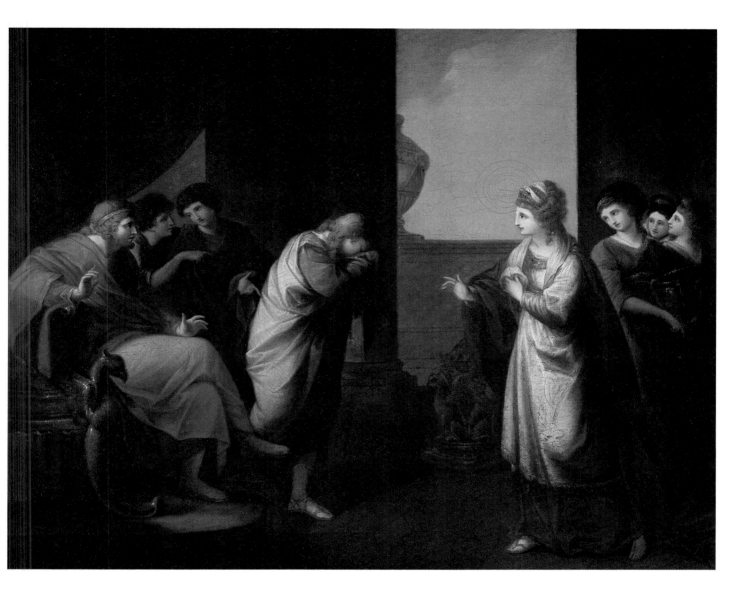

cess in Italy where she had been befriended by Winkelmann and Nathaniel Dance. She became the close friend of Reynolds after her arrival and he proposed her as a founder member of the Royal Academy. She exhibited *The Return of Telemachus* in the R.A. exhibition of 1771, and another version in that of 1775, and *Penelope invoking Minerva's Aid for the Safe Return of Telemachus* in 1774.

As well as classical history paintings, Angelica Kauffmann was involved in the abortive scheme for decorating the walls of the nave of St Paul's Cathedral with biblical subjects, and she contributed one picture to Boydell's Shakespeare Gallery: a scene from *Two Gentlemen of Verona*.

Several versions of *Telemachus at the Court of Sparta* are known and the prime version was engraved by Ryland (see cat. no. 22). The tentative attribution to James Harvey is based upon a photograph of the *Cleopatra on her Barge*, signed and dated 1789, sold at Christie's, 8 November 1963 (lot 107), see E. K. Waterhouse *Dictionary of Eighteenth Century British Painters*, Woodbridge, 1981, p.161.

M.J.B.

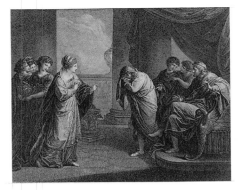

22. *Telemachus is recognised at the Court of Sparta by the Grief which overcame him on learning of the Sufferings of his Father, Odysseus*

William Wynne Ryland (1732–83)
after **Angelica Kauffmann** (1740–1807)
Stipple engraving in reverse, printed in sanguine, Proof before Title, trimmed inside the plate mark with loss of publication line at the bottom, published by W. W. Ryland 1778.

This composition by Angelica Kauffmann was also engraved in mezzotint, in the same sense as the original painting, by Thomas Burke, published 15th September 1773 by W. W. Ryland (see Boerner, 1979, nos. 94 & 110, with full bibiliography).

William Wynne Ryland was a pupil of Simon François Ravenet in England and then studied in Paris for five years under Roubillac (design) and J. P. Le Bas (engraving). With Gabriel Smith (1724–83), he introduced the French crayon manner into England and made his English debut with 57 plates for *A Collection of Prints in Imitation of Drawings*, published by Charles Rogers in 2 vols., 1762–78. Ryland was appointed Engraver to the King, and made numerous stipple engravings after Angelica Kauffmann, but he also had an extensive business as a printseller which was unsuccessful and he was hanged for forgery in 1783.

P.C.-B.

23. *Venus Anadyomene*

George Sigmund Facius and Johann Gottlieb Facius (both active in London from 1776 to after 1802), after **James Barry** (1741–1806)
Stipple engraving, oval format and sepia ink, published 1 July 1778 by John Boydell

James Barry, of humble Irish origins, was convinced that art could and should play a social and political role in the life of the community, but his quarrelsome nature, which led to his expulsion from the Royal Academy in 1799, and increasing melancholy, undermined his attempts to establish in Britiain the Grand Style in History Painting. His masterpieces are undoubtedly the complex polemical mural decorations illustrating *The Progress of Human Culture* (1777–84) which decorate the Great Room of the Royal Society of Arts, London, and *King Lear Weeping over the Body of Cordelia* (Tate Gallery) painted for Boydell's Shakespeare Gallery (completed 1787 and included in the inaugural exhibition which opened 4 May 1789).

Barry's painting of *Venus Anadyomene*

was exhibited at the Royal Academy in 1772 as 'Venus Rising from the Sea' (Hugh Lane Municipal Art Gallery of Modern Art, Dublin) to general approbation, though Horace Walpole found "the line between the heroic and the ridiculous closer than he would have liked". The most frequently engraved of all Barry's works, the entire composition was engraved in mezzotint by Valentine Green (1772), and it was through these prints that it influenced artists in both France and America (Pressly, 1983, p.54).

The Facius brothers were born in Regensburg *c*.1750, and trained as engravers in Brussels, before coming to London in 1776 to work for Boydell.

P.C.-B.

24 *The Return of the Prodigal Son*

Benjamin West P.R.A.
(1738 Springfield — London 1820)
Oil on canvas, 50 x 40 inches
(127 x 101.5 cm)
PROVENANCE: Sir James Earle, *c*.1804 ; and thence by descent
EXHIBITED: London, Royal Academy 1773 (307) ("The Prodigal Son received by his Father")
LITERATURE: Helmut von Erffa and Allen Staley *The Paintings of Benjamin West*, New Haven and London (Yale University Press), 1986, p.339, no. 322

At least two variants of this subject are recorded, including one for Dr Johnson, Bishop of Worcester, painted *c*.1767, and another exhibited at the Royal Academy in 1771 with a pendant, *Tobias Curing His Father's Blindness*. The latter is untraced, but is known from a mezzotint by John Young.

The fact that West exhibited the same subject at the Royal Academy in consecutive years implies that it had undergone a re-appraisal and that the present (1772) version is compositionally of a much higher order. The obsequious pose of the son, the glowering father and the theatrical gestures of the family seen in the earlier picture have been transformed into a graver and more intelligible

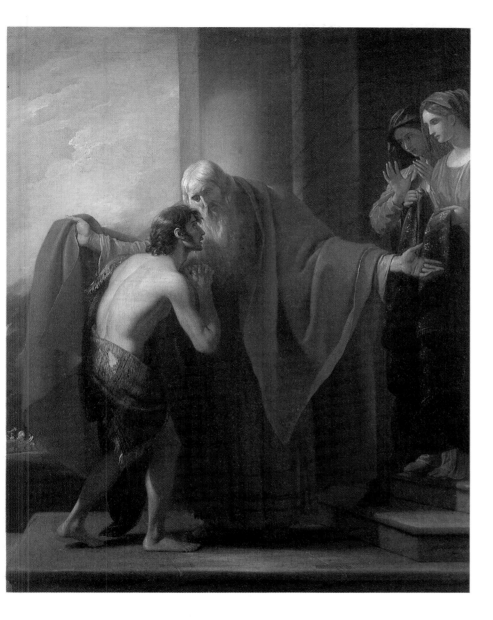

whilst the golden sunlight of a new morning and the vignette at bottom left, typical of West, showing an overseer and ploughman indicate the continued stability of money which has been, quite literally, ploughed back into the estate.

Allen Staley (op. cit) has pointed out that as an American in England during the course of the War of Independence, West's position was ambiguous and not made easier by his post as a courtier with an official appointment as History Painter to the King. His *Death of General Woolfe* (cat. no. 18) had, moreover, paved the way for the inclusion of contemporary scenes as history painting. Any overt demonstration of his feelings would have finished his career, yet many of his pictures at this time are capable of an alternative, political, interpretation of which West might not always have been consciously aware. It is worth mentioning in this context that, according to Farington, one of the reasons for West's temporary fall from Royal favour was the King's 'having been informed of his holding democratic principles'.

West painted *Saul and the Witch of Endor* (cat. no. 63) where a king learns of his impending death, defeat and the loss of his kingdom, in the same year as the Battle of Saratoga which was a humiliating defeat for the British. Similarly his illustrations of the heath scene from *King Lear* were painted at the time of George III's first mental illness. They are some of West's least Neo-Classical and most Baroque works. In 1771 he painted another picture of homecoming, *Chryseis Returned to her Father,* and it is possible that the theme of the prodigal son had a personal meaning for an exile who had taken his talents abroad, felt estranged from his country, and hoped for forgiveness. This interpretation would explain the excitable Baroque nature of the earlier version of the painting and the sustained power of the image in its later, more cogently formed variant.

M.J.B

image. The haggard son, his arrogance vanished with his inheritance, is scarcely recognised by his sisters, whilst his father's eloquent gesture, shielding his son's nakedness with his cloak held out by his right hand, and motioning his welcome with his left, implies that the past is forgotten. This sweeping gesture also serves to articulate the composition which is finely balanced. The son's abject crouch is contrasted with the pose of his sisters who are as startled and up-right as the pillar at their side. The mounting of the flight of steps implies the son's re-instatement to his former position, as does the rich cloth that one sister holds,

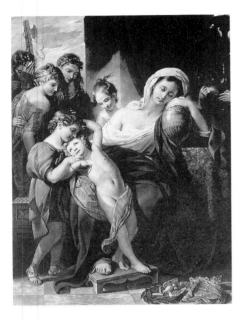

25. Agrippina, surrounded by Her Children, Weeping over the Ashes of Germanicus

Valentine Green (1739–1813), after **Benjamin West** (1738–1820)

Mezzotint, Scratched Letter Proof, published 25 July 1774 by J. Boydell as "from the picture in the possession of A. Vesey, Esq., painted in 1773"

West's depiction of Agrippina as a devoted widow is evidently inspired by Giulio Cesare Proccaccini's *Holy Family* compositions, and the painting (John and Mable Ringling Museum of Art, Sarasota, Florida) was exhibited at the Royal Academy in 1773 (303). The theme of Agrippina must have been very popular at this time because, apart from West's treatments (Erffa & Staley, 1986, pp.178-82), it was also addressed by Gavin Hamilton (Royal Academy, 1772), James Durno (Society of Artists, 1772) and Alexander Runciman (Royal Academy, 1781), as well as James Nevay (1762-72) (Macmillan, 1986, p.42).

<div align="right">P.C.-B.</div>

26. The Siege of Namur by Capt. Shandy & Corporal Trim

James Bretherton (active 1770–90) after **Henry William Bunbury** (1750–1811)

Etching with dry point, published 26 January 1773 by James Bretherton

27. The Damnation of Obadiah

James Bretherton (active 1770–90) after **Henry William Bunbury** (1750–1811) (1750–1811)

Etching with dry point, published 30 January 1773 by James Bretherton

28. The Battle of Cataplasm

James Bretherton (active 1770–90) after **Henry William Bunbury** (1750–1811) (1750–1811)

Etching with dry point, published 3 February 1773 by James Bretherton

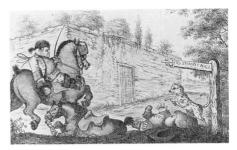

29. The Overthrow of Dr Slop

James Bretherton (active 1770–90) after **Henry William Bunbury** (1750–1811) (1750–1811)

Etching with dry point, published 3 February 1773 by James Bretherton

Henry William Bunbury was born in Mildenhall, Suffolk, 2nd son of the Rev. Sir William Bunbury, Bart., and was educated at Westminster School and Cambridge before departing on the Grand Tour and studying drawing in Rome. Always a gentleman-amateur artist with independent means, and equally at home with artists and actors as in London society, he specialised in light, often satirical subjects. Matthew Darby brought Bunbury's drawings to the attention of the public in 1771, but the following year Bunbury transferred to James Bretherton, from Cambridge, who had established himself in business at 134 New Bond Street (Riely, 1983). The collaboration with Bretherton lasted some ten years, but Bunburys drawings were from the early 1780s engraved in stipple by William Dickinson and Thomas Watson.

He exhibited at the Royal Academy, including 8 subjects from *The Arabian Nights Entertainment* (1785), and contributed 22 Shakespearean subjects to Thomas Macklin (1792–96).

Published in 1773, Bunbury's illustra-

tions to the immensely popular *Tristram Shandy*, by Laurence Sterne (1713–68), are amongst his earliest and James Bretherton's etchings convey much of the freshness of the original drawings, made in 1770, which are in the Lewis Walpole Library, Yale University, Farmington. Such literary illustrations form one of the streams of late eighteenth century narrative art in England.

P.C.-B.

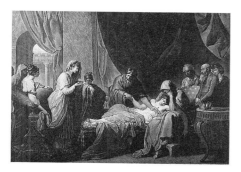

30. *Erasistratus, the Physician, discovers the Love of Antiochus for Stratonice*

Valentine Green (1739–1813), after **Benjamin West** (1738–1820)
Mezzotint, Scratched Letter Proof, published 27 May 1776 by J. Boydell as "From the Original Picture in the Possession of Lord Grosvenor"

Exhibited in the Royal Academy in 1775 (33), the painting is signed and dated 1772 and displays signifcant similarities with a lost painting by James Barry exhibited at the Royal Academy in 1774. Both recall the composition of Gavin Hamilton's *Andromache Bewailing the Death of Hector* engraved by Dominicus Cunego (1764) (Erffa & Staley, 1986, pp.169-70, no. 15)

P.C.-B.

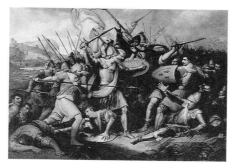

31. *The Battle of Agincourt*

Thomas Burke (1749–1815) after **John Hamilton Mortimer** (1740 –79)
Stipple engraving, published 1 November 1783 by Jane Mortimer and dedicated to Charles, Duke of Rutland

Exhibited posthumously at the Royal Academy in 1779 (203), the painting (private collection, United Kingdom) illustrates the passage in vol. 1 of Rapin's *Histoire d'Angleterre*. Mortimer was an early entrant in the field of British history painting and won the Second Premium offered by the Society of Arts in 1763 for his *Edward the Confessor spoiling his Mother at Winchester*, exhibited at the Free Society of Artists, 1763 (142). The following year he won the First Premium for his *St Paul preaching to the antient Druids in Britain* (exhibited that year at the Free Society of Artists (123); Town Hall, High Wycombe). However, during the 1770s he expanded his range of history paintings, including *King John Delivering Magna Charta to the Barons* (Society of Artists, 1776 (69); stipple engraving by W. W. Ryland published 4 May 1785) (see Nicolson, 1978, pp.28-30; Pressly, 1979, p.75).

Mortimer may have been encouraged by the example of Andrew van Rymsdyk who exhibited his *Battle of Agincourt . . . Henry V, Act IV* at the Society of Artists in 1776 (82).

A Dubliner, Thomas Burke, adopted the engraving styles of Bartolozzi and (less often) Earlom, and also engraved Mortimer's *King John*.

P.C.-B.

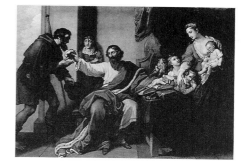

32. *Alfred the Great Dividing His Loaf with a Pilgrim*

William Sharp (1749–1824) after **Benjamin West** (1738–1820)
Engraving, published 9 November 1782 by John Boydell

Depiction of events in the early history of England was complicated by a hazy knowledge of Anglo-Saxon dress, so that West utilised a bizarre collection of garments for his *Alfred the Great*, more closely associated with contemporary theatre than the Epic Composition synthesis achieved in respect of *The Death of General Wolfe*. The painting, exhibited at the Royal Academy in 1779 (341), was presented by Boydell to the Worshipful Company of Stationers in 1779/80 and remains in its possession.

William Sharp succeeded William Woollett as the leading English line engraver and after the latter's death completed his plate of *General Monk Receiving Charles II on the Beach at Dover* (see cat. no. 18). Sharp made his reputation with the above engraving and when Copley's negotiations with Bartolozzi over the engraving of his *Siege of Gibraltar* foundered Sharp was engaged. A £2,000 fee was negotiated, with none in advance, and Copley was financially ruined when after very lengthy delays the plate was eventually completed, and he was held to that contract.

P.C.-B.

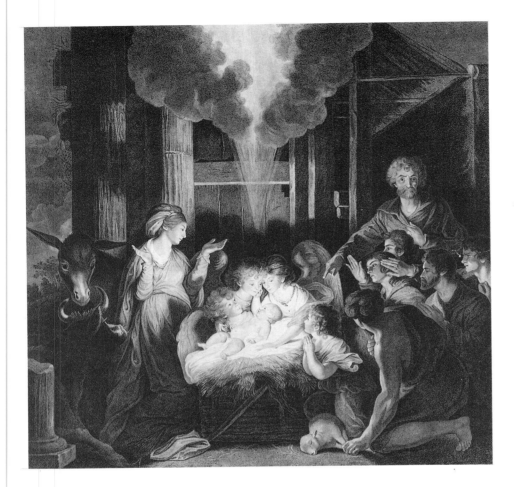

33. *The Nativity*

Georg Sigmund Facius and
Johann Gottlieb Facius
(both active in London from 1776
to after 1802), after
Joshua Reynolds (1723–92)
Stipple engraving, Proof Before Title and
publication Line [published 1785

Perhaps inspired by the example of
Brasenose College, Oxford, which had
commissioned windows painted after
designs by John Hamilton Mortimer
(complete by 1776), Reynolds was com-
missioned by New College, Oxford, in
1777, to prepare designs for a new west
window for its Gothic chapel. The com-
position was painted on glass by Thomas
Jervais (or Jarvis) from paintings in oil
provided by Reynolds and consisted of
the Nativity above, with seven Virtues
below. The completed window was
stipple engraved by Richard Earlom
(published 1785). The cartoon for the
central panel was exhibited by Reynolds
at the Royal Academy in 1779 and sold
to the Duke of Rutland for 1,200 guineas,
only to be destroyed in the Belvoir Castle
fire of 1816. This painting was reduced to
the above rectangular stipple engraving
by the Facius brothers which empha-
sized its indebtedness to Correggio's
Adoration of the Shepherds ('La Notte')
seen by Reynolds when in Italy (1750–52)
but by then in Dresden. The finished

panels of painted glass were exhibited in
London in May 1783 and installed later
that year (see Penny, 1986, p.32;
Rosenblum, 1986, pp.44–45).

P.C.-B.

34. *The Battle of the Boyne*

John Hall (1739–97) after
Benjamin West (1738–1820)
Engraving, published 18 October 1781 by
B. West, J. Hall and W. Woollett "From
the Picture in the Collection of Lord
Grosvenor"

Exhibited by West at the Royal Academy
in 1780 (58), the painting is signed and
dated 1778 and was almost certainly
commissioned by Lord Grosvenor to
take its place in the group of historical
paintings by West hung in the same
room at Grosvenor House, London, as
The Death of General Wolfe. In this West
has applied to great effect his Epic
Composition synthesis, with accurately
observed uniforms and easily recognized
portraits of individuals organised
around the central figure of William III
on a white horse, accompanied by Prince
George of Denmark and the Duke of
Ormonde.

John Hall was trained in London by
Ravenet at the same time as W. W.
Ryland and on the death of Woollett he
was appointed Historical Engraver to
George III. On this occasion he presented
to the King an impression of the above
print.

P.C.-B.

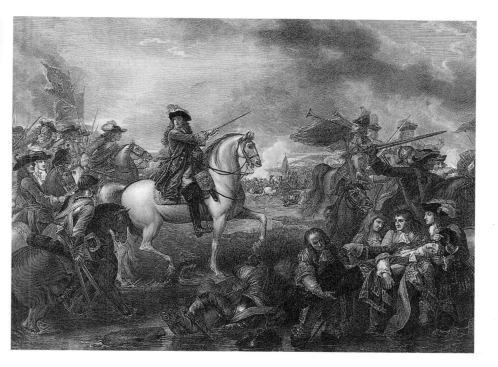

35. *The Battle of La Hogue*

William Woollett (1735–85) after
Benjamin West (1738–1820)
Engraving with etching 18th State,
published 18 October 1781 by B. West,
W. Woollett & J. Hall

Also purchased by Lord Grosvenor to be
hung with *The Death of General Wolfe* at
Grosvenor House, *The Battle of La Hogue*
was probably commissioned as a pair
with *The Battle of the Boyne*. Neither
signed nor dated, it was first exhibited in
1780 at the Royal Academy (73) as 'The
Destruction of the French Fleet at La
Hogue, 1692', but it was probably in
hand in West's studio in 1774/75. The
violence of the action is enhanced by the
wealth of realistic detail which gives this
evocation of a late seventeeth century
naval engagement the immediacy of di-
rect reportage. The relationship between
West's painting and *The Triumph of De
Ruyter in the Thames,* by Dirk Langendyk,
discussed by Dunlap (1834, I, p.89) is
summarised by Fagan (1885, p.53).
William Dunlap was working in West's
studio at the time and is a valuable
source (Erffa & Staley, 1986, pp.209-10).
For the engraving see Fagan 1885 pp. 52-
53, no. CXIV.

P.C.-B.

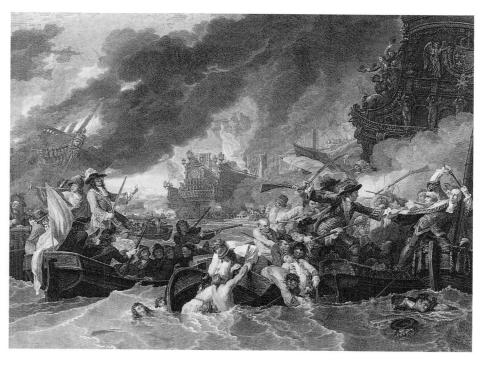

Cimon fell in love and eventually married her. The effects of love transformed the rustic Cimon, turning him into an elegant and polished gentleman. This painting bears numerous points of similarity with the illustration Stothard provided for Dryden's *Cymon and Iphigenia* in the fourth volume of Harrison's *Lady's Poetical Magazine,* published in between 1781 and 1872. On this basis our picture can be dated to *c.*1780.

Thomas Stothard was born in London, and first displayed an interest in painting during his schooling in Yorkshire. In 1769 he became an apprentice to a designer of silk brocades, where he remained for many years before entering the Royal Academy Schools in 1773. He exhibited for the first time in 1777, at the Incorporated Society of Artists, but in 1778 he first exhibited at the Royal Academy, and he continued to show his work there annually throughout his long career. Stothard was elected Associate of the Academy in 1792 and a full Academician in 1794. He produced work for Boydell's Shakespeare Gallery and for Macklin and Bowyer's Poetic and Historic Galleries.

Stothard was also a prolific book illustrator from 1779, and a designer of silver. He received a number of major commissions for interior decorative work, including the painting of the staircase at Burghley House in 1799–1803, the cupola of the Advocates Library, Edinburgh, in 1822, and the extensive mural decoration of Buckingham Palace.

M.J.B.

36. *Cimon & Iphigenia*

Thomas Stothard, R.A.
(1755 — London — 1834)
Oil on canvas, 36½ x 28½ inches
(92 x 72.4 cm)
EXHIBITED; Coral Gables, Florida, The Lowe Art Museum, 'The Art of Collecting', 22 January — 22 February 1987

LITERATURE: A. C. Coxhead *Thomas Stothard, R.A.: An Illustrated Monograph,* London, 1906, p.35-36 illustrated

The subject of this painting derives from Boccaccio's *Decameron,* v, i, as recounted by Dryden. Although of noble birth, Cimon was coarse and uncultured. Coming upon Iphigenia in the forest,

37. *The Death of Lord Chatham*

Francesco Bartolozzi (1725–1815) after
John Singleton Copley (1738–1815)
Engraving with etching, 3rd State, published 10 December 1788 by J. S. Copley

William Pitt the Elder, Earl of Chatham, was taken ill in the House of Lords during its session of 2 April 1778, but he died in his bed 11 May 1778. Thus

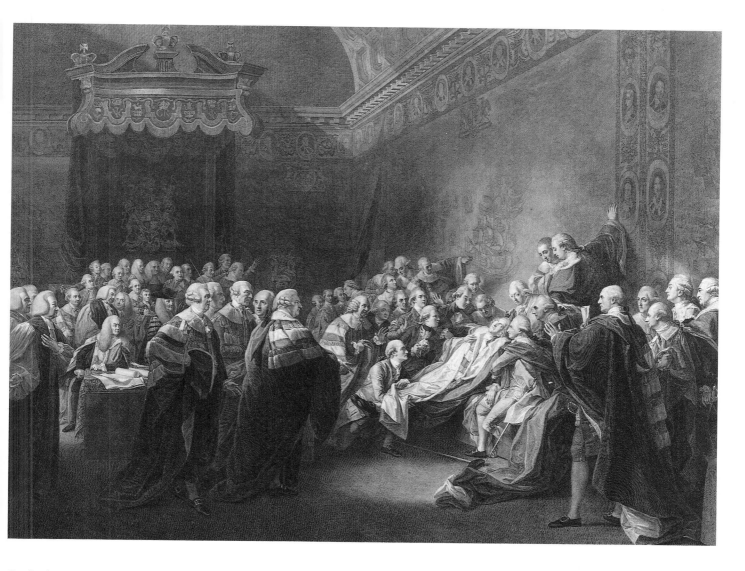

Copley's intensely dramatic and carefully observed scene does not represent a real event, though the impact is of one. Copley, with a well-developed grasp of the commercial possibilities for such an artistic *tour-de-force*, hired in 1781 the Great Room in Spring Gardens to display the painting privately and some 20,000 paid one shilling admission. As a vast narrative group portrait, as well as a dramatic scene, the large engraving was commissioned by Copley from Bartolozzi at a cost of £2,000 and the intermediate drawing was prepared by Henry Cipriani (after 1761–1820), the son of Gian Battista Cipriani. It attracted 1,720 subscribers, of which 320 were for proofs before letters, between April 1780 and August 1782. Eventually some 2,500 subscriptions were received and the profits exceeded £5,000 within a few years, mainly from the sale of these engravings. The huge painting (90 x 121 inches), executed 1779–81, was purchased by Alexander Davison for 2,000 guineas at the opening exhibition of The British Institution, in 1806, and presented by the Earl of Liverpool to the National Gallery in 1830 (transferred to the Tate Gallery, 1929). For the painting see Prown, 1966, II, pp.276-91 & 437-40, pls. 393-415, and engraving see De Vesme & Calabi, 1928, p.143, no. 538.

P.C.-B.

38. Ascension of Christ

Georg Sigmund Facius and
Johann Gottlieb Facius
(both active in London from 1776
to after 1802), after
Benjamin West (1738–1820)
Stipple engraving, trimmed to image
(published 2 January 1797 by John and
Josiah Boydell)

Royal patronage of Benjamin West began
with George III's commissioning *The
Departure of Regulus from Rome* in 1768,
but the project for decorating the Royal
Chapel at Windsor Castle was broached
in 1779. According to William Carey he
received the commission for its decora-
tion in February 1780 (Erffa & Staley,
1986, pp.577-81), and West exhibited the
first painting for it — *Christ Healing the

Sick — in 1781. *The Ascension of Christ*, in-
tended for the central position of the side
wall of the Royal Chapel, was exhibited
at the Royal Academy in 1782 (144) and
between 1781 and 1801 West completed
eighteen large paintings, with the nine-
teenth left unfinished, despite the oppo-
sition from 1796 of the architect, James
Wyatt. From 1780 West received a
stipend of £1,000 p.a. as Historical
painter to the King and the Windsor
Royal Chapel project was central to the
c.60 paintings he executed for George III.
By 1804 the project was effectively dead,
but it was not until 1828 that George IV
gave all but one of the paintings to
West's sons, including the *Ascension of
Christ* which was acquired by the Bob
Jones University, Greenville, South
Carolina, in 1963.

P.C.-B.

39. A Tale of Romance

40. A Moral Homily

John Opie R.A.
(St Agnes 1761–1807 London)
Oil on canvas, 71 x 47 inches
(180.5 x 119.4 cm) (each)

Opie had a considerable early success
with his picture *The Schoolmistress* shown
at the Royal Academy in 1784. A genre
grouping of children with an old
schoolmistress it prompted one critic to
write 'could people in vulgar life afford
to pay for pictures, Opie would be their
man'. Of course such people couldn't af-
ford paintings and rich people dislike
looking at images of paupers unless they
are made to look happy. Nonetheless,
Opie enjoyed a considerable fashionable
success with other types of painting and
the 1790s were largely taken up with a
succession of portraits and history pic-
tures. After his second marriage in 1798,
however, he returned to genre painting
and his work began to include a greater
number of female figures rendered in a
more sensitive manner than hitherto.

A Tale of Romance appears to be related
to a smaller *Ghost Story* painted some-
time after 1782 and engraved as *A
Winter's Tale* in 1785. There is evidence
that Opie worked on the present picture
at two different times, first painting the
governess seen in *A Moral Homily* as a
background figure and then removing
her, and substituting a landscape. Such
pairings of romance and morality were
not uncommon in the late eighteenth
century.

Opie's early career and training were
curious. He was discovered as an unlet-
tered youth with a passion for painting
by William Walcott ('Peter Pindar') who
trained him in the art of realistic portrai-
ture and then released him upon London
society as an untrained rural genius at a
time when noble savages were all the go.
'The Cornish Wonder' was introduced to
the King and Queen who bought two
paintings from him and he never wanted
for commissions afterwards. Despite the
febrile basis for this early success he con-

tinued to adapt and learn and his portrait style especially when dealing with children, where flattery was not essential, was unforced and full of character. He painted *The Assassination of James I* and *The Assassination of Rizzio* for Alderman Boydell who gave them to the Guildhall and these led to his election as a Royal Academician. He also contributed to Boydell's, Macklin's and Bowyer's galleries.

Opie was made Professor of Painting at the Royal Academy Schools in 1805 and his *Lectures* to the students are notably commonsensical and show a wide ranging knowledge. It is notable how like French *Têtes d'Expressions* favoured by French academicians throughout the eighteenth century are the grouped heads in these two paintings.

M.J.B.

41. *Oliver Cromwell Dissolving the Long Parliament*

John Hall (1739–1797), after
Benjamin West (1738–1820)
Engraving, published 5 April 1789 by B. West, J. Hall and E. Woollett "From the original Picture in the possession of The Right Honourable the Earl Grosvenor"

Almost certainly commissioned by Lord Grosvenor, and destined for the room in Grosvenor House arranged around *The Death of General Wolfe*, this painting (signed and dated 1782) was first exhibited at the Royal Academy in 1783 (62) as 'Oliver Cromwell ordering the mace to be taken away when he expelled the long parliament'. West here creates history with a totally convincing action, including many portraits (notwithstanding the death of Henry Ireton some eighteen months previous to the event!), and thereby an image of an event which has lost little of its potency after more than two centuries (see Erffa & Staley, 1986, pp.204-06, no. 83 for history).

P.C.-B.

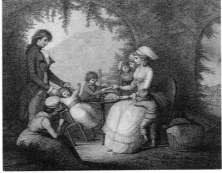

42. *Charlotte*

Francesco Bartolozzi
(1725–1815) after
Henry William Bunbury (1750–1811)
Stipple engraving, published 21 August 1783 by William Dickinson

Subtitled: "The Shade of my Mother hovers round me when in the still evening I sit on the right of her Children. I wish that she could look upon us, and see them. I kept the promise I made her

to be a Mother to them." The subject is taken from *The Sorrows of Young Werther* (1774), Goethe's early semi-autobiographical epistolary novel (*Die Leiden des jungen Werthers*). To the subsequent embarrassment of its author, this was a sensation throughout Europe and 'Wertherism' was coined to describe a man's early self-indulgent moods of melancholy. Engraved from a drawing by Bunbury, for the print see De Vesme & Calabi, 1928, p.374, no. 1415.

P.C.-B.

Stipple engraving and aquatint came into general use c.1775 and with former it was easier and quicker to obtain a reasonable quality image than it was with line engraving. It was also suitable for colour printing using the *a la poupée* technique of inking plates which had been introduced c.1760. Stipple engravings after George Morland were a huge commercial success, with some 500 pairs of *Dancing Dogs* and *Selling Guinea Pigs* sold in a few weeks. These changes encouraged the production and sale of inexpensive engravings with undemanding subjects intended to be framed and hung as decoration in modest interiors – commonly known as 'furniture prints' – most of these are based on drawings and watercolours specifically executed for the purpose, rather than oil paintings. This had long been the practice for book publishers, but was a new departure for prints issued singly.

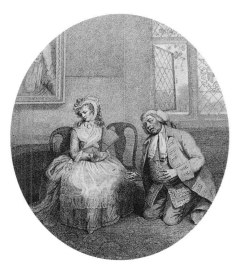

43. *Clarissa Harlowe & Solmes*

John Raphael Smith
(1752–1812) after
William Beechey (1753–1839)
Stipple engraving, published 19 April
1783 b J. R. Smith

Published in 1748–49 (8 vols.), Samuel Richardson's long epistolary novel, *Clarissa*, was much read and many artists turned to it for literary subjects with commercial potential. The scene is subtitled:

Dearest Madam, what can I say? On
my knees I beg —
And down the ungraceful wretch
dropped on his knees.
Vol: II Page 218

Included in J. R. Smith's catalogue of before 1787, it was then priced @ 3/- (Smith, 1800, no. 59).

Primarily a portrait painter, Sir William Beechey entered the Royal Academy Schools in 1774 and exhibited at the Royal Academy from 1776. He also studied under Zoffany and painted occasional fancy pictures, but during the years 1782–87 he was established in practice as a portrait painter in Norwich. Elected Royal Academician in 1798, he was knighted in the same year.

J. R. Smith was an easy-going painter,

engraver and print publisher, from Derby. Little is known about his training, though he was a superlative mezzotint engraver (active from 1769) and Mezzotint Engraver to the Prince of Wales from 1784. He gave up engraving in 1802, but before then both Girtin and J. M. W. Turner had in their early days coloured prints for his firm.

P.C.-B.

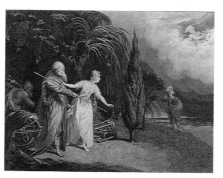

45. *Miranda*

Caroline Watson (*c.*1761–1814) after
Robert Edge Pine (*c.*1730–88)
Stipple engraving, published 1 June 1784
by John Boydell

Subtitled: What is't a Spirit?
Lord how it looks about!
believe me, Sir,
It carries a brave Form. But
'tis a Spirit.
I might call him a thing
divine.
For nothing natural, I ever
saw so noble.
Tempest/Act 1st.

46. *Ophelia*

Caroline Watson (*c.*1761–1814) after
Robert Edge Pine (*c.*1730–88)
Stipple engraving, published 1 June 1784
by John Boydell

Subtitled: There's Rue for you . . .
. . . and here's some for me,
You may wear your Rue
with a difference.
. . . I would
Give you some Violets,

But they withered all when
my Father dy'd.
Hamlet/Act 4th.

Robert Edge Pine won the top premiums from the Society of Arts in 1760 (*The Surrender of Calais to Edward the Third*, engraved by F. Aliamet and published in 1762) and 1763 (*Canute reproving his Courtiers for their Flattery*, engraved by F. Aliamet and published in 1772 with a dedication to Hugh, Duke of Northumberland). Subsequently, despite success with portraits of actors in character parts and other innovative portraits (*The President and Stewards of the Middlesex Hospital laying the Foundation Stone of the Building*, exhibited at the Free Society of Artists, 1761 (78)) he turned to more 'radical' subjects (*Earl Warren resisting the 'Quo Warranto' statute*, exhibited at the Society of Artists, 1771, Sudbury Hall).

In 1782 he held in London an exhibition of Shakespearean history paintings, but in the following year, at the end of the American War of Independence, he left to settle in the United States, though he exhibited at the Royal Academy in 1784 (378) *Lord Rodney in Action, aboard the* Formidable, *attended by his principal Officers*. The paintings exhibited in 1782 anticipated Boydell's Shakespeare Gallery, but the project was unsuccessful and presumably Pine took them to the United States since they were subsequently destroyed in a fire in Boston. The engravings by Caroline Watson are to be associated with that venture. Daughter and pupil of the engraver, James Watson, she was appointed in 1785 Engraver to Queen Caroline.

P.C.-B.

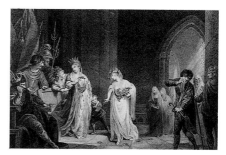

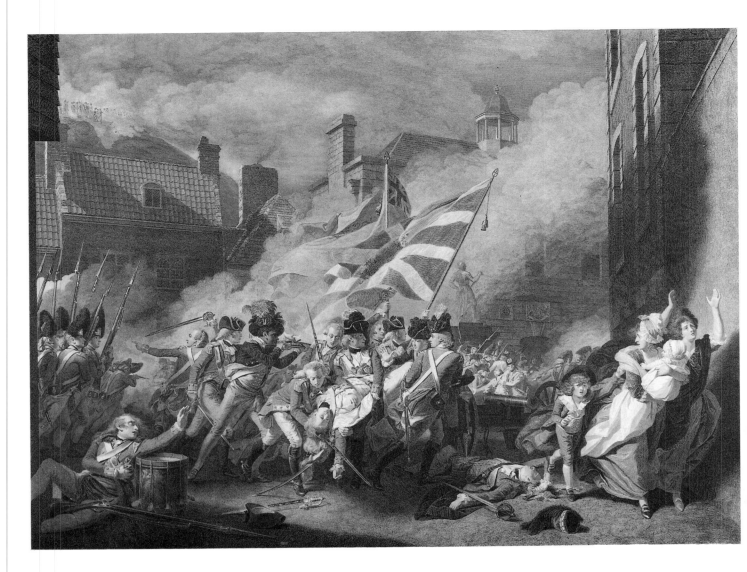

44. *The Death of Major Pierson and the Defeat of the French Troops in the Market Place of Saint Helier, in the Island of Jersey, Jan. 6, 1781*

James Heath (1757–1834) after
John Singleton Copley (1738–1815)
Engraving with etching, published 5
April 1796 by J. & J. Boydell

On 5 January 1781 some nine hundred French troops, under de Rullecourt, landed unopposed on Jersey and marched into St Helier, where the governor surrendered. The remaining British troops, billetted around the island, were assembled by the twenty-four-year-old Major Francis Pierson and attacked the French. In the ensuing battle, which took place in the Market Place of St Helier, Pierson was killed at the moment of victory, and the French forces soon afterwards capitulated. Major Pierson became a national hero and Copley's large painting (94 x 143 inches) presents a violent contemporary scene depicted with cruel realism designed to have the maximum impact on the viewer.

Commissioned by John Boydell (for £800) the painting was exhibited from 22 May 1784 at the great room, 28 Haymarket, together with *The Death of Chatham,* daily 8 a.m. to midnight, one shilling admission. Subscriptions were taken for the engraving by James Heath, and the exhibition was transferred in

August 1784 to the 2nd floor top-lit gallery in Boydell's house, Cheapside. The intermediate drawing was executed by Josiah Boydell and Heath's engraving was eventually published in 1796 (Prown, 1966, II, pp.302- 10 & 440-43, pls. 442- 63). The painting was purchased for the National Gallery in 1864 and transferred to the Tate Gallery in 1919.

James Heath had been apprenticed to Joseph Collyer and his early productions were mostly after Stothard and Smirke in *Novelist's Magazine* and Bell's *British Theatre & British Poets*. Associate Engraver of the Royal Academy in 1791, he became Engraver to the King in 1794.

P.C.-B.

47. The Parting of Hotspur and Lady Percy

William Dickinson (1746–1823) after **Henry William Bunbury** (1750–1811)
Stipple engraving with etching, published 26 June 1784 by W. Dickinson

Dedicated to Lady Williams Wynne, the elements of elegant caricature are charcteristic of the approach of Bunbury to such scenes, while the mixed costume styles reflect contemporary theatrical custom.

A Londoner, William Dickinson ob-

tained a premium from the Society of Arts in 1767 and spent most of his working career there, both as an engraver and as a print publisher, but subsequently he moved to France and died in Paris.

P.C.-B.

48. A Caricature Head, apparently of an actor playing Sir Peter Teazel

Robert Smirke R.A.
(Wigton 1753–1845 London)
Oil on canvas

Sir Peter Teazel is one of the chief characters in Sheridan's *The School for Scandal* first produced in 1777. An old man who has married a young wife, has his life made wretched by her frivolity and the fashionable society that she keeps, full of backbiting, gossiping wastrels. Added to this is his correct, if wrongly focussed, suspicion that she is having an affair with a young man. The exaggerated wig that the character in this small study wears was one which was popular with comic actors in the 1780s. Whilst not exactly guaranteed to bring the house down, it was generally worn by ineffectual and absurd comic characters. In fact, there was a cross-over between the stage and Smirke's non-theatrical illustrations. Several of his designs for book illustrations and frontispieces to novels which were never translated into plays nonetheless show the exaggerated comic expressions and dress of theatrical characters.

M.J.B.

50. Sterne conducting Maria into Moulines

James Parker (1750–1805) after **James Northcote** (1746–1831)
Stipple engraving, published 17 February 1786 by John Harris

After the revision of the first version of Volumes I and II of *Tristram Shandy*, Laurence Sterne published them in 1759 and the remaining volumes followed in 1761–67. Maria first appears in Volume IX of *Tristram Shandy*, and then in *A Sentimental Journey through France and Italy*, published in 1768.

James Northcote was born in Plymouth and, on coming to London, became resident assistant to Joshua Reynolds, 1771–75. He exhibited at the Royal Academy from 1773 but returned to Plymouth to earn from portraits sufficient to travel to Italy (1777–80). Returning again to Plymouth he worked there until 1781 when he finally settled in London. *Sterne and Maria* is listed by Gwynn, 1897, p.271, no. 186, as "Stern and Maria (small – the print by Parker)". From 1786 he was closely concerned with Boydell's Shakespeare Gallery and painted a number of his most ambitious works for it (see cat. nos. 49 & 66).

James Parker was a pupil of Basire and one of the founders, and a governor of the Society of Engravers. Employed by Boydell on the Shakespeare Gallery he engraved eleven plates.

P.C.-B.

49. *The Murder of the Princes in the Tower*

James Northcote, R.A.
(Plymouth 1746–1831 London)

Oil on canvas, 69 x 52¼ inches,
175 x 132.5 cm)
Signed on the scabbard of the murderer
in armour: 'James Northcote pinxt 1805'

PROVENANCE: Commissioned by
Samuel Whitbread and recorded at
Southill Park, by 1809; thence by descent.
EXHIBITED: Possibly British Institution,
 1806, no. 31 ('The Death of Edward IV
 in the Tower').
Museum of London, *Paintings, Politics
 and Porter, Samuel Whitbread II and
 British Art*, 1984, no. 107
LITERATURE: Stephen Gwynn:
 *Memorials of an Eighteenth Century
 Painter*, London, 1898, p.205, no. 428;
Oliver Millar: 'The Pictures' in *Southill: A
 Regency House*, 1951, pp.49-50;
c.f. Winifred H. Friedman: *Boydell's
 Shakespeare Gallery*, New York
 (Garland), 1976

The murder of the young Edward IV and
his brother Richard, Duke of York, took
place on the orders of their uncle Richard
III. The subject is taken from Act IV,
scene III of Shakespeare's *Richard III*. The
murder itself is not seen on the stage but
is described in graphic detail by Sir
James Tyrrel,
> 'The tyrannous and bloody act is
> done,/The most arch deed of
> piteous massacre/that ever yet this
> land was guilty of/Digton and
> Forrest, who I did suborn/To do
> this piece of ruthful butchery,
> /Albeit they were flesh 'd villains,
> bloody dogs,/melted with tender-
> ness and mild compassion,/wept
> like two children in their death's sad
> story./'O thus' quoth Dighton 'lay
> the gentle babes,/with their al-
> abaster innocent arms; their lips
> were four red roses on a stalk; and,
> in their summer beauty, kiss'd each
> other. A book of prayers on their
> pillow lay;/'which once', quoth
> Forrest 'almost chang'd my mind'.

Northcote's depiction of this subject is of
the greatest significance since his earlier
version, exhibited at the Royal Academy
in 1786, was sold to Alderman John
Boydell and, according to Northcote, in-
spired him to embark on the ambitious
project for a Shakespeare Gallery. The
picture was exhibited publicly in his
premises in Cheapside where it created a
sensation by virtue of its contrast of

tender innocence and dreadful villainy or, as the critic of *The Diary* put it "To the innocent beauty of character which distinguishes the work of Guido, the artist has opposed the terrific graces of Michaelangelo."

Farington praised its telling use of detail and Horace Walpole later praised it as one of the few paintings in the gallery that had come close to the impossible task of illustrating Shakespeare. The contrast of soft fabric and hard steel, gentle foreground light and awful gloom, and placid expressions and bared teeth inspired emotional sensibility in viewers such as one young German viewer who wrote "The impression left by this picture must remain unforgettable in every mother's mind".

The idea for a Shakespeare Gallery was mooted over dinner at Boydell's house a few months after the exhibition of the painting and, according to Northcote, "it seems not unlikely that this picture first suggested the scheme to their minds as it had been greatly admired". (Gwynn, 1897, pp.204 pp). The gallery which eventually extended to over 120 pictures commissioned from more than thirty artists was enthusiastically supported by Northcote, who, also contributed *Romeo and Juliet with Friar Lawrence in the Capulet's Tomb* (cat. no. 66).

Following the lottery and sale of the pictures in 1805 the earlier version entered the collection of the Earl of Egremont at Petworth. The Southill version was painted in the same year as the sale and is first recorded in the Whitbread collection in 1809, the same year that Whitbread commissioned a series of portraits from Northcote. The subject obviously appealed to Whitbread's social conscience as it vividly illustrated the unpleasant results of political tyranny, and he emphasized this by hanging it as a pendant to Gainsborough's *Good Shepherd* (after Murillo; Waterhouse, 1958, no. 1026). He is recorded as having paid £10 to Samuel Woodburn to enlarge the Gainsborough by about six inches, so that the two pictures would match each other in the drawing room at Southill.

The commission may have resulted from the fact that although Northcote was paid £42 for the original painting by Boydell in 1786, it had fetched £105 at the sale of the Boydell pictures in 1805. A compromise price at a greater sum than the original commission but less or equal to the figure achieved at auction may have been agreed between Whitbread and Northcote following the sale.

Clearly, Northcote's picture impressed Théodore Géricault who copied it during his visit to England between 1820 and 1822.

M.J.B.

51. *The Murder of James I, King of Scotland, in the Monastery of the Dominicans near Perth., on the 12th Feb. 1437*

Thomas Ryder (b.1746), after
John Opie (1761–1807)
Stipple engraving, published by John & Josiah Boydell, 1 August 1792

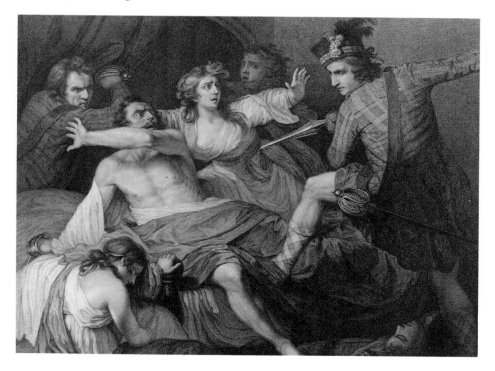

Exhibited at the Royal Academy in 1786 (96), as "James the First of Scotland, assassinated by Graham, at the instigation of his uncle, the Duke of Athol. Vide Buchanan's *History of Scotland*", the painting was bought by Boydell and, with the *Assassination of Rizzio* bought from the Royal Academy the following year, given to the Guildhall, London (both destroyed). These splendidly convincing Baroque compositions were amongst the most distinguished history paintings of their time and led to Opie's election as a Royal Academician, in 1788.

Scottish subjects were increasingly popular after the publication of William Robertson's *History of Scotland* in 1759. James Boswell, in 1765, commissioned in Rome from Gavin Hamilton *'The Abdication', Mary Queen of Scots resigning her Crown* which was exhibited at the Royal Academy in 1776 (124) and was the first public manifestation of the pictorial cult of Mary Queen of Scots (Hunterian Art Gallery, University of Glasgow).

Thomas Ryder was employed by Boydell on the engravings for the Shakespeare Gallery, for which he executed eight of the large plates.

P.C.-B.

52. *Alexander III of Scotland Saved from a Stag by Colin Fitzgerald (The Death of the Stag)*

Francesco Bartolozzi
(1725–1815) after
Benjamin West (1738–1820)

Stipple engraving, unfinished working proof with major differences of detail, trimmed to image. No lettered proofs are known to De Vesme & Calabi, 1928, I, p.135, no. 517, or Erffa & Staley, 1986, pp.190-91, no. 54, but engraved in 1788 (advice from David Alexander)

Exhibited at the Royal Academy in 1786 (148) as 'Alexander, the third, King of Scotland, rescued from the fury of a stag, by the intrepidity of Colin Fitzgerald, the ancestor of the present Mackenzie family', it had been commissioned by Francis Humberston MacKenzie (1754-1815) for 800 guineas. He was created Lord Seaforth and Baron MacKenzie of Kintail in 1797, but the huge painting (144 x 205 inches), remained in West's studio until 1821, and is now in the National Gallery of Scotland.

P.C.-B.

53. *The Attempt to Assassinate the King*

Francis Jukes (1746–1812) (etching and aquatint) and
Robert Pollard (1755–1838)
(engraving) after
Robert Smirke (1753–1845)

Open letter Proof, trimmed to plate mark
Published 9 October 1786 by Robert Pollard

Subtitled: "On the second of August 1786 Margaret Nicholson under the pretence of presenting a Petition, attempted to

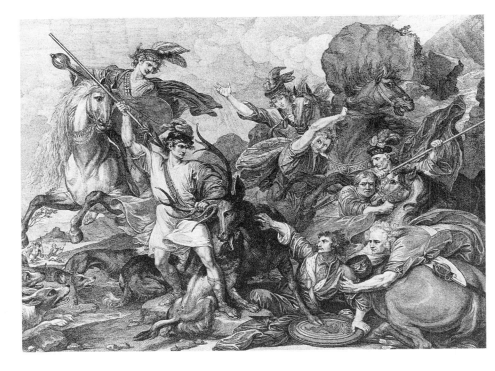

stab his Majesty as he was alighting from his Chariot at the garden entrance to St. James's Palace near Marlborough Wall, but was hapily prevented by Mr Topper one of the King's footmen and an attendant Yeoman by whom she was secured. At the same time the Sovereign with great coolness and humanity said — Don't hurt the woman — The poor Creature appears to be insane. After several examinations no doubt of her insanity remaining she was sent to Bethlem Hospital".

Apart from its significance as an attempt to portray accurately a real scene within weeks of the event having taken place, this print demonstrates how quickly the production process could respond in the mid-1780s to the commercial opportunities offered by a major event and prefigures the response to the execution of Louis XVI. The event took place 2 August 1786 and in a little over nine weeks Robert Pollard commissioned the original painting from Robert Smirke, had Francis Jukes etch the outlines and aquaint the broad areas of light and shade, and complete the engraving of the plate himself. This is in contrast to the 12 years needed by James Heath to produce his exceptionally high quality line engraving of *The Death of Major Pierson*.

Robert Smirke entered the Royal Academy Schools in 1772 and exhibited at the Society of Artists (1775–78) before exhibiting at the Royal Academy from 1786. A very active subject painter and illustrator, Smirke specialised in

theatrical scenes and literary subjects, working for both Boydell's Shakespeare Gallery and Bowyers's *History of England. The Attempt to Assassinate the King* reveals the impact of the modern history compositions of West and Copley in the move towards reportage of contemporary events, but it remained exceptional in Smirke's oeuvre.

Robert Pollard was originally a silversmith, and then a painter who received some instruction from Richard Wilson, before learning engraving, and he often worked from his own compositions. Financially unsuccessful he died in poverty and was then the last surviving member of the Incorporated Society of Artists, which had been formed in 1765.

P.C.-B.

54. *St Preux and Julia*

Francis Wheatley (1747–1801)
(designed and etched),
with aquatint by
Francis Jukes (1746–1812)
and engraving by James Hogg
(active late 18th century),
Coloured in watercolour
Published 14 June 1786 by J. R. Smith
A pair to catalogue no. 55.

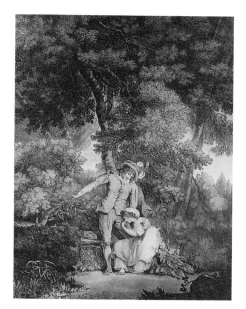

55. *Henry and Jessy*

Francis Wheatley (1747–1801)
(designed and etched),
with aquatint by
Francis Jukes (1746–1812)
and engraving by James Hogg
(active late 18th century)
Coloured in watercolour
Published 14 (corrected in pencil from 11) June 1786 by J. R. Smith
A pair to catalogue no. 54.
Subtitled: [Long?] at my feet
despanding Jessy lay
Henry, she said, by thy dear form subdu'd,
See the sad reliques of a nymph undone!
I find, I find this rising sob renew'd
I sigh in shades and sicken at the sun.

Shenstone

Included in J. R. Smith's catalogue of before 1787 they were then priced (uncoloured) @ 6/- each.

Wheatley was born in London and originally trained at Shipley's Academy, winning prizes for drawing at the Society of Arts, 1762/3. He entered the Royal Academy Schools in 1769, but was largely self-taught and after early successes settled in Dublin to escape his creditors (1779–83). However, from his return to London in 1783 he worked closely with print publishers and sellers, not least in the production of a wide range of furniture prints.

Before his stay in Ireland, Wheatley had personally executed at least three mezzotints, but after his return he etched the small plate of *Gipsies cooking their kettle* (Webster, 1970, p.57, fig. 64; p.159, no. E4), which is signed and dated 1785 on the plate. Wheatley also himself etched the plates of the pair of prints *St Preux and Julia* and *Henry and Jessy* in 1786, and his drawing for the former (British Museum, signed and dated 1785, Cummings and Staley, 1968, p.135 no.76) is identified by Webster (1970, p.59) as his first design for a furniture print after his return from Ireland. St Preux and Julia at Meillerie depicts "a celebrated scene from Rousseau's *La Nouvelle Héloise* in which sublime emotions are expressed against a background of sublime scenery", but what exactly were Wheatley's motives in choosing Henry and Jessy, from Shenstone's *Elegy* (XXVI), 'The Chase of Jessy', remain uncertain, and the nature of the contrast is heightened by the explicit subtitle.

Francis Jukes learnt aquatint from Paul Sandby (1730–1809), who had refined the technique in the mid-1770s, and contributed many plates to William Gilpin's Picturesque Tours.

P.C.-B.

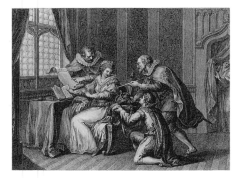

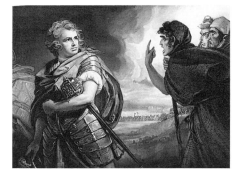

56. *The Dukes of Northumberland and Suffolk praying Lady Jane Grey to accept the Crown,* by

Francesco Bartolozzi
(1725–1815) after
Giovanni Battista Cipriani (1727–1785)

Stipple engraving, Proof Before Title, published 14 February 1786

Cipriani was born in Florence and after training in the Late Baroque style was brought by William Chambers and Joseph Wilton from Rome to England in the early 1750s where he played an important role in the development of English Neo-Classical painting. A foundation Royal Academician and close friend of Bartolozzi, Cipriani executed a number of history paintings and *Lady Jane Grey* was amongst the last. For the engraving see De Vesme & Calabi, 1928, p.139, no. 528, where the engraving is dated 1785–86, and for the pair to it, published in 1789, see cat. no. 72.

P.C.-B.

57. *Mr. Henderson in the Character of Macbeth*

John Jones (after 1740–97) after
George Romney (1734–1802)

Mezzotint and etching, First State — with artists' names in dotted letters and the rest of the inscription scratched, publication line partially trimmed away [published 19 May 1787].

John Henderson (1747–85) was one of the most popular actors of his day and rival of David Garrick. He was also a friend and fellow clubman of Romney ('The Unincreasables'), and sat for him in October and December 1780 (see Ward & Roberts, 1904, II, p.76). The painting was presumably executed in 1780, though there is a smaller replica in the Garrick Club. In Matthews's *Gallery of Theatrical Portraits* it is stated that two of the witches are portraits of Charles Macklin, the actor, and John Williams who wrote under the name of Anthony Pasquin. The painting belonged to Henderson and under the terms of his Will it was raffled amongst the surviving members of The Unincreseables, the lot falling to William Long, the surgeon. For the print see Chaloner Smith, 1878–83, no. 36, and Horne, 1891, p.47, no. 67.

For George Romney see cat. no. 17, but John Jones was a mezzotint engraver active in London who was appointed Engraver to the Prince of Wales and Engraver to the Duke of York, and like many other mezzotint engravers he turned to stipple engraving during his later years.

P.C.-B.

58. *The First Interview of Werter & Charlotte*

after **Henry William Bunbury**
(1750–1811)

Stipple engraving, Open Letter Proof before the plate was reduced, published by John Raphael Smith, 15 October 1787.

Originally published 16 October 1782 as a roundel, 12⅛ inches in diameter and priced in the pre-1787 catalogue @ 7/6 (Smith, 1787, no. 37), the composition was enlarged to the present rectangular format (according to Frankau (1902, pp. 24 & 122, no. 140) the plate measures 14 x 13¾ inches).

Subtitled: Charms that the bliss of Eden might restore
That Heaven might envy & mankind adore
I saw and oh what heart could long rebel
I saw – I lov'd – and bade the world farewell.

For the continued popularity of *The Sorrows of Young Werter* and 'Wertherism' see cat. no. 42.

P.C.-B.

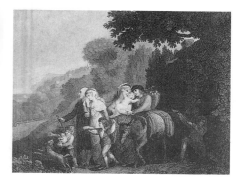

59. Le Village Abandonné

Alexandre Chapponnier
(1753–c.1824) after
John Keyse Sherwin (1751–90)
Stipple engraving with etching, published in Paris "chez Bance, Rue du petit Pont au Grand Balcon Quartier St Jacques"

Alexandre Chaponnier was born in Geneva but settled in Paris where he executed stipple engravings after Huet, Schall, Boilly and others, and copied prints by Cazenave and, here, J. K. Sherwin, whose engraving of *The Deserted Village* was published in 1787. John Keyse Sherwin was primarily an engraver, trained under Astley and Bartolozzi, but in 1772 he won the Gold Medal of the Royal Academy for his picture of *Coriolanus taking leave of his Family*. He exhibited chalk drawings at the Royal Academy (1774–80) and *The Deserted Village* (from the poem by Oliver Goldsmith published in 1770) was engraved from his own design. As an engraver, his style was closer to that of William Woollett than Bartolozzi, and after Woollett's death he was appointed Engraver to the King. Chaponnier's pirated plate would appear to have been published soon after 1787 when English prints were in great demand in continental Europe.

P.C.-B.

60. Sorrows of Werter

Jean Marie Delattre (1746–1845) after
William Hamilton (1750/51–18010
Stipple engraving, published 5 January 1788 by Ann Bryer

Subtitled:'Conrade was kneeling at Bertha's Feet — who with a timid air had given Him her Hand, whilst the Mother (Mrs. Menheil) stood before Them, and with a Look of the utmost Tenderness, bent rather forward, with her Arms extended, as if to embrace Them both in the Attitude They were then in'.
Eleanora: from the Sorrows of Werter. a Tale. Vol. 2. Pa. 133.

Jean Marie Delattre (Delâtre) was born in Abbeville and came to England in 1770. He worked under Bartolozzi and executed illustrations for Bell's *British Poets*, but he died in reduced circumstances, in Fulham, a few months before his 100th birthday. For William Hamilton see cat. no. 95.

P.C.-B.

62. Lingo and Cowslip

Edmund Scott (c.1746–c.1810),after
Henry Singleton (1766–1839)
Stipple engraving, published 1 May 1788 by J. Birchall

Subtitled: Oh cowslip the Great Old Roman
Hero's. Perhaps you never heard of Moses,
Homer, Hercules or Wat Tyler;
Vide. O'Keef's Agreable Surprise
Annotated in pencil on the bottom margin of the print "Mr Edwin" below Lingo and "Mrs. Wells" below Cowslip.

John Edwin, the elder (1749–1790) was a highly talented comic actor who began his professional career in Dublin and became established in London in the mid-1770s. There he entered into a close association with the dramatist John O'Keefe (1747–1833) who was the author of many of the comic songs for which Edwin was famous.

Henry Singleton entered the Royal Academy Schools in 1783, winning the silver and gold medals in 1784 and 1788 respectively, and exhibited at the Royal Academy, 1784–1839, a large number of scenes of literary genre. Also a talented portrait painter, his large painting of *The Royal Academicians in General Assembly under the Presidency of Benjamin West* (signed and dated 1795, Royal Academy) goes far beyond the confines of the

group portrait to create a contemporary event in the mould of Zoffany's *Royal Academicians at the Royal Academy* (1772) and *Tribuna* (both Royal Collection). Edmund Scott was a pupil of Bartolozzi.

P.C.-B.

61. *John Howard, Esq., visiting and relieving the Miseries of a Prison*

James Hogg
(active late 18th century), after
Francis Wheatley (1747–1801)
Engraving with etching, printed in colour, published 9 April 1790 by Thomas Simpson and James Hogg

Signed and dated 1787, the painting (Earl of Harrowby) was exhibited at the Royal Academy in 1788 (31) and depicts the famous prison reformer visiting an old man in prison surrounded by his family. The impact of Greuze on Wheatley's depiction of him and the range of emotions displayed by the various members of his family is clear and much of Wheatley's later work is pervaded by the influence of Greuze. The exact purpose of the painting is unclear, but the search for new subject matter and a taste for sentimentality encouraged exploitation of the philanthropic genre. Furthermore, acclaimed as a particularly good likeness of Mr. Howard, who allegedly refused to sit for a portrait, this could not but improve the commercial prospects of an engraving of a 'difficult' subject (Webster, 1970, p.68 & pp.135-36, no. 57, and, for the engraving, p.169, no. E68).

P.C.-B.

63. *Saul and the Witch of Endor*

William Sharp (1749–1824) after
Benjamin West (1738–1820)
Engraving, Proof Before Title, [published by J. & J. Boydell, 1788], some restoration

The painting of *Saul and the Witch of Endor,* signed and dated 1777, was never exhibited by West, though it was engraved three times. Erffa & Staley (1986,

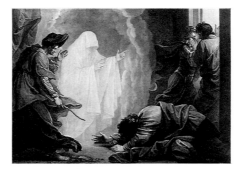

p.312) quote Baker, 1875, p.42, who states that the Second State of the above engraving was published in 1788. This would appear to be the date at which this very striking dramatic image first became known. Sharp engraved it again, in 1800, for Macklin's *Bible,* for which he was paid £400.

P.C.-B.

64. *Jacob and Rachel*

William Nutter (1754–1802) after
Benjamin West (1738–1820)
Stipple engraving, Proof Before Title, published 1 January 1803 by Benjamin Beale Evans

Erffa & Staley (1986, p.293, no. 247) draw attention to the considerable confusion between the different versions of *Jacob and Rachel* by West, and that he never exhibited any painting with this title. The present state of the engraving, with the 1803 publication line, was apparently unknown to Erffa & Staley, but it fits well with the painting of *Jacob drawing water at the well for Rachel and her flock* in *Public Characters* and the other early lists of West's works, and may thus represent the painting sold by Noel Desenfans in 1786 which was reproduced by the Polygraphic Society *c.*1788 (12) and in the possession of Mrs. Evans by 1804

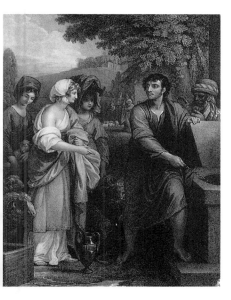

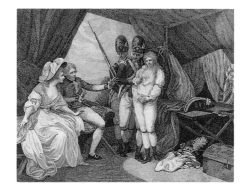

(Erffa & Staley, pp. 293-94, no. 248). The location of the painting is unknown, and Erffa & Staley reproduce the stipple engraving printed in colours and published by Rudolph Ackermann in January 1825, also engraved by William Nutter. On the basis of that print they tentatively date the painting to the 1760s, but there is no evidence of its composition becoming known before c.1788 via the Polygraphic Society (see also cat. no. 19).

P.C.-B.

65. *Amyntor & Theodora*

Peltro William Tomkins
(1760–1840) after
Thomas Stothard (1755–1834)
Stipple engraving, published 12 April
1796 by Thomas Macklin
Sub-title: 'Vide Mallet'

Stothard's paintijng of *Amyntor and Theodora*, illustrating David Mallet's poem for Macklin's Poets Gallery, was exhibited there in 1788, when a reviewer observed: 'This representation is at the point of time when Amyntor first views his beloved Theodora, after she is landed from the skiff. It is painted by Mr. Stothard, who by the performance, has shown himself an artist of great merit. The languid state of Theodora, Amyntor's surprise, and the characteristic manner of the group of islanders, are all beautifully expressed. In the composition of the piece, there is considerable skill and genius.' See Bennett, 1988, p.22.

Thomas Macklin began his career as a cabin boy, before training as a gilder of picture frames and then entering business as a print and picture dealer. He opened his Poets Gallery in Pall Mall in 1787/88 which combined publishing with a permanent display. He commissioned 100 pictures for engraving and, published in parts, issued to subscribers at the rate of two a year, with each part containing four prints (each with an extract of the author represented) the published *Poets Gallery* was very successful, and the *Illustrated Bible* was added from 1790 (published 1791–1800). Macklin died in 1800 and the Gallery closed soon afterwards.

P.C.-B.

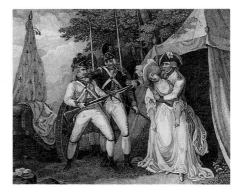

67. *Clara attempts the Life of Marianne*

R. Stanier after
Francis Wheatley (1747–1801)
Stipple engraving, published 12
February 1789 by E. M. Diemar

P.C.-B.

68. *The Identity of Clara Revealed*

R. Stanier after
Francis Wheatley (1747–1801)
Stipple engraving, published 12
February 1789 by E. M. Diemar

These scenes are from *Linda and Clara, or the British Officer* (Act V, Scene VI), by James Fennel (1766–1816). Fennell's career, as an actor, began in Edinburgh in 1787 and he came to London in 1791. He then acted at Richmond where he brought out his *Linda and Clara*, a comedy in three acts, subsequently enlarge to five. This he published in 1791, but in 1792 he emigrated to the United States of America where he met with considerably greater success (*D.N.B.*). Nevertheless, in these scenes, Wheatley catches well the humour and vivacity of the play. The present whereabouts of the original paintings is not known, but for the engravings see Webster, 1970, p.191, nos. E192 & E193, under 'Undated Engravings after Francis Wheatley', as 'Lindor'.

P.C.-B.

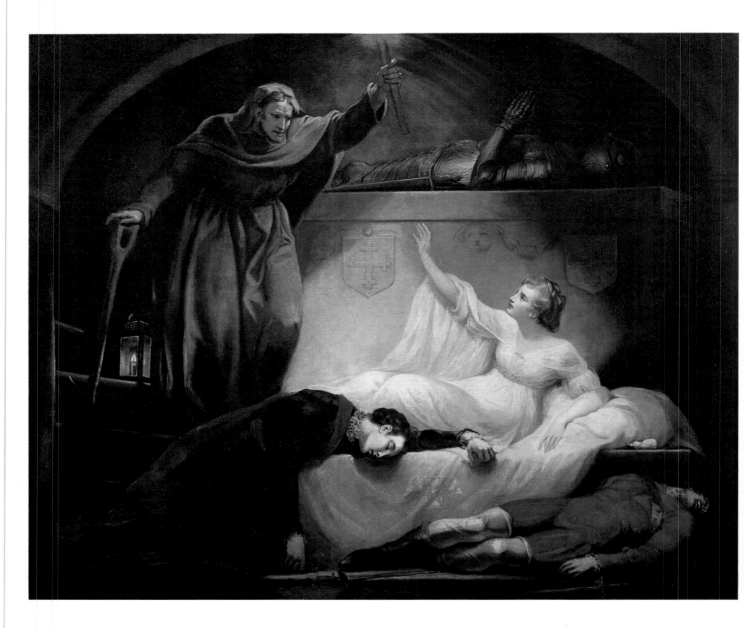

66. *A Monument Belonging to the Capulets, Romeo and Paris dead; Juliet and Friar Lawrence*

James Northcote R.A.
(Plymouth 1746–1831 London)
Oil on canvas, 108½ x 132 inches
(276 x 335 cm)

PROVENANCE: Boydell's Shakespeare Gallery;
Christie's, Boydell Gallery sale, Third Day, 20 May, 1805, lot 51, , sold to G. Stainforth Esq. for £210
Northbrook Collection, Stratton Park sale, 27th Nov., 1929, lot 492
LITERATURE: Stephen Gwynn,

Memories of an Eighteenth Century Painter, London, 1898, p.273, no. 254, under 'Pictures Painted in the Year 1789' — 'Last Scene in 'Romeo and Juliet' (Shakespeare for Boydell — print by Simon)'
Winifred H. Friedman, *Boydell's Shakespeare Gallery'*, New York

(Garland)

cf. Robin Hamlyn, 'An Irish Shakespeare Gallery', *Burlington Magazine*, CXX , August 1978, pp.514-529

ENGRAVED: Heath
P. Simon

The scene depicted is the final tragic denouement of Shakespeare's *Romeo and Juliet*. Romeo and Juliet, the star-crossed lovers from feuding families are secretly married by Friar Lawrence. Romeo is then banished from Verona for killing Tybalt in a fight that was not of his making and leaves for Mantua. Friar Lawrence promises to reveal their marriage at an opportune moment but Juliet is pressured by her father to marry Count Paris. She consults the Friar who advises her to consent to the marriage but to swallow a potion on the eve of the wedding which will make her appear dead. He will warn Romeo to come to the Capulet's tomb and take her to Mantua when she wakes. The Friar's message to Romeo miscarries and he believes her dead.

Buying poison he comes to the vault to have a last sight of Juliet. He chances upon Count Paris outside the tomb whereupon they fight and Paris is killed. Romeo then kisses Juliet for the last time, drinks the poison and dies. Juliet awakens and seeing Romeo dead guesses what has happened, stabs herself, and dies.

Northcote's depiction shows the moment at which Juliet first awakens.

Juliet: O comfortable friar! Where is my Lord?/I do remember well where I should be,/And there I am. Where is my Romeo?

Friar Lawrence: I hear some noise. Lady come from that nest/of death, contagion and unnatural sleep;/A greater power than we can contradict/Hath thwarted our intents./come, come away;/thy husband in thy bosom there lies dead;/And Paris too. come, I'll dispose of thee/Among a sisterhood of holy nuns./Stay not to question, for the watch is coming;/come, go, good Juliet, I dare no longer stay.

Juliet: Go, get thee hence, for I will not away.

(Exit Friar Lawrence)

As Friedman has pointed out (op.cit.) the fragile and wistful elements of the depiction are in keeping with contemporary accounts of the staging of the play. Certainly, the scene with its plaintive central character and softly tragic air contrasted well with the harsh qualities of Northcote's *The Murder of the Princes in the Tower* (cat. no. 49) which also hung in Boydell's Shakespeare Gallery.

Northcote had a difficult start as a portraitist after leaving Reynold's studio and so: "I betook myself from necessity to painting small historical and fancy subjects from the most popular authors of the day, as such subjects are sure of sale amongst the minor print dealers." This hack work must have been demeaning for Northcote, having graduated from Reynold's high-minded household where conversation revolved around the great Italian masters, but it taught him the essentials of making his paintings accessible to the public. "Those who look at exhibited pictures", he later wrote "are generally persons who, at the time, merely seek amusement and will not subject themselves to any trouble; if they can comprehend the subject at first sight well and good; if not, they will pass on to another picture. It is therefore necessary to mark the story distinctly, to have a fine effect of light and shade, and everything that facilitates their seeing and comprehending the picture".

The great size of the present picture, with its life-sized figures and horizontal format, helped to give the effect of a contemporary stage, and in an age of panoramas, dioramas, et al, a sense of immediacy was highly desirable. In Woodmason's later Irish Shakespeare Gallery the contributing artists were limited to a standardised upright canvas size of 5' 6" x 4' 6" which caused Fuseli, amongst others, to complain that the potential for realising his ideas was severely limited as a result. Boydell's venture was altogether more generous; not only did he offer Reynolds as much money as he wanted for his first canvas for the Gallery in order to ensure his involvement in the project,but he appears not to have set any limit on the size of the larger canvases.

Clearly the effect, coupled with Northcote's avowed aim to "fix the subject'" worked. The critic of the *Public Advertiser* noted of Northcote's Boydell pictures (paraphrasing George II's comment upon Pitt) "I like to talk to that man, for he makes me understand him" and went on to say "for English history he has given us English pictures, marked with that energetic aim . . . that Baronial hardihood."

Northcote called the time spent painting for Boydell's Gallery "The golden age of my life" and said to Ward that "that singular and bold undertaking came at exactly the right time for me". Boydell enabled him to leave behind his earlier catchpenny work and was: "that true patron, for though he only employed me as one tradesman does another in the way of business, yet he enabled me to do something which I never could have done but for him." Three plates were engraved after the painting. The large plate by Heath was found inadequate by Boydell although his small plate was published, and a woebegone thing it is. A replacement for the large plate was commissioned from Simon. Even at this late date in his commercial activity, Boydell, who had trained up a school of English engravers, found it hard to recruit a sufficient number of craftsmen adequate to the task, and it is interesting to see that although Northcote was paid £210 for his painting, Simon received £315 for the plate.

At the sale of the Shakespeare Gallery, organised by Christie's following Boydell's lottery, the picture was again bought for £210, making it more expensive than any of those by Fuseli and the most valuable single item after three of Reynolds' four paintings and Smirke's set of pictures, *The Seven Ages of Man*.

M.J.B.

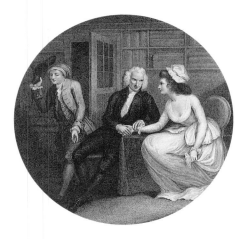

69. *Sterne in the Glove Shop*

James Parker (1750–1805) after
James Northcote (1746–1831)

Stipple engraving, Proof Before Title and
Publication Line, annotated close to
bottom margin of print "London
Published by John Harris 1789 London
(sic)"

Taken from the painting listed by
Gwynn under 1784 (1897, p.271, no. 192)
as "Stern in the Glove Shop (small— the
print by Parker)", the subject is derived
from Laurence Sterne: *A Sentimental
Journey through France and Italy*, pub-
lished in 1768, and the engraving was
published as a pair to *Stern conducting
Maria into Moulines* (cat. no. 50).

P.C.-B.

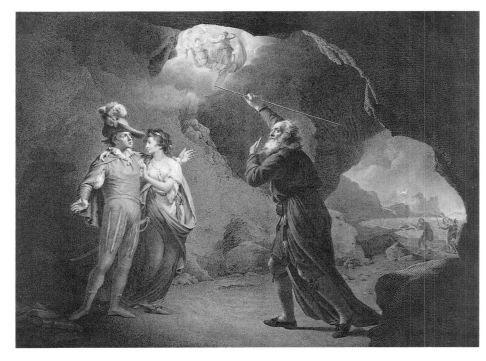

70. *Ferdinand and Miranda in Prospero's Cell*

Robert Thew (1758–1802) after
Joseph Wright (of Derby)(1734–97)

Stipple engraving, 2nd State, published
4 June 1800 by J. & J. Boydell.

Purchased by Boydell for the
Shakespeare Gallery in September 1789
for 300 guineas (Nicolson, 1968, p.245,
no. 233) the painting was sold from the
Shakespeare Gallery, Second Day's Sale,
18 May 1805 lot 55, to the Earl of
Balcarres for 66 guineas. It remained in
the Crawford Collection until sold from
Haigh in November 1946, but its present
whereabouts are unknown. The very
large size — 102 x 144 inches — indicates
that it was painted at least with the
Shakespeare Gallery in mind, and it was
displayed at the opening exhibition, al-
though Wright had quarrelled with
Boydell in 1786 concerning his contribu-
tions.

Boydell rejected Wright's *Romeo &*

Juliet (Royal Academy, 1790 (1); 70 x 95
inches, partly repainted during the
winter of 1790/91 and displayed at the
Society of Arts, 1791 (220)), while his
*Antigonus in the Storm, from The Winter's
Tale* (Act III, Scene 3) was purchased by
Boydell for his Shakespeare Gallery, by
means of a ruse, for £126. This large
painting, c.70 x 95 inches, had also been
exhibited at the Royal Academy in 1790
(221) and partly repainted during the
winter of 1790/91. It was exhibited at the
Society of Arts in 1791 (219) before being
engraved by Samuel Middiman (for 300
guineas, published 4 June 1794). The pre-
sent whereabouts of this version is un-
known (for these paintings see Nicolson,
1968, p.245, nos. 219 & 220).

Robert Thew was a serving soldier
until 1783, but trained in Hull as an en-
graver; he was taken into the employ-
ment of John Boydell to work on the
Shakespeare Gallery and was appointed
Engraver to the Prince of Wales.

P.C.-B.

86

71. *The Dead Soldier*

James Heath (1757–1834) after
Joseph Wright (of Derby) (1734–97)
Line engraving with etching, 4th State —
Open Letter Proof with publication line
altered to: "Published April 4: 1797, by
James Heath, . . ."

Exhibited at the Royal Academy in 1789
(236), James Heath successfully obtained
the rights to engrave it. The painting was
in the possession of John Leigh Philips
by 4 May 1797 when the 6th State was
published, and most of the work on this
large plate (image 430 x 594 mm. and ad-
vertised in July 1795 as the same size as
The Death of General Wolfe (430 x 599
mm.) was undertaken 1795–97. The pre-
sent whereabouts of this painting is un-
known, but see Nicolson, 1968, p.246, no.
238) and for the engraving see Clayton,
1990, pp. 254-55, no. P39.

P.C.-B.

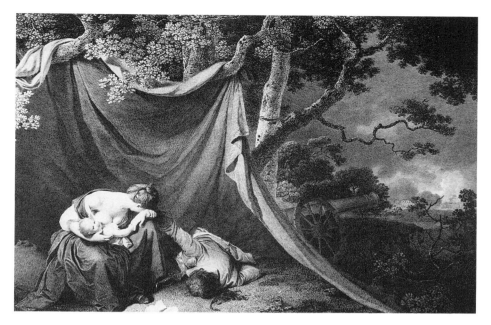

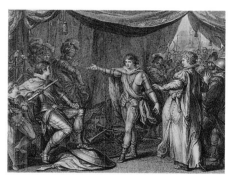

72. *The Heroism of Prince Edward son of Henry VIth*

Francesco Bartolozzi (1725–1815) after
Giovanni Battista Cipriani (1727–85)
Stipple engraving, Open Letter Proof
before Sub-Title (except "Vide Repins
History Anno 1453"), published by
James Birchall 4 June 1789

Painted at the end of Cipriani's life, this
scene from English history was engraved
by Bartolozzi as a pair to Cipriani's
*Dukes of Northumberland and Suffolk
praying Lady Jane Grey to accept the Crown*

published by W. Palmer in 1786 (see cat.
no. 56). By the end of the 1780s these his-
torical furniture prints were being pub-
lished in some numbers to cash in on the
market being developed so vigorously
by Boydell and others. For the engraving
see De Vesme & Calabi, 1928, p.137, no.
524.

P.C.-B.

73. *Choir of St Paul's, on the Day of Solemn Thanksgiving for the Recovery of His Majesty, April 23, 1789*

Robert Pollard (1755–1838) after
Edward Dayes (1763–1804)
Etching and aquatint, lacking publication
line.

The watercolour painter, Edward Dayes,
first exhibited at the Royal Academy in
1786 and his topographical drawings
rank amongst the best before the emer-
gence of Girtin (his pupil) and J. M. W.
Turner in the mid–1790s. He was also a
mezzotint engraver and appreciated the
commercial advantages to be reaped
from the rapid publication of accurate
representations of contemporary events.
Robert Pollard had collaborated with

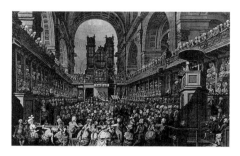

Robert Smirke and Francis Jukes to pro-
duce in 1786 *The Attempt to Assassinate
the King* (cat. no. xx).

This print is to be associated with the
drawing Dayes exhibited at the Society
of Artists, 1791 (61) depicting "Their
Majesties at St. Paul's", unless the latter
is for the engraving – *Celebration of the
Recovery of George III* – by James Neagle,
after Edward Dayes, published 1793
(Stevenson, 1976, p.43, fig. 78).

P.C.-B.

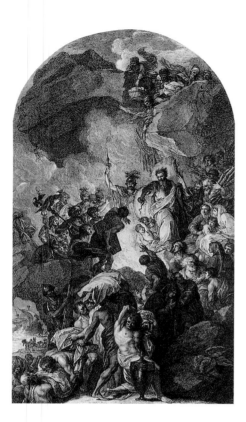

tion focussing on the central fire is controlled by the X-disposition of the main masses of figures, probably suggested by Tintoretto's *Brazen Serpent* in the Scuola di San Rocco. For the engraving see De Vesme & Calabi, 1928, p.59, no. 279.

<div style="text-align: right">P.C.-B.</div>

74. *St Paul Shaking the Viper from his Hand after the Shipwreck*

Francesco Bartolozzi
(1725–18150 after
Benjamin West (1738–1820)
Engraving and etching, Proof Before Letters ("Published as the Act directs Sept.er the 17 1790" in etched letter)

Altarpiece of the Chapel of St Peter and St Paul at the Royal Naval College, Greenwich, the painting was commissioned c.1782 and installed in 1789 (Erffa & Staley, 1986, pp.384-85, no. 397, signed and dated 1789). The commission was originally given to J. S. Copley, but contemporaries believed that it was transferred to West through the intervention of George III, and it is the only major oil painting by West (300 x 168 inches) to remain in the position for which it was painted. The dynamic, Baroque composi-

75. *Vicar of Wakefield, Olivia's Return to her Father*

Charles Gauthier Playter
(active 1780s — died 1809) after
Thomas Stothard (1755–1834)
Stipple engraving, published
1 September 1789 by J. & J. Boydell

Extensive quotation as Sub-Title concluding "Vide Dr. Goldsmith's Vicar of Wakefield. Vol II. Chap III."

The oil painting, as by Henry Singleton, but with the subject correctly identified, passed through the hands of D. Heinemann, Munich (photo in Witt Library), and this engraving appears to be en suite with *Vicar of Wakefield, Young Thornhill's First Interview*, engraved by Simon and published by the Boydells, 1787. Stothard contributed 6 illustrations to the 1792 edition of *The Vicar of Wakefield*, published by E. Harding & J. Good (Bennett, 1988, p.70).

<div style="text-align: right">P.C.-B.</div>

76. *Prospero, Miranda and Caliban (Shakespeare, Tempest, Act I, Scene II)*

Pierre Simon II (before 1750–c.1810) after
Henry Fuseli (1741–1825)
Stipple engraving, published 20 September 1797 by J. & J. Boydell.
Sub-Title: Quotation from speech by Prospero

Prospero, Miranda and Caliban was the first of the nine paintings Fuseli executed for Boydell's Shakespeare Gallery and according to a letter from him to William Roscoe, 25 November 1789, this large painting (c.96 x c.138 inches) was complete by then. Sold in the Shakespeare Gallery Sale, Third Day, 20 May 1805, lot 41, to John Green (21 guineas), the painting was subsequently cut up and the half-length fragment of *Prospero* (29 x 19¾ inches) was purchased by the York City Art Gallery in 1950 (Schiff & Viotto, 1977, p.92, no. 67).

As the apostle of *Sturm und Drang* in England, Fuseli endeavoured to introduce its wildness and rejection of conventions into English history painting. Notwithstanding his intellectual stature, he remained an isolated figure in English painting, though his contributions to Boydell's Shakespeare Gallery are amongst the most distinguished paintings executed for it.

Pierre Simon II engraved plates for Worlidge's *Antique Gems* and twelve for Boydell's *Shakespeare Gallery*. The second and third paintings contributed by Fuseli to the Shakespeare Gallery were *Titania and Bottom in the Wood, from the*

Midsummer Night's Dream (Tate Gallery, 85 x 108 inches) and *Titania and Oberon (Titania's Awakening)* (Kunstmuseum, Winterthur, 87½ x 110 inches). These were lots 38 and 40 in the Second Day of the Shakespeare Gallery Sale and both were purchased by the Marquess of Buckingham, for 53 guineas and 52 guineas respectively.

Second son of Johann Caspar Füssli the Elder (1706–82), who was a painter and writer on art as well as town clerk of Zurich, and godson of the painter Salomon Gessner, Johann Heinrich (Henry) grew up in an intensely artistic environment and as a boy assisted his father with his art historical writings. However, Johann Caspar wished him to study to became a Zwinglian minister and he was duly ordained at the age of twenty in 1761. During these formative years he studied widely under the guidance of Johann Jakob Bodmer and Johann Jakob Breitinger, including Homer, Dante, Shakespeare, Milton and the Nibelungenlied, and later, in 1766, he was to meet Jean-Jacques Rousseau and David Hume in Paris.

Coming to London in 1764, he translated Winckelmann into English — *Reflections on the Paintings and Sculptures of the Greeks* (published 1765)— with little response, and his *Remarks on the Writings and Conduct of J. J. Rousseau*, published in 1767, was almost totally ignored. However, he began then to take a closer interest in Shakespeare and from these early years in London dates his drawing of *Garrick as Duke of Gloucester Waiting for Lady Anne at the Funeral Procession of her Father-in-Law, King Henry VI* (Kunsthaus, Zurich), signed and dated 1766, illustrating *King Richard III*, Act I, Scene 2 (Schiff, 1975, pp.69-70, no. 43). In 1768 he met Sir Joshua Reynolds and on the strength of such drawings he was encouraged by him to become a professional painter. To this end he left for Italy early in 1770 and in Rome he rapidly became a key artistic personality whose activities were reported to the German *Sturm und Drang* artists and writers by Johann Caspar Lavater.

In a letter from Lavater to Johann Gottfried Herder, dated 4 February 1774, reference is made to sixteen paintings of Shakespearean subjects already executed by him in Rome. One of these may have been the painting of *Hubert yielding to the entreaties of Prince Arthur. From Shakespeare's Tragedy of King John* which he exhibited at the Society of Artists in 1775 (86) with which can also be associated the drawing of the same subject in the British Museum (Schiff, 1975, pp.71-72, no. 48).

After a brief stay in Zurich, 1778–79, he returned to London where he rapidly made a name for himself in both intellectual and artistic circles (his first major artistic success being *The Nightmare*, exhibited at the Royal Academy, 1781. Thus from the early 1780s Henry Fuseli was the artist of greatest intellectual stature working in England and it is not surprising that he was,(with Romney, West and Paul Sandby) one of the artists invited in November 1786 by John Boydell, then Lord Mayor of London, to the dinner at which the Shakespeare Gallery project was launched.

From his return to London in 1779/80, Fuseli gained, in addition to the circle of radical intellectuals around the bookseller and publisher Joseph Johnson, a group of more conservative patrons. The latter included the bankers Thomas Coutts and William Roscoe, and the art collector William Lock of Norbury. Fuseli's work for the Shakespeare Gallery also revived his earlier ambitions, since towards the end of his stay in Rome (1777–78) he had conceived the idea of a great complex of Shakespearian frescoes which consciously took as their point of departure Michelangelo's Sistine ceiling (four drawings in the British Museum; see Schiff, 1975, pp. 72-73, nos. 50-53). the inclusion of Fuseli in Boydell's dinner, and the scale of his subsequent participation, are evidence in favour of the view that Fuseli had played a crucial role in the genesis of the project. Between 1786 and the opening of the first exhibition of the Shakespeare Gallery, in 1789, Fuseli's energies were primarily directed at the production of the nine paintings commissioned from

him, but in 1790, with financial support from Roscoe and others, he embarked on his independent Milton Gallery.

P.C.-B.

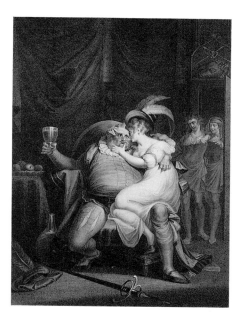

78. *Falstaff, Doll Tearsheet, Prince and Poins, at the Boar's Head, in Eastcheap (Shakespeare, Second Part of King Henry the Fourth, Act II, Scene IV)*
William S. Leney
(active 1790–after 1808) after
Henry Fuseli (1741–1825)
Stipple engraving, published 25 March 1795 by J. & J. Boydell

Painting No. 5 contributed by Fuseli to the Shakespeare Gallery (1785–90) (Schiff & Viotto, 1977, p.90, no. 43) and sold in the Shakespeare Gallery Sale, Second Day, 18 May 1805, lot 14, to W. Lygon, M.P. (15½ guineas). The composition is only known from the above engraving by William Leney who was a pupil of Tomkins and undertook a number of plates for the Shakespeare Gallery before emigrating to the United States of America. There he engraved banknotes, but by 1808 he was farming near

Montreal. The composition derives from a drawing of the same subject executed in Rome in 1771, now in the Kunsthaus, Zurich (Schiff, 1975, pp.70-71, no. 45).

P.C.-B.

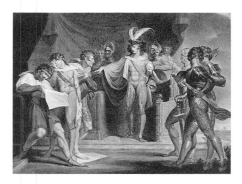

79. *Henry V condemns to death Cambridge, Scrope and Grey (Shakespeare, King Henry the Fifth, Act II, Scene II)*

Robert P. Thew (1758–1802) after **Henry Fuseli** (1741–1825)

Stipple engraving, open letter proof published 1 December 1798 by J. & J. Boydell

Sub-Title: Quotation from speech by King

Painting No. 6 contributed by Fuseli to the Shakespeare Gallery (1786–89) and sold in the Shakespeare Gallery Sale, First Day, 17 May 1805, lot 16, to John Green (8½ guineas), present whereabout unknown. A smaller version (48 x 61 inches), possibly a modello for the above, is in the Shakespeare Memorial Theatre Picture Gallery and Museum, Stratford-upon-Avon (Schiff & Viotto, 1977, pp.90-91, nos. 44 & 45).

P.C.-B.

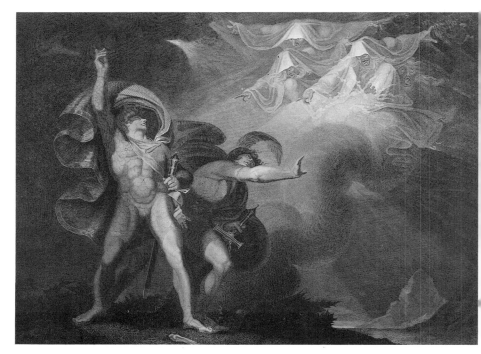

77. *The Three Witches appear to Macbeth and Banquo (Shakespeare, Macbeth, Act I, Scene 3)*

James Caldwall (1739–after 1789) after **Henry Fuseli** (1741–1825)

Stipple engraving, published 23 April 1798 by J. & J. Boydell

Painting No. 4 contributed by Fuseli to the Shakespeare Gallery (1785–90) and sold in the Shakespeare Gallery Sale, First Day, 17 May 1805, lot 54 to T. Pares (20 guineas), present whereabouts unknown (Schiff & Viotto, 1977, p.91, no. 59).

James Caldwall was a brilliant pupil of Sherwin and highly regarded as a virtuoso engraver.

P.C.-B.

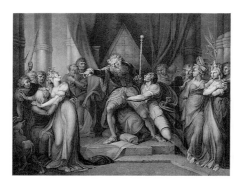

80. *Lear turning away Cordelia (Shakespeare, King Lear, Act I, Scene I)*

Richard Earlom (1743–1822) after **Henry Fuseli** (1741–1825)

Stipple engraving, published 1 August 1792 by John and Josiah Boydell

Sub-Title: Quotation from speech by Lear

Painting No. 7 contributed by Fuseli to the Shakespeare Gallery (1785–90) and

sold in the Shakespeare Gallery Sale, Second Day, 18 May 1805, lot 52, to John Green (21 guineas). Subsequently in the Neeld Collection at Grittleton House, the large painting (102 x 144 inches) is now in the collection of the Art Gallery of Ontario, Toronto (Schiff & Viotto, 1977, p.92, no. 62).

P.C.-B.

81. *Hamlet and the Ghost (Shakespeare, Hamlet, Act I, Scene IV)*

Robert P. Thew (1758–1802) after **Henry Fuseli** (1741–1825)
Stipple engraving, published 19 September 1796 by J. & J. Boydell

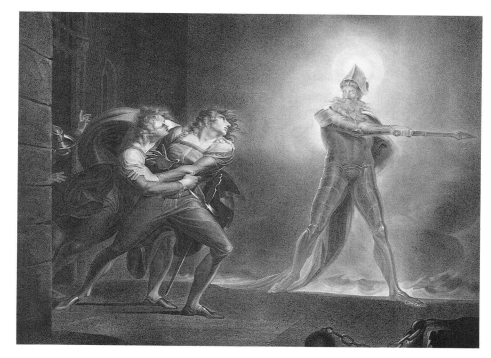

Painting No. 8 contributed by Fuseli to the Shakespeare Gallery (1785–90) and sold in the Shakespeare Gallery Sale, First Day, 17 May 1805, lot 52, to — Nicholson (37 guineas). Until 1839 in the collection of William Earle, Liverpool, the present whereabouts of the large painting is unknown, but a small replica (17 x 24 inches) is in a private collection in New York (Schiff &Viotto, 1977, p.91, nos. 51 & 52).

Elected a full Member of the Royal Academy in February 1790, despite lack of support from Reynolds, Fuseli threw all his energy into the Milton Gallery project when no further contributions to the Shakespeare Gallery were required (for fullest discussion see Schiff, 1963). This project has to be considered in the context not only of the thematic collections of individual paintings being created by Boydell, Macklin , Bowyer and, subsequently Woodmason, but also the pictorial cycles such as Benjamin West's for the Royal Chapel, Windsor, and James Barry's *Progress of Civilisation* for the Society of Arts.

Fuseli focussed his artistic production on the Milton Gallery from 1790 until its opening, with 49 paintings, at Christie's in Pall Mall, 20 May 1799. Despite critical acclaim from Thomas Lawrence and other Academicians, the public response was lukewarm and Fuseli closed it early,

at the end of July. Seven more paintings were added and the Gallery reopened in March 1800, but popular success continued to elude it. After its final closure a number of paintings were purchased by Fuseli's friends and patrons, including Coutts and John Julius Angerstein. However, the lack of success of the Milton Gallery had impelled him, in 1799, to apply for the post of Professor of Painting at the Royal Academy in order to obtain a reliable income from which to support his wife. He began work as professor in 1801, and, elected Keeper of the Royal Academy at the end of 1804, he resigned as Professor the following year.

P.C.-B.

82. *The Infant Shakespeare attended by Nature and the Passions*

Benjamin Smith
(active late 1780s–1833) after **George Romney** (1734–1802)
Stipple engraving, Open Letter Proof, published 29 September 1799 by J. & J. Boydell

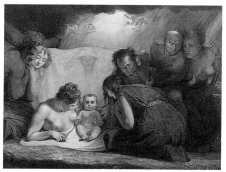

Sub-titled: Nature is represented with her face unveiled to her favourite Child, who is placed between Joy and Sorrow.
On the right hand of Nature are Love, Hatred &
Jealousy: on her left hand, Anger, Envy, & Fear

Commissioned by the Boydells for the Shakespeare Gallery, the painting was sold at the Shakespeare Gallery Sale, Second Day, 18 May 1805, lot 65 (62 guineas) to Michael Bryan. A pupil of

Bartolozzi, Benjamin Smith executed some of the best stipple engravings for the Shakespeare Gallery, including the above.

P.C.-B.

84–90. *The Seven Ages of Man*
(Shakespeare, As You Like It, Act II, Scene VII)

Peltro William Tomkins
(1760–1840) (First Age)

John Ogborne (*c*.1725–95) (Second & Fourth Ages)

Robert P. Thew (1758–1802) (Third Age)

Pierre Simon II (before 1750–*c*.1810) (Fifth & Seventh Ages) &

William S. Leney (active 1790–after 1808) (Sixth Age) after
Robert Smirke (1752–1845)

Stipple engravings, printed in colours, all published 4 June 1801 by
J. & J. Boydell

Sub-titled with running sequence of quotations from the play

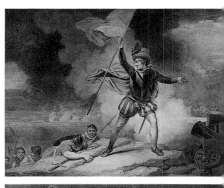

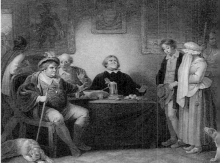

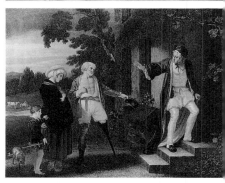

Smirke exhibited at the Royal Academy in 1798 (88) *The seven ages of man, from Shakeapear,* with seven quotations from the play, but only one number is allocated in the catalogue. The set of *The Seven Ages of Man* commissioned by Boydell is very unlikely to have been exhibited at the Royal Academy before being placed on display in his Shakespeare Gallery and the above may have been a set of small repetitions within a single frame. Furthermore at the Shakespeare Gallery Sale, Second Day, 18 May 1805, lot 57, *"Shakespere's Seven ages,* by Smirke" were sold to Nathan Bailey for the very large sum of 240 guineas. Indeed, the sum fetched was some two and a half times the prices paid that day for major works by West and Northcote, and in the entire Sale only two major works by Reynolds fetched more under the hammer. This suggests that either seven separate paintings were sold in the same lot and fetched on average prices reasonably consistent with those achieved by other paintings by Smirke in the Sale, or the very high price reflected their commercial potential as a source of engravings, or both.

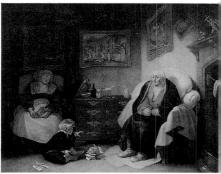

P.C.-B.

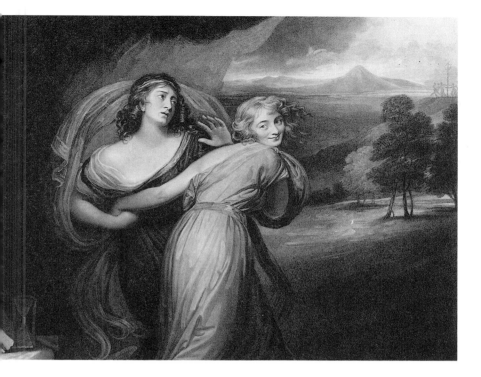

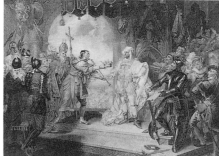

91. *Richard II resigning the Crown to Bolingbroke (Shakespeare, King Richard II, Act IV, Scene I)*

Benjamin Smith
(active late 1780s–1833) after
Mather Brown (1761–1831)

Stipple engraving, printed in colour, published 4 May 1801 by J. & J. Boydell

A native of Boston, Mather Brown settled in England in 1781, and although welcomed by J. S. Copley (Brown's grandfather had been a patron during Copley's American period and he had painted Brown's mother) he chose to study under Benjamin West. Eccentric and increasingly variable in quality, particularly after *c.*1800, he painted *Richard II resigning the Crown to Bolingbroke* for Boydell's Shakespeare Gallery. The painting was sold in the Shakespeare Gallery Sale, First Day, 17 May 1805, lot 30 (20 guineas) to Sir Charles Burrell, but unlike West who took great pains over historical details, Mather Brown's figures are clad in a bizarre range of historicist armour and accoutrements.

P.C.-B.

3. *Il Penseroso, L'Allegro*

George Keating (1762–after 1799) after
George Romney (1734–1802)

Stipple engraving, 1st State (Scratched Letter Proof), published 1 September 1798 by George Keating

Sub-titled: (Il Penseroso) "Hence, vain
 deluding joys/ Milton";
 (L'Allegro) "Hence, loathed
 Melancholy/Milton"

Said to be portraits of Mrs Yates and Mrs Jordan (Horne, 1891, p.61, no. 139) the figures represent Milton's companion poems *L'Allegro* and *Il Penseroso* probably written in 1631 but not printed until 1645. They are now identified (Chamberlain, 1910, p.57) as a dual portrait of the actress, Miss Wallis, painted in 1788. To a limited extent exploring the older contrast between *La Vita Attiva* and *La Vita Contemplativa*, Milton's invocation to the goddess Melancholy was an important influence on the meditative graveyard poems of the 18th century.

Romney exhibited in 1770 two separate paintings of *L'Allegro* and *Il Penseroso* (Chartered Society, Spring Gardens) and these were full-length, but, increasingly neurotic, after 1772 he refused to exhibit his paintings to the public, and by the time of his retirement to Kendal in 1798 he was all but overwhelmed by melancholy. For the painting at Petworth see Collins Baker, 1920, no. 80, as *Mirth and Melancholy*.

P.C.-B.

93. *Rasselas Prince of Abissinia*

James Parker (1750–1805) after
Thomas Stothard (1755–1834)

Stipple engraving, published 5 March
1791 by John Harris

Sub-titled: "Their way lay through the
fields, whose shepherds tended their
flock, & the lambs were playing upon
the pasture. This, said the poet, is the
life which has been often celebrated
for its innocence & quiet; let us pass
the heat of the day among the shep-
herds' tents, & know whether all our
searches are not to terminate in pas-
toral simplicity."

<div style="text-align: right">Dr Johnson's Search after Happiness
Plate I
P.C.-B.</div>

94. *Rasselas Prince of Abissinia*

James Parker (1750–1805) after
Thomas Stothard (1755–1834)

Stipple engraving, published 5 March
1791 by John Harris

Sub-titled: "As they advanced they
heard the sound of Musick, and some
Youths and Virgins dancing in the
grove; and going still further, beheld a
stately palace built upon a hill sur-
rounded with woods."

<div style="text-align: right">Johnson's Rasselas Chap. 20
Plate II</div>

Impressions of both plates are in the
Stothard collections of Robert Balmanno
(British Museum, 813-14) and Samuel
Boddington (Huntingdon Library, San
Marino, California, vol. 5, p.86). J. & E.
Harding published their edition of
Johnson, Samuel: *The History of Rasselas,
Prince of Abissinia* in 1796 with four
plates by Stothard (Bennett, 1988, p.73),
and see also Coxhead, 1906, p.181. First
published in 1759, Dr. Johnson's didactic
romance was originally undertaken as a
pot-boiler to pay for his mother's fu-
neral, but its wise and humaine melan-
choly ensured its continued popularity
through the second half of the eighteenth
century.

<div style="text-align: right">P.C.-B.</div>

96. *Marian*

Peltro William Tomkins
(1760–1840) after
Henry William Bunbury (1750–1811)

Stipple engraving, published 20
November 1791 by Thomas Macklin

Sub-titled:

> Last Friday's eve, when, as the sun
> was set,
> I, near yon stile, three sallow gipsies
> met:
> Upon my hand they cast a poring look
> Bid me beware, and thrice their heads
> they shook:
> They said, that many crosses I must
> prove,
> Some in my worldly gain, but most in
> love.
> Next morn I miss'd three hens & our
> old cock,
> And off the hedge two pinners and a
> smock:
> I bore these losses with a Christian
> mind,
> And no mishaps could feel while thou
> wert kind
> But since alas! I grew my Colin's
> scorn,
> I've known no pleasure, night, or
> noon, or morn.
> Help me ye gipsies bring him home
> again,
> And to a constant lass give back her
> swain.

<div style="text-align: right">Vide Gray's Pastoral</div>

A pupil of Bartolozzi, many of Tom-
kins's earlier plates were after Angelica
Kauffmann, but subsequently he en-
graved plates for *The British Gallery of
Pictures* and *The Stafford Gallery*.

92. *The Tempest, Act V, Scene 1: 'The Entrance of the Cell opens and discovers Ferdinand and Miranda playing at Chess'*

Francis Wheatley R.A.
(1747 – London – 1801)

Oil on canvas, 20¼ x 15 inches (51.4 x 38 cm)

PROVENANCE: Boydell's Shakespeare Gallery; Christie's Boydell Gallery sale, Second Day, 18 May 1805, lot 46, bought by H. Donaldson for 45 guineas

LITERATURE: Boydell's Shakespeare Gallery, Winifred H. Friedman, New York (Garland), 1976
The Boydell Shakespeare Prints, A. E. Santaniello, New York, 1979

ENGRAVED: Stipple engraving by Caroline Watson, published by John & Josiah Boydell, 1 December 1795 (*Francis Wheatley,* Mary Webster, London, 1870, no. E119)

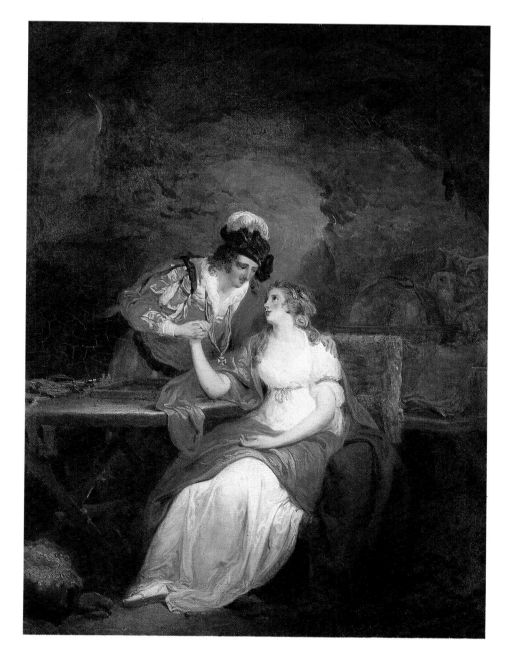

The scene shows Ferdinand, the son of Alonso, and Miranda, the daughter of Prospero, who have fallen in love at first sight. They are playing a game of chess which Shakespeare uses as a metaphor for their love.

> Miranda: Sweet Lord, you play me false
> Ferdinand: No, my dearest love, I would not for the world
> Miranda: Yes, for a score of kingdoms you should wrangle, and I would call it fair play.

The image was published by Boydell, both as a larger and smaller print.

A critic reviewing the picture in 1790 (V. & A. press cuttings) remarked that the figure of Miranda was "very well drawn" and went on to say that "all the objects in the painting are conceived with the spirit of Teniers and (are) not unworthy of his pencil in their execution". He disliked the figure of Ferdinand however — "too feminine — he is not man enough for the fair, innocent and artless Miranda". Wright of Derby's Ferdinand (cat. no. 70) also suffered some similar heckling and it appears that Miranda was a popular favourite amongst contemporary audiences and that they were anxious to find an "appropriate" Ferdinand for her.

M.J.B.

97. *Sin and Death at the Gates of Hell*

Thomas Stothard (1755 – London – 1834)
Oil on paper, laid down on board, 5 x 6½
inches (12.7 x 16.5 cm)
LITERATURE: A. C. Coxhead: *Thomas
Stothard, R.A.*, London, 1906, p.103

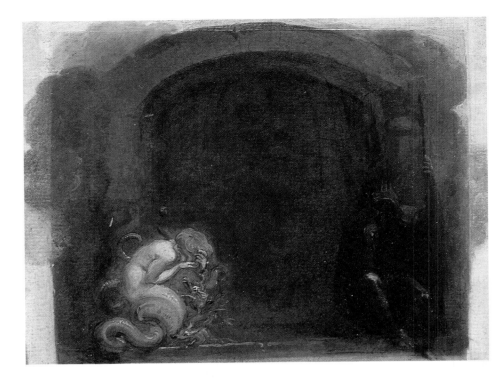

This tiny, beautiful sketch is a study for a
book illustration for Book II of Milton's
*Paradise Los, (*first printed in 1667).
Milton's Hell is parliamentary, ruled by
Satan who forms an army, organises a
council and builds himself a palace —
Pandemonium. In Book II the council de-
bates the launching of an attack to re-
cover Heaven but there is a general lack
of nerve stemming from fear of worse
torments. Beelzebub tells of the creation
of Earth inhabited by God's creation,
Man, who may prove susceptible to evil
and form a means of revenge. Satan
undertakes to visit it alone, and is de-
scribed passing through the gates of Hell
guarded by Sin and Death from where
he passes upwards through Chaos to-
wards our world.

Hogarth painted a variant of the scene,
Satan, Sin and Death (Tate Gallery) be-
tween 1735 and 1740 in a painting that
was owned by Garrick and depicted the
moment when all three characters find
that they are incestuously related.

Stothard, who was described by Ellis
Waterhouse as "The most pleasing and
prolific book illustrator of his day" (high
praise on both counts!) executed a series
of illustrations for *Paradise Lost* which
were engraved by Bartolozzi and pub-
lished by Jeffryes in 1792–3. Another edi-
tion appeared in 1818 and a third in
1826.

Coxhead (op. cit.) records the work as
"*Sin and Death,* one each side of a gloomy
portal. Sin is a female figure, with the
lower half of a serpent in many coils."

M.J.B.

98. *O Mistress Mine where are you roaming? . . .*

James Hogg (active late 18th century)
after **Richard Westall** (1765–1836)
Stipple engraving, with fictive frame
border, published 1 January 1793 by
James Hogg and John Raphael Smith
Title continues:

O, stay and hear; your true love's
 coming,
Trip no further, pretty sweeting
Journey's end in lover's meeting.
From a Ballad of Shakespeare
Twelfth Night. Act 2

Richard Westall was originally appren-
ticed to an heraldic engraver on silver,
but in 1895 he was admitted to the Royal
Academy Schools and he rapidly made
his name through the large and highly
finished subject pieces in watercolours
he exhibited at the Royal Academy. In
1790–94 he shared a house with Thomas
Lawrence and was elected an Associate
of the Royal Academy in 1792. Book
illustrations became from this time his
main output, but he painted 22 pictures
for Boydell's Shakespeare Gallery, in-
cluding five large compositions, but
none illustrating *Twelfth Night.* For
Boydell Westall designed in addition
illustrations to Milton, and he worked
also for both Macklin and Bowyer.

P.C.-B.

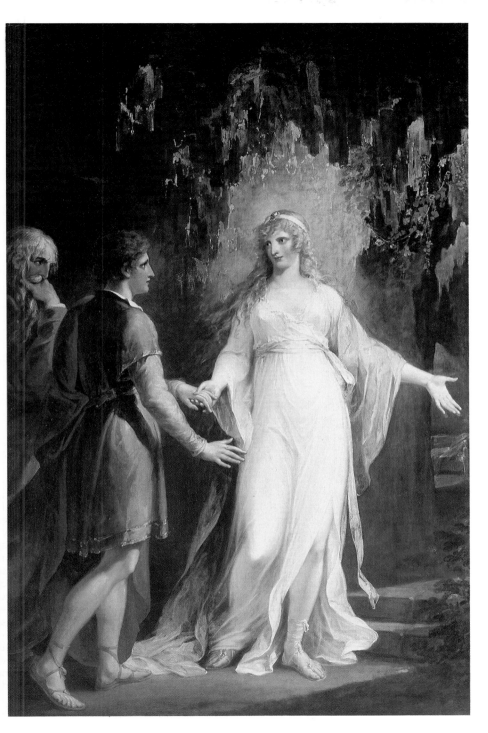

95. *Calypso receiving Telemachus and Mentor in the Grotto*

William Hamilton R.A.
(1751 – Chelsea – London – 1801)
Oil on canvas, 98½ x 61 inches
(250.5 x 155 cm)
EXHIBITED: Royal Academy 1791 (133)

Telemachus was the son of Ulysses and Penelope. The Odyssey relates that when his father failed to return home at the end of the Trojan war Telemachus set out to search for him accompanied by the Goddess Athena, who was disguised as his old guardian Mentor. The story was elaborated in a romance, *The Adventures of Telemachus,* by the French writer Fenélon, published in 1699, and this was the source for 18th century French artists, and also for British artists of the late 18th and early 19th centuries. Fenélon relates how Telemachus was shipwrecked on the island of the nymph Calypso, where Ulysses too had been wrecked and kept by Calypso who had wanted to marry him. Similarly, Calypso fell in love with Telemachus and detained him by persuading him to relate his previous adventures. Venus sent Cupid to aid her in her designs, but Telemachus fell in love with Eucharis, one of Calypso's nymphs, thereby provoking the goddess's wrath. Cupid incited the other nymphs to burn a new boat that Mentor had built to aid Telemachus's escape. Telemachus was delighted by this delay, but he was thrown into the sea by Mentor and they were picked up by a passing vessel. This painting shows the first encounter with Calypso, who invites him up a flight of stairs towards a welcoming couch.

William Hamilton was born in 1751 in Chelsea, then a separate village, of Scottish parentage. His father had worked with the architect and decorator Robert Adam (1728–92), with whom William had trained before being sent by Adam to study with Antonio Zucchi (1728–95) in Italy. Returning to London, Hamilton studied at the Royal Academy Schools from 1769. He exhibited at the Royal Academy from 1774 until his

death in London on 2nd December 1801, becoming Associate in 1784, and a full Member in 1789. His exhibits consisted mainly of history paintings and theatrical portraits. From 1778 he was regularly employed by the publisher John Murray, and he also contributed to Thomas Macklin's Poets Gallery and Bible, and to Boydell's Shakespeare Gallery.

Hamilton was a leading figure of what may be called the second generation of British Neo-Classicism, which had been established in Rome by the joint efforts of the Scot Gavin Hamilton (1723–98) and the American Benjamin West (1738–1820). Hamilton specialised in subject pictures in a rather more painterly and softened form of the Neo-Classicism than that of his precursors, sometimes however showing the influence of Henry Fuseli (1741–1825) with whom he collaborated on illustrations to Gray's *Poems* published in 1800, Milton's *Paradise Lost* (1802 and 1802), and Thomson's *Seasons*, which had also been the subject of his most famous series of illustrations, those of 1797. In this period it was common practice to prepare for engraved illustrations with large paintings which could be exhibited separately, and Hamilton also painted a large number of independent pictures of literary and historical subjects (see Boase, 1963; Hammelmann, 1975; Butlin, 1988).

Two small oil versions or sketches entitled *Telemachus* & *Aeneas and Dido,* each 23½ x 15½ inches, were sold at Christies, London, 19 November 1970, Lot 172, as a pair. It is probably not a coincidence that the companion to the present *Calypso* in the 1791 Royal Academy exhibition was no. 176, entitled *Aeneas communicating to Dido the neccessity of his departure from Carthage.*

M.B.

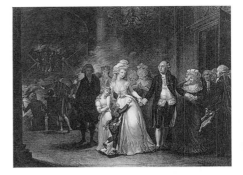

99. *Sabrina releasing the Lady from the Enchanted Chair*

Edmund Scott (*c*.1746–*c*.1811) after **Thomas Stothard** (1755–1834)

Stipple engraving, published 7 February 1793 by John Raphael Smith

Included in J. R. Smith's catalogue of before 1787 this print was priced @ 12/-.

Sub-titled: Milton's Comus

The oil painting by Stothard, identified as *An Illustration to Shakespeare,* was sold at Sotheby's, London, 22 March 1972, lot 8 (14½ x 18½ inches, present whereabouts unknown), but this engraving is not listed by Bennett (1988) as a book illustration.

P.C.-B.

100. *The Separation of Lewis the Sixteenth from his Family, in the Temple, In consequence of a Resolution of the Commune of Paris on the 29th of September 1792*

Luigi Schiavonetti (1765–1810) after **Charles Benazech** (1767–94)

Stipple engraving, published 1 June 1793 by Messrs. Colnaghi

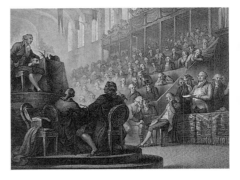

101. *The Memorable Address of Lewis the Sixteenth, At the Bar of the National Convention, After his Counsel Mr Deséze had closed his Defence on the 26 of December 1792*

Luigi Schiavonetti (1765–1810) after **William Miller** (*c*.1740–*c*.1810)

Stipple engraving, published 20 November 1796 by Testolini

102. *Historical Account. The Memorable Address of Louis XVI . . .,* Key plate

Etching, published 15 March 1797 by Testolini

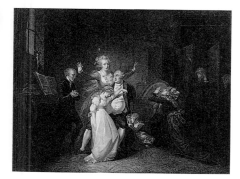

103. *The Last Interview between Lewis the Sixteenth and his Disconsolate Family in the Temple, On the 20th of January 1793, The day previous to His Execution*

Luigi Schiavonetti (1765–1810) after **Charles Benazech** (1767–94)

Stipple engraving, published 10 March 1794 by Messrs. Colnaghi

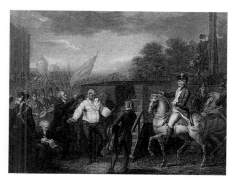

104. *The Calm and Collected Behaviour of Lewis the Sixteenth on Parting From His Confessor Edgeworth, The Moment Before a Period Was Put to His Existence on The 21 of January 1793, In consequence of the Sentence of the National Convention passed the Night of the 19th of the same Month,* by Luigi Schiavonetti (1765–1810) after **Charles Benazech** (1767–94)

Stipple engraving, published 1 February 1795 by Messrs. Colnaghi

105. *Historical Account, Explanatory of the Third Print, Representing Louis XVI on Parting from his Confessor Edgeworth . . .,* key plate

Etching, with scratch inscription "London Published according to the Act of Parliament"

Set of six plates, from the Liechtenstein Collection

See Bindman, 1989, pp.130-31, nos. 89, 90 & 92

Charles Benazech was on his way back from Rome when he visited Paris during the French Revolution and he may have witnessed some of the more dramatic events, including the execution of Louis XVI in January 1793. The key plate entitled *Historical Account of the last interview of Louis XVI with his family, before his execution; to elucidate the second print of the series formed on that interesting event* (British Museum; see Bindman, 1989, pp.131-32, no. 93) is undated, as is cat. no. 102 which refers to the execution as the "Third Print", and the sequence of publication suggests that the original plan was for three prints only, from paintings by Benazech, published in chronological order at approximately ten month intervals. Benazech died, however, at the early age of 27, in 1794, and the fourth episode — 'The Memorable Address of Louis XVI' — was either an afterthought left by Benazech and largely painted by William Miller, or, more likely, a later addition to the set published by Colnaghi since both it and its key plate were published in 1796 and 1797 respectively by Testolini.

The execution of Louis XVI sent shock waves round Europe and print publishers rushed to satisfy popular demand for images of the event (see Bindman, 1989, p.131). Benazech's final image (cat. no. 104) was the subject of numerous copies and imitations across Europe and a version of the original painting (Versailles Museum) is dated 1793, whilst Schiavonetti's engraving was re-engraved by Anthony Cardon and pub-

lished by Colnaghi 1 March 1797, suggesting that the Schiavonetti plate of 1795 was already worn out (or otherwise unavailable) well before then.

The change in title to *Louis the 16th with his Confessor Edgeworth ascending the fatal Steps* is analysed in detail by Bindman (1989, p.48) in the context of the changing emphases being placed on his execution, but at a more popular level interest had been stimulated in 1793 by, for example, exhibits such as the full-size working model of a guillotine set up in the picture gallery in Haymarket which had, not long before, exhibited the Old Master paintings which had belonged to Sir Joshua Reynolds.

Benazech's images were thus not without competition, and apart from popular and satirical prints rushed out, both Schiavonetti and Mariano Bovi engraved the series of images painted by Domenico Pellegrini, whilst Mather Brown was on 1 February 1793 announced to have already begun work on his painting of *The Final Interview of Louis the Sixteenth*. The large version of this composition (Wadsworth Athenaeum, Hartford, Conn.) was touring northern towns later the same year. Much the most distinguished of the contemporary paintings is that by William Hamilton: *Marie Antoinette leaving the Conciergerie* (Sutton Place Foundation; Bindman, 1989, p.152, no. 136, ill.). Her execution took place 16 October 1793, but Cardon's engraving was not published until 1800 when it had been overtaken by other momentous events.

Charles Benazech was the son of the engraver, Peter Paul Benazech, who had settled in London, and he studied in France under Greuze. In Rome 1782, Charles Benazech returned via Paris during the French Revolution, and his best known works are the above. William Miller specialised in portraits and history painting, working on Boydell's Shakespeare Gallery (*Masquerade Scene in Romeo and Juliet,* purchased in 1805 by the Armourers and Braziers' Company, and *King Edward hunting at Middleham Park, Yorkshire,* sold

in 1805 to Colonel Sneyd), but he remains a shadowy figure despite exhibiting scenes from Shakespeare at the Society of Artists, 1780–83, and at the Royal Academy, 1788–1803. Luigi Schiavonetti, from Bassano, completed his training in London under Bartolozzi and the Louis XVI plates are his most important.

P.C.-B.

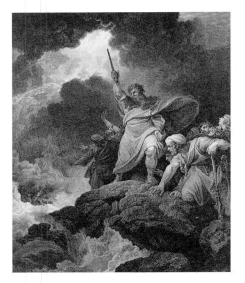

106. *The Destruction of Pharo's Host*

James Fittler (1758–1835) after
Philippe Jacques de Loutherbourg
(1740–1812)

Engraving, published December 1793 by Thomas Macklin

Loutherbourg was born in Strasbourg, the son of Philippe Jacques de Loutherbourg the elder, who was miniature painter to the Court of Darmstadt. The family moved to Paris in 1755 and he was trained under Carle van Loo and François Joseph Casanova. He first exhibited at the Salon in 1763 and was nominated 'Peintre du Roi' in 1766, but in November 1771 he left for London and during the years 1773–1785 Loutherbourg was in partnership with first Garrick and then Sheridan, the

genius who transformed the stage and costume designs at Drury Lane.

His theatrical designs were highly influential but towards the end of this period he began to lose interest in the orthodox theatre and turned instead to other projects, including the "negromantic" environment he created for William Beckford at Fonthill for Christmas 1781. Meanwhile his Eidophusikon had from its first performance, 26 February 1781, proved a great success and counted both Reynolds and Gainsborough amongst its enthusiastic admirers. Loutherbourg's last major theatrical production for Covent Garden was *'Omai', or, a trip round the world* in 1785, but his artistic career was interrupted in 1786–89 by his brief and stormy relationship with the theurgist and freemason, Count Cagliostro, and his subsequent attempt to practice as a faith-healer.

On returning to art, Loutherbourg agreed in autumn 1789 to Thomas Macklin's proposals for illustrating a new edition of the *Holy Bible*, to be funded by subscriptions, and as the project progressed annual exhibitions of work completed were held in his Poets Gallery from 1790 until 1794 when the subscription list was complete. Although Reynolds, West, Fuseli, Hoppner, Stothard and Hamilton contributed designs, Loutherbourg provided 22 of the 71 plates, together with the opening and concluding vignettes, totalling some 125 items. Macklin claimed to have spent some £30,000 on the illustrated *Holy Bible*, but with the outbreak of war with revolutionary France in 1793 and the virtual destruction of the export trade his finances were severely injured, though not as disastrously as those of the Boydells. For Loutherbourg see Joppien, 1973.

James Fittler trained in the Royal Academy Schools from 1778 and was elected Associate Engraver in 1800. He engraved many plates for Forster's *British Gallery* and Bell's *British Theatre*, and a number of plates after Loutherbourg's later battle scenes.

P.C.-B.

107. *The Playful Galatea*

William Hamilton R.A.
(Chelsea 1751 – 1801 London)
Oil on canvas, 94 x 57 inches
(239 x 145 cm)
EXHIBITED: Royal Academy, 1794 (89)
LITERATURE: Butlin, 1988, pp. 171-74

The Playful Galatea was listed in the 1794 Royal Academy catalogue with the reference 'vide Virgil's Eclogues, Pastoral the Third'. This tells of the quarrel of Damoetes and Menaclas and how Palaemon gets them to settle their differences by a song contest in which each boasts of his loves. Damoetes starts off by saying how:

Young Galatea, wanton girl, in sport
Pelts me with apples: To the willow-grove
Then flys; but wishes not to fly unseen.

(This is from the translation by Joseph Trapp, published in 1718 and again in 1735. Another possible source, the translation of 1797, is ruled out because he uses there the name 'Phyllis' of Galatea).

An annotated catalogue of the Royal Academy exhibition of 1794, in the Tate Gallery, shows that this picure hung at the head of the Great Room, on the right of a full-length portrait of George III by Gainsborough Dupont. Above this, interestingly in view of the common provenance (at least in recent years) of cat. no. 95 and this picture by Hamilton, was a painting entitled *The Arrival of Telemachus and Mentor on the Island of Calypso*, 'Vide Telemachus', by one S. Medley.

M.B.

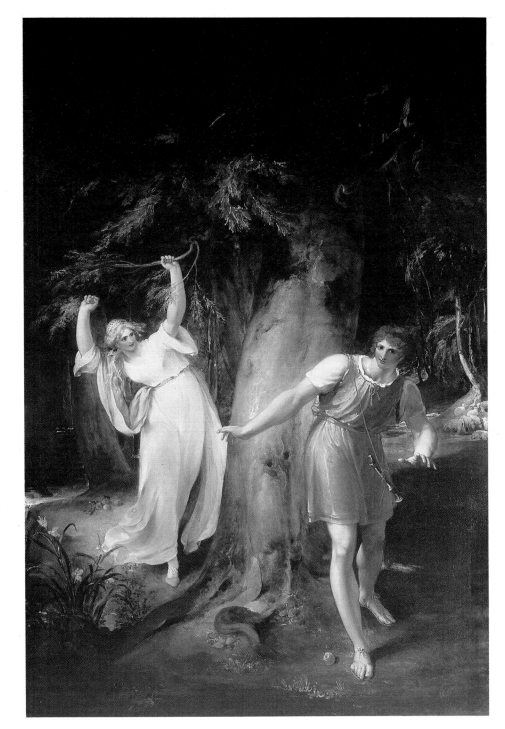

108. *Portia and Bassanio, The Merchant of Venice, Act III, Scene 2*

Richard Westall RA

(Hertford 1765–1836 London)

Oil on Canvas, 32 x 22 inches
(81.3 X 55.9 cm)

Signed with initials and dated 1795

PROVENANCE: Commissioned by Alderman Boydell for his Shakespeare Gallery; Boydell Gallery Sale, Christies, 17 May, 1805, Lot 9. Sold to John Green, £11-0-6.

LITERATURE: Winifred H Friedman, *Boydell's Shakespeare Gallery*, New York (Garland), 1976.

ENGRAVED: G. Noble, 1802, for Boydell's *Dramatic Works of Shakespeare*, as *Merchant of Venice, Act III, Scene 2*.

Bassanio, a noble but poor Venetian woos the rich Portia. According to her father's will she must set her suitors a task — to choose which of three caskets (one of gold, one silver and one lead) contains her portrait. Bassanio rightly chooses the lead casket and they are pledged to marry, as are his friend Gratiano and her maid Nerissa.

Westall's picture, which was one of the smaller pictures exhibited in the Shakespeare's Gallery (all of approximately 30 x 21 inches), shows the three caskets on a side table together with the miniature and script that Bassanio has found in the lead casket. The scene is set on the loggia of Portia's palace and Portia and Bassanio are shown nearest to the viewer with Gratiano and Nerissa together with another maid behind.

The painting is notable for Westall's use of rich colouring and thick impasto which give his pictures considerable liveliness.

M.J.B.

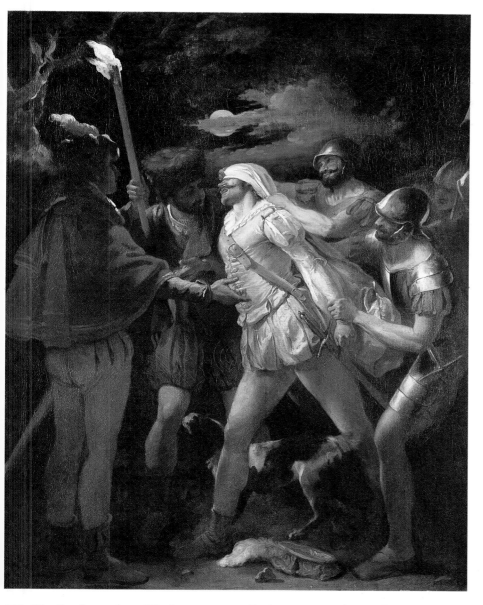

109. *The Condemnation of Bushy,*

(King Richard the Second, Act III, scene 2)

Henry Tresham
(Dublin 1750–1814 London)
Oil on canvas, 66¼ x 53¼ inches
(168 x 135 cm)

Bushy was, together with Green, one of Richard II's two favourites. Following the King's defeat they are arrested and accused by Bolingbroke:

You have misled a prince . . ./You have in manner with your sinful hours/Made a divorce betwixt his queen and him . . ./Myself — a prince by fortune of my birth,/Near to the King in blood and near in love/Till you did make him misinterpret me — /Have stoop'd my neck under your injuries . . ./This and much more, much more than twice all this, /Condemns you to the death. See them delivered over/To execution and the hand of death.

The picture shows Bushy, dressed in the finery of a courtier being led away to execution by Bolingbroke's men whose hard faces and rough clothing contrast with his appearance.

Tresham studied initially in Dublin and then London and was taken to Rome by John Campbell (later Lord Cawdor). He travelled to Naples and Bologna, and became a member of the Academies at Rome and Bologna. He was subsidised by Sir Clifton Witheringham, Bart., a doctor, who gave him £100 a year. This stipend was later withdrawn following a poor report upon his industry by the Bishop of Derry. His work at this time showed a strong influence of Henry Fuseli. Back in England he became A.R.A. in 1791 and R.A. in 1799. He was appointed Professor of Painting at the Royal Academy Schools in succession to Opie in 1807.

Throughout his time in Rome and again in England he acted as an art dealer and in Northcote's waspish phrase 'Tresham . . . combined the pursuit of art with the more lucrative business of supplying English collectors with Old Masters'. He superintended *Longman's British Gallery of Pictures* and contributed a descriptive text. He was considered a connoisseur of paintings and published several volumes of his own verse. He contributed pictures for all the literary and historical galleries established by Boydell, Macklin and Bowyer, but curiously not for Woodmason's Irish Shakespeare Gallery.

M.J.B.

110. *Mrs Siddons, as Il Penseroso*

Richard Westall
(Hertford 1766–1836 London)

Watercolour over pencil, heightened
with bodycolour and gum arabic,
24 x 19 inches (61 x 48 cm)

Signed and dated, lower right,
"R Westall/1795"

William Hazlitt wrote of Sarah Siddons
that "Power was seated on her brow . . .
she was tragedy personified". Indeed,
unlike the diverse Garrick, whose por-
trait by Westall is also included in this
exhibition (cat. no. 121), Siddons seldom
attempted comic or romantic roles. She
was born the daughter of a strolling
actor–manager, Roger Kemble, whose
children included the comic and
romantic actor Charles Kemble and the
tragedian John Philip Kemble. Her first
attempt on the London stage came to
nothing but her second in 1782 was such
a success that she was heralded as a
tragic actress without equal and she
maintained that position until her retire-
ment in 1812.

Amongst Shakespearean roles, Lady
Macbeth was probably her most famous
and she also had two notable successes
in Nicholas Rowe's 'She-Tragedies'
Calista and *Jane Shore* whose moral tone,
stressing the suffering and penitence of
victimized women, were calculated in
Rowe's phrase, to inspire "Pity, a sort of
regret proceeding from good-nature".
She was a friend of Dr Johnson, Horace
Walpole and Reynolds and wrote a
highly flattering autobiography whose
tone set the pattern for others down the
years. Sarah Siddons's pose is very sim-
ilar to that of *Lady Macbeth with a letter*
painted by Westall, which was shown in
Boydell's Shakespeare Gallery and en-
graved by J. Parker.

A print titled *Il Penseroso* after this
watercolour was engraved by J. Ogborne
and published by Boydell, 25 March
1797, from the Shakespeare Gallery, and
appeared as an illustration to Milton's
Works, p.111. There also exists a portrait
by Westall of her daughter, Miss
Siddons, in conté and watercolour on
paper.

M.J.B.

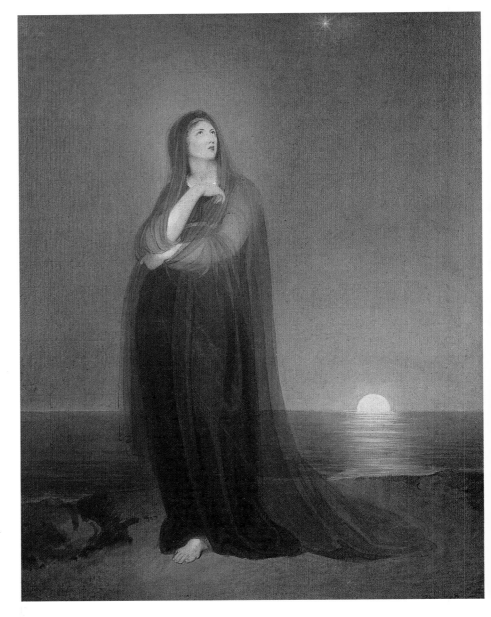

111. *Camilla fainting in the Arms of her Father*

George Keating (1762–after 1799) after
Henry Singleton (1766–1839)
Stipple engraving, Proof Before All
Letters

112. *Camilla recovering from her Swoon*
George Keating (1762–after 1799) after
Henry Singleton (1762–1839)
Stipple engraving, Proof Before All
Letters

Illustrating *Camilla, or a Picture of Youth,*
by Fanny Burney, published in 1796 in
five volumes, Singleton is here main-
taining the traditions of literary subject
painting. George Keating was an Irish
engraver who trained under William
Dickinson and was active in London as a
mezzotint and stipple engraver, 1784–99.
P.C.-B.

114. *Lucy of Leinster*

Francesco Bartolozzi (1725–1815) after
Henry William Bunbury (1750–1811)
Engraving, published 10 May 1799 by
Thomas Macklin
Sub-titled:

Of Leinster, fam'd for maidens fair,
 Bright Lucy was the grace;
No e'er did Liffy's limpid stream
 Reflect so sweet a face:
'Till luckless love, and pining care,
 Impair'd her rosy hue,
Her dainty lip, her damask cheek,
 And eyes of glossy blue.
Ah! have you seen a lily pale,
 When beating rains descend?
So dropp'd this slow-consuming
 maid,
 Her life now near its end.
 Vide Colin & Lucy

The poet Thomas Tickell (1685–1740)
published his sentimental ballad *Lucy
and Colin* in 1725 and it was much ad-
mired by Gray and Goldsmith. For the
engraving see De Vesme & Calabi, 128,
p. 383, no. 1445.
P.C.-B.

115. *The Approach of the British
Squadron . . . off the Mouth of the Nile
in the evening of 1st of August 1798*

Robert Pollard (1755–1838) after
Nicholas Pocock (1740–1821)
Etching and aquatint, published 20 May
1799 by Nicholas Pocock
From the collection of the Duke of
Roxburgh, Floors Castle

At the Royal Academy in 1799 Nicholas
Pocock exhibited two paintings of the
Battle of the Nile entitled *View of the
French line of Battle in the Bay of Beguieres,
with the approach of the British Squadron
under Rear Admiral Lord Nelson, to the at-
tack on the evening of the glorious 1st of
August, 1798* and *View of the position of the
two fleets (taken from the van of the French
line) in action at half past nine o'clock at
night, La Guerrire, Le Conquerant and
Spartiale dismasted, the l'Orient on fire,
August 1st, 1798.* The first was engraved
for vol. 1 of the *Naval Chronicle,* and
apart from British sources, Pocock also
obtained material from a drawing by a
French officer in Admiral de Bruey's
fleet (Cordingly, 1988, p. 83).
P.C.-B.

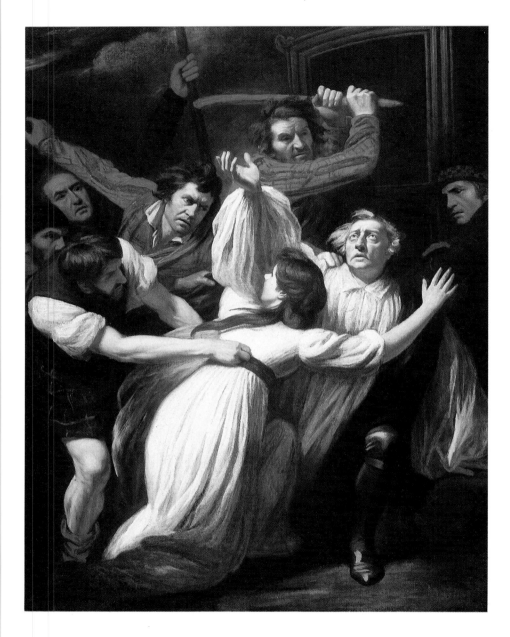

113. *The Death of Archbishop Sharpe*

John Opie R.A.
(St Agnes 1761 – 1807 London)
Oil on canvas, 88½ x 68½ inches
(224.8 x 174 cm)

PROVENANCE: Painted in 1797 for
engraving and publication in Bowyer's
edition of Hume's *History of England*,
London, 1806. Bowyer's Historic Gallery
(sold 30 May 1807, for 30 guineas)
EXHIBITED: Royal Academy, 1797 (257)

ENGRAVED: Thomas Holloway,
published March 1799
LITERATURE: J. J. Rogers, *Opie and his
Works*, London, 1878, p. 194, no. 10
A. Earland, *John Opie and his Circle*,
London, 1911, p. 335
T. S. R. Boase, 'Macklin and Bowyer',
*Journal of Warburg and Courtauld
Institutes*, XXVI, 1963, pp. 148-177

James Sharpe, was a pragmatist, who
would sacrifice principle to expediency
and who earned respect and dislike in
equal measure. After an education at
Edinburgh and Oxford he was presented
with a church and living by the Earl of
Crawford and two years later was
elected a minister of Edinburgh. He did
not take up his place, however, due to
Cromwell's invasion of Scotland, and in-
stead he became head of a group of
churchmen calling themselves
Resolutioners who wished to drive out
Cromwell and were not averse to
bishops within the Church of Scotland.
He was dragged south and imprisoned
in the Tower by Cromwell, then released
only to re-appear as ambassador for the
Resolutioners causing Cromwell to re-
mark 'the gentleman after the Scotch
way ought to be called Sharp of that ilk'.
He was taken up by Monck who
despatched him to negotiate with King
Charles at Breda. By stealth he managed
to suppress any direct appeals to the
King by Presbyterians, whose cause he
claimed to represent, in favour of his
own brand of reformed Episcopalian
church. Thus he duped the Presbyterians
and meanwhile paved the way to his
own advancement. He became, in turn,
His Majesty's Chaplain in Scotland;
Professor of Divinity at St Mary's
College, St Andrews; and, after the es-
tablishment of episcopacy in 1661,
Archbishop of St Andrews.
Rather than trying to reconcile
Presbyterians and Episcopalians, he then
sought to extinguish the Presbyterians,
and having complained in London of a
lack of vigour in the administration, re-
turned with the title of Primate of
Scotland and set about the suppression
with renewed force. He may well have

been right in believing that a workable reconciliation was an impossibility, but the Presbyterians, whose ambassador he had once claimed to be, understandably held him in almost universal contempt. In 1668 he was shot at in the High Street in Edinburgh by a man called Mitchell who was later hanged. In May of the following year a group of Fife lairds who were hoping to ambush and capture Carmichael, the sheriff-substitute of Fife and the man responsible for the persecution of Presbyterians in the county, saw the Archbishop's carriage approaching along the road. Exhilarated to have the organ grinder and not his monkey in their sights, and taking the coincidence for an act of God, they resolved to kill him. Having shot at him and, remembering Mitchell's failure, believing him proof against bullets they pulled him from the carriage and, despite the brave protests of his daughter Isabella, clubbed and hacked him to death. The murderers escaped to the west of Scotland and the consequent insurrection became the basis for Walter Scott's *Old Mortality*. Sharpe was buried in the church of St Andrew's, beneath a grandiloquent monument.

The painting was executed for William Bowyer's *Historic Gallery*. Bowyer, who had trained as a miniaturist and had risen to become Miniaturist to the Queen and Water-Colour Painter to the King, then established himself as a print dealer with premises in Pall Mall. In 1792 he issued a prospectus for an illustrated edition of Hume's *History of England*, placing emphasis on an elevated rendering as opposed to the sensationalist images which had decorated some earlier editions. The scheme followed along the lines established by Boydell with the paintings exhibited in Bowyer's house in Pall Mall and the prints bound and published in folio volumes. Opie painted 11 canvases for the gallery and this was engraved by Holloway and published in 1799. Bowyer had taken the lease of the section of Schomberg House which was occupied by Gainsborough and then his widow until midsummer 1792. The top floor was converted into a

gallery to exhibit some of the paintings commissioned and boost sales of the large folio edition of Hume which was published from 1793 to 1806.

In fact, Bowyer's gallery followed Boydell's example uncomfortably close, and in spite of a special trading agreement that Bowyer had registered with Napoleon's government, his business nonetheless suffered and in May 1807, following a lottery, the pictures were auctioned by Coxe.

<div align="right">M.J.B.</div>

116. *The Warrior's Farewell*
(Act 3 of *Edward the Black Prince* by William Shirley)

William Hamilton R.A.
(London 1751–1801 London)
Oil on canvas, 20½ x 20½ inches
(52 x 52 cm)
PROVENANCE; C. H. McCormick 1355, sold by Agnews, 1936 (label no 8510) to Curtis
ENGRAVED: Collier

This small colourful canvas, painted as a feigned tondo, depicts an episode, in Act III of William Shirley's play *Edward the Black Prince*, which first appeared at

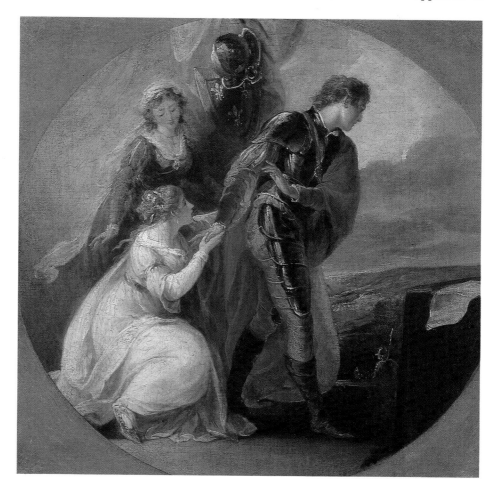

Drury Lane on 6th January 1750. Garrick then took the part of Edward but it was Barry, as Lord Ribemont, a French nobleman, here depicted leaving for battle, who was voted the success of the piece and earned the play its popularity.

Hamilton was a leading figure of what may be called the second generation of British Neo-Classicism, which had been established in Rome by the joint efforts of the Scot Gavin Hamilton (1723–1798) and the American Benjamin West (1738–1820). Hamilton specialised in subject pictures in a rather more painterly and softened form of the Neo-Classicism of his precursors, sometimes, however, showing the influence of Henry Fuseli (1741–1825) with whom he collaborated on illustrations to Grey's *Poems* published in 1800, Milton's *Paradise Lost* (1802 and 1802), and Thomson's *Seasons*, which had also been the subject of his most famous series of illustrations, those of 1797. In this period, it was common practice to prepare for engraved illustrations with large paintings that could be exhibited separately, and Hamilton also painted a large number of independent pictures of literary and historical subjects.

The picture demonstrates the cult of the dashing chivalrous hero which was becoming prominent at the start of the nineteenth century. The attention to the detail of the armour is also interesting at a time when 'correct' medieval armour was again being manufactured and chivalrous jousts were being fought, a pattern of fashion which would culminate in the coronation of George IV and the tournaments at Firle and Eglantine.

William Shirley (fl. 1739–1780) was engaged in the Portugal trade until forced out of Lisbon in 1753 and developed in London his dramatic talents, cooperating with Garrick.

However, he later quarrelled with Garrick and revenged himself in 1758 by printing a pamphlet entitled *Brief remarks on the original and present state of the drama* including a humorous dialogue called 'Hecate's Prophecy' in which Garrick was ridiculed under the name of Roscius.

M.J.B.

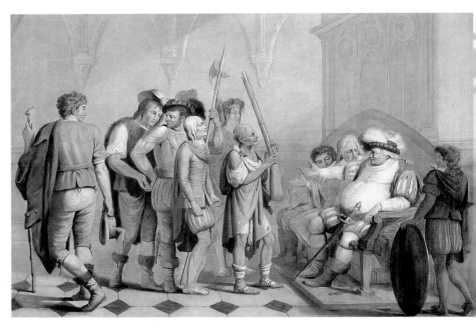

117. *KING HENRY IV, PART II, Act III, Scene II: Justice Shallow's seat in Gloucestershire* — Shallow, Silence, Falstaff, Bardolph, Boy, Mouldy, Shadow, Wart, Feeble and Bullcalf

James Durno
(London 1745 – 1795 Rome)
Oil on canvas, 28¼ x 42 inches
(71.2 x 104 cm)
Pair to cat. no. 118, see below

PROVENANCE: Sotheby's, 14th October 1953, lot 3 (the pair)
LITERATURE: c.f. *Boydell's Shakespeare Gallery,* Winifred H. Friedman, New York (Garland), 1976
c.f. *The Boydell Shakespeare Prints,* A. E. Santaniello, New York, 1979
c.f. *The Fuseli Circle in Rome,* Nancy Pressley, Exh. Cat. B.A.C. Yale 1979

118. *THE MERRY WIVES OF WINDSOR, Act IV, Scene II: Ford's House* – Ford, Shallow, Page, Caius, Sir Hugh Evans, Falstaff (as the Old Woman of Brentford), Mrs Ford and Mrs Page

James Durno
(London 1745–1795 Rome)
Oil on canvas, 28¼ x 42 inches
Pair to cat. no. 117

PROVENANCE: Sotheby's, 14th October 1953, lot 3 (the pair)
LITERATURE: c.f. *Boydell's Shakespeare Gallery,* Winifred H. Friedman, New York (Garland), 1976
c.f. *The Boydell Shakespeare Prints,* A. E. Santaniello, New York, 1979
c.f. *The Fuseli Circle in Rome,* Nancy Pressley, Exh. Cat. B.A.C. Yale 1979

These two images are reduced versions of the large canvases which were painted for Boydell's Shakespeare Gallery, and one of which, the scene from *The Merry Wives of Windsor*, was bought by Sir John Soane at the Shakespeare Gallery sale of 1805 (9 guineas) and hangs in the Soane Museum, London. The large paintings

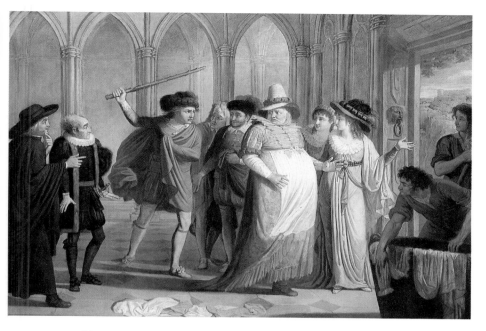

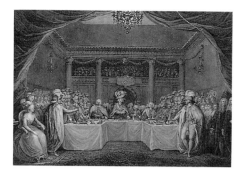

123. *Installation Dinner, At the Institution of the Most Illustrious Order of St Patrick in St Patrick's Hall within the Castle of Dublin, March 17th 1783*

James Keyse Sherwin (1751–90) et al (inscribed "finished by others since his decease"), after
J. K. Sherwin
Engraving, Open Letter Proof, published 17 March 1803 by Robert Wilkinson

The engraving is dedicated to George Marquess of Buckingham who had been, in 1783, the original Grand Master of the Order of St Patrick, and it was very probably begun as a private plate. Sherwin also engraved Buckingham's portrait by Gainsborough, but long after the death of Sherwin in 1790 from dissipation an attempt was made to provide for his widow and this plate was completed through the goodwill of fellow engravers. No doubt the considerable number of portraits included provided a potential market.

P.C.-B.

were engraved by T. Ryder.

The scene from *Henry IV* shows Falstaff selecting recruits to fight with him in King Henry's army and is one of the more humorous moments in the play. The incident from the *Merry Wives of Windsor* shows Falstaff disguised as a woman in order to escape from the house of Ford who has threatened to kill him. Unfortunately, the only clothes that fit him are those of a fat old witch whom Ford dislikes almost as much.

Durno studied in Andrea Casali's Academy in London and in the studios of Benjamin West and J. H. Mortimer. He won prizes for drawings at the Society of Arts in 1762 and 1765 and for History Pictures in 1766, 1770 and 1773. He exhibited at both the Free Society of Artists and the Society of Artists of Great Britain. In 1769 he entered the Royal Academy Schools and in 1774 he went to Rome where he remained until his death. He came second in the competition for the ceiling of the Great Hall of the Doge's Palace in Genoa in 1783 and there are drawings for this in Berlin.

Both the large versions for Shakespeare Gallery and these smaller versions were painted in Rome and this caused one contemporary artist writing in *The Diary* to admit that, while the recruiting scene was "fraught with humour" the fact that Durno had been studying Greek statues and Roman figures meant that "his figures have not an English air". They seem on the contrary to follow an eighteenth century line of caricature extending from Hogarth and especially seen in artists such as Thomas Patch and Joshua Reynolds during their time at Rome. The scene from the *Merry Wives of Windsor* was also well received and the reviewer for *The Public Advertiser* described it as having parts that were finished with "the delicacy of a miniature".

M.J.B.

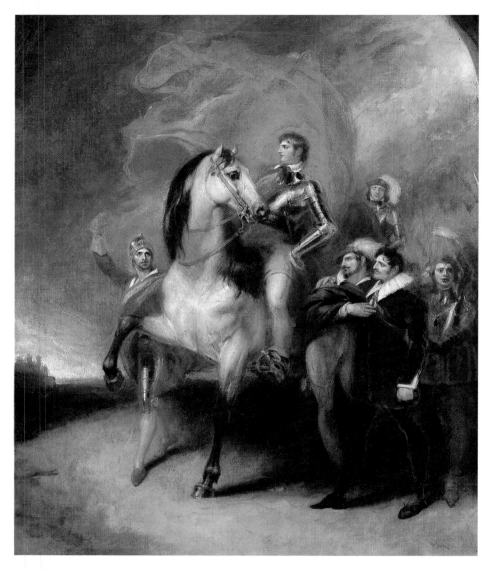

The English army defeated a French force three times its size at Crécy and amongst those killed was the brave, blind King of Bohemia whose motto, *Ich Dien*, and emblem of three ostrich feathers were adopted by the Black Prince in celebration of his victory. The fact that the prince is not wearing these emblems here indicates that the scene depicted is prior to that victory.

The age of Edward III and his son, the Black Prince, had an especial significance for the later Hanoverian kings. George III remodelled Windsor Castle extensively to return it to the chivalrous Gothic of its founder and included a series of large-scale canvases of the life of Edward III by West, including *Edward III with the Black Prince after the Battle of Crécy* of 1788, for the Audience Chamber (Erffa & Staley, 1986, pp. 184-95, no. 58).

As early as 1811–1813, the Prince Regent had himself painted as the Black Prince in a portrait by P. E. Stroehling, now lost. After Waterloo, the Black Prince's victories at the battles of Crécy and Poitiers took on especial importance. This was also represented at Windsor in the remodelling, this time by George IV, which included a new St George's Hall, for dinners of the revitalised Order of the Garter, and the Waterloo Chamber, built to house an annual dinner in celebration of the great victory.

M.J.B.

119. *Edward the Black Prince at the Head of the English Army*

Richard Westall R.A.
(Hertford 1766 – 1836 London)
Oil on canvas, 42⅞ x 35¼ inches
(109 x 89.5 cm)

The outbreak of war with France in 1793 led to fierce feelings of patriotism. One obvious artistic manifestation was the number of paintings and prints of battles and heroes of the war, and another was the search for historical analogies.

The event depicted is almost certainly the Battle of Crécy which took place in August 1346 immediately after Edward III's successful crossing of the Somme. Crécy is situated a few miles to the north of Abbeville which may be indicated by the embattled towers seen in the background at left.

120. *Trueman leads Maria to see the condemned Barnwell in Prison*

David Allan (1744–96)

Pen and grey ink and watercolour, 7½ x 5⅞ inches (18.4 x 14.9 cm)

Inscribed: (top) "George Barnwell Act 5" and (below) "Madam, reluctant I lead you to this dismal scene./This is the seal of misery & guilt. Here awful justice reserves for/publick Victims. This is the entrance to a shamefull death."

PROVENANCE: Mr. Martin's Sale of the Artist's Effects: Edinburgh, 11 February 1797 (sixth day) lot 171 (2), described as "Pr. Sketches from George Barnwell"

George Lillo (1693–1739) produced in 1731 the tragedy *The Merchant* which he soon afterwards renamed *The London Merchant; or The History of George Barnwell*, with George Barnwell played by Theophilus Cibber and that of Maria by Lillo's first wife. A major prototype for the 'domestic drama', *George Barnwell* was shortly after David Allan's death revived again at Covent Garden, 28 September 1796, with Charles Kemble as Barnwell, Mrs. Siddons as Millwood and Miss Pope as Lucy.

M.J.B.

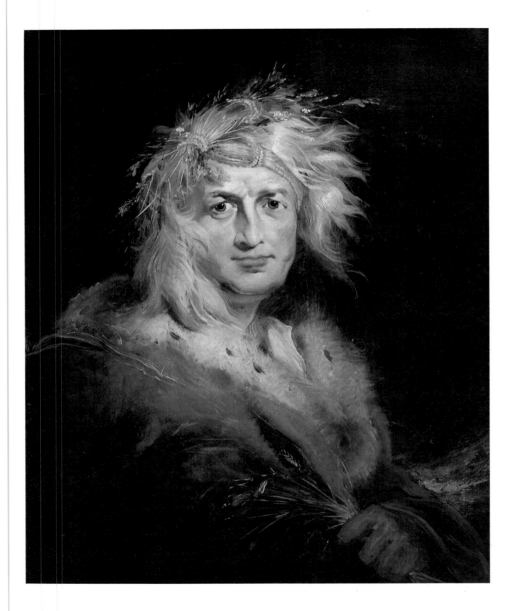

121. *David Garrick as King Lear*

Richard Westall, R.A.
(Hertford 1766 – 1836 London)

Oil on canvas, 28¾ x 23½ inches
(73 x 59.5 cm)

Inscribed on the back of canvas "David
Garrick/as King Lear/by R. Westall
R.A."

PROVENANCE: the Akron Art Institute,
Akron, Ohio

Garrick played King Lear over ninety
times over the course of his career; it was
his most-performed tragic role and
one of his most acclaimed. The present por-
trait vividly conveys the brilliant mad-
ness of Garrick's Lear. Westall con-
tributed numerous illustrations and sev-
eral pictures to be engraved for Boydell's
Shakespeare Gallery between 1795 and
1802, though none of *King Lear*, and this
picture appears to be a specially commis-
sioned independent work.

David Garrick (1717–79) was born in
Hereford, the son of a recruiting officer
of Huguenot descent. He was educated
in Lichfield where he had the good luck
to be a pupil of Dr Johnson. He went
with Johnson to London and then set up
with his brother in the wine trade before
turning to the stage as a writer as well as
a performer. His burlesque drama *Lethe*
was performed at Drury Lane in 1740
and the following year he took a part in
Southern's play *Oroonoko* at Ipswich.

His first classical role came in the fol-
lowing year playing *Richard III* in
London and was greeted by critical ac-
claim. His roles included both comical
and classical and he wrote a number of
lively farces such as *The Lying Valet* and
A Peep behind the Curtains and collabo-
rated with Colman in *The Clandestine
Marriage*. In 1747 he joined Lacy in the
management of the Drury Lane Theatre
and produced there many of
Shakespeare's plays. In 1776 he sold his
share to Sheridan and other investors for
£35,000 and retired, a wealthy man. His
fame as an actor was unsurpassed and in
addition to tributes from Boswell, Fanny
Burney and Burke (amongst many
others) he was painted by Hogarth,
Reynolds, Gainsborough and Zoffany.
The face in the present image, however,
painted after the actor's death in 1774
appears to be based on the death mask
which was drawn by Robert Edge Pine
("with eyes inserted") and published as
a mezzotint in 1779, whilst the composi-
tion is based on the Roman Emperors by
Rubens following Titian and Giulio
Romano.

M.J.B.

122. *Katherine and the Tailor*

Thomas Stothard R.A.

Oil on canvas, 27½ x 21 inches
(70 x 53 cm)
ENGRAVED: James Heath, published 1
May 1803, by J. Heath and G. & S.
Robinson, ns *The Taming of the Shrew*

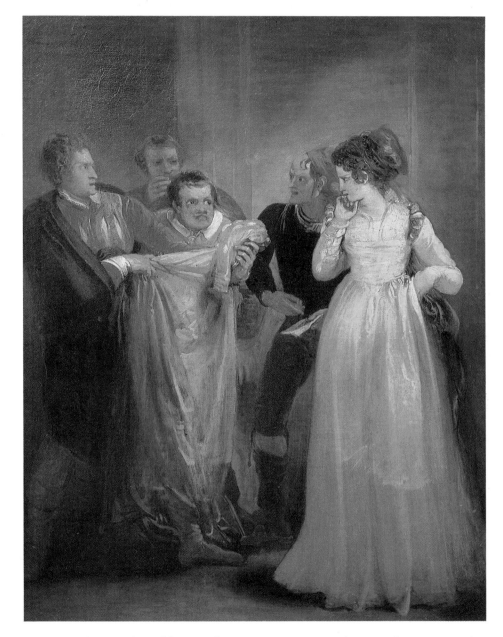

This painting conforms in size to the smaller Boydell canvasses for his Shakespeare Gallery, which were all roughly 30 x 21 inches. Stothard contributed several paintings to the project including *The Meeting of Othello and Desdemona on the Platform at Cyprus, The Masquerade Scene in Henry VIII,* and *Valentine, Protheus, Silvia, and Julia. Katherine and the Tailor* does not seem to have been a subject commissioned by Boydell. George Stevens's edition of the *Dramatic Works of William Shakespeare,* with two illustrations from paintings by Stothard, was published by the Boydells in 1802, and shortly afterwards he contributed 16 illustrations to Manley Wood's edition of 1806 and four for the Longman edition published in 1807.

The play tells the story of two sisters, Katherine, the shrew of the title, and Bianca, who has many admirers but may not marry before her sister. Petruchio undertakes to woo Katherine to gain her dowry and to pave the way for his friend Hortensio who is in love with Bianca. He claims to find Katherine's awful behaviour charming. He arrives late and poorly dressed for their wedding and then takes her back to his country house where he begins in earnest on his campaign to tame her. Claiming that nothing he or his servants can offer her is of a suitable standard for a woman of such refinement and sensitivity, he deprives her of sleep and food and she returns a broken woman, utterly tamed.

The scene, from Act IV, scene 3, shows the arrival of the tailor bringing a sumptuous new dress for Katherine. She likes it well enough, 'I never saw a better fashioned gown,/more quaint, more pleasing, nor more commendable', but Petruchio feigns disgust 'O Mercy, God! what masquing stuff is here?/What's this? A sleeve? 'Tis like a demi-cannon/What up and down, carv'd like an apple tart?/Here's snip and nip and cut and slish and slash,/Like to a censer in a barber's shop.'

Stothard uses the possibilities of the scene to caricature three contrasting moods — Katherine's furious dudgeon to the right, the tailor's appalled disbelief and Petruchio's fained anger, aided and abetted by his servants.

M.J.B.

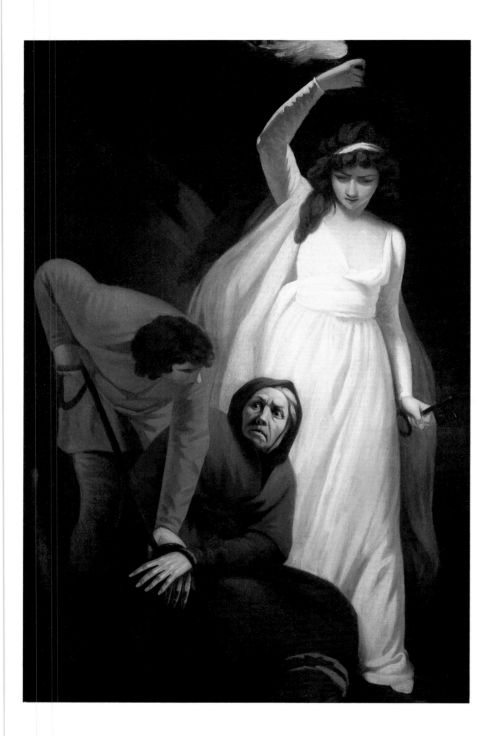

124. *Gil Blas taking the key from Dame Leonarda in the Bandit's Cavern*

John Opie, R.A.
(St Agnes 1761 – 1807 London)
Oil on canvas, 84 x 54 inches
(212 x 138 cm)
PROVENANCE: Christie's, 12 December 1903, lot 73 (24 guineas) to Ziman
LITERATURE: c.f. John Jope Rogers, *Opie and his Works,* London, 1878, p. 213
Ada Earland, *John Opie and his Circle,* London, 1911, pp. 205, 211
c.f. Mary Peter, *John Opie 1761–1807,* Arts Council, exh. cat., London, 1962

The picture shows Gil Blas tying the old crone, Dame Leonarda, to a table leg. Donna Mencia holds a torch and the key with which they will escape from the dungeon.

The novel, *Gil Blas* was written by Alain-René Lesage (1668–1747), regarded as the first major writer in France to live entirely by his pen. He produced over 60 farces and librettos and specialised in picaresque narratives such as *Le Diable Boiteux. Gil Blas* was considered to be his masterpiece and its twelve volumes, each short and eminently readable, were written over the period from 1715 to 1735. They are written with a fine, ironic wit and provide a shrewd but good-humoured presentation of human nature. The eponymous hero starts by telling of his upbringing in Oviedo, as the son of two servants. Pleased with his own intelligence and fancying himself a philosopher he sets out for university at Salamanca. The redoubtable philosopher soon turns out to be a greenhorn and stumbles from one disastrous encounter to another with a series of charlatans and rogues who take advantage of his obvious innocence. Running away from one such encounter, he is accosted in a forest by two elegantly dressed young men who turn out to be highwaymen and take him back to their cave where he becomes scullion to the group of bandits, working under the ugly old cook, Dame Leonarda. After six months of this slavery he becomes the most junior member of the group of bandits and on

his first outing with them waylays a carriage containing the beautiful Donna Mencia de Mosquera whom the bandits take back to their cave as booty. Gil Blas feels sorry for her which, compounded by his self-pity, makes him resolve on a plan of escape. He pretends to have belly ache which gives him the day off from robbing and while the bandits are away he holds up the cook, Dame Leonarda, ties her to a table leg and taking the key to the grate which seals off the cave makes good his escape with Donna Mencia and as much money as they can carry.

The novel was translated into English by Tobias Smollett in 1749, the year after the publication of his own *Roderick Random* which was heavily influenced by it. His translation was immensely popular and had a distinct influence upon English comic novels throughout the eighteenth century. A version with illustrations by Robert Smirke was produced in 1822.

Northcote and Opie were sometimes regarded as existing at opposite extremes as history painters. Opie's pictures were generally praised by his contemporaries for their "depth" and "boldness" whereas Farington records that Northcote's pictures, specifically *The Princes in the Tower*, (cat. no. 49) were praised for their attention to telling details.

Reynolds's goad to Northcote, newly returned from Italy, that Opie was "like Carravaggio, but finer" may seem to overstate the case, but his pictures have a confident flourish, without the overt sensationalism of Fuseli, that appealed to his contemporaries.

M.J.B.

127. *The Battle of Alexandria, on the 21st of March 1801*

Anthony Cardon (1739–1822) after
Philippe Jacques de Loutherbourg
(1740–1812)
Engraving, published 1806 by Anthony Cardon

Loutherbourg's second master, in Paris, was the eminent painter of battles, François Casanova, and between 1763 and 1771 he exhibited at the Salon five battle paintings. Military subjects did not claim his attention again until the end of the decade when he executed the splendid *Mock attack before George III* (1779) and *Review of Warley Camp before George III* (1780) which were presented to the King by the officers concerned (Royal Collection). Catherine the Great commissioned *the Battle between the Turks and the Russians under their General Potemkin near Bender* (Royal Academy, 1783) for which she supplied armour and weapons in order to ensure accuracy, but with *The Battle of Valenciennes*, commissioned by the print dealers V. & R. Green and Christian von Mechel, Loutherbourg emerged as the outstanding battle painter of the Revolutionary and Napoleonic Wars.

This was exhibited in Bowyer's Historic Gallery in 1794, to be joined the following year by his painting of *Lord Howe's victory on 1st June 1794*, which was conceived as a naval pendant. In June 1799 the two paintings were auctioned at Christie's and purchased by Mr T. Vernon of Liverpool who lent them for public display. Powerful public attractions and symbols of patriotic fervour, they were hugely popular, and the engravings after them found an eager market from their publication in 1801. *The Battle of Alexandria* and its companion picture, *The Landing of the British Troops in the Bay of Aboukir* (both in the collection of Lady Abercromby), form part of this series of paintings, including *The Battle of Maida* (cat. no. 134), which confirmed Loutherbourg's pre-eminence in a field strangely neglected by British painters since Wootton.

Antoine Alexandre Joseph (Anthony) Cardon was born in Brussels and trained as a painter in Vienna, before studying in Rome for three years and in Naples where he was trained as a engraver. He worked on the engravings in Sir William Hamilton's *Etruscan Antiquities* and was by the mid-1790s working for Colnaghi in London.

P.C.-B.

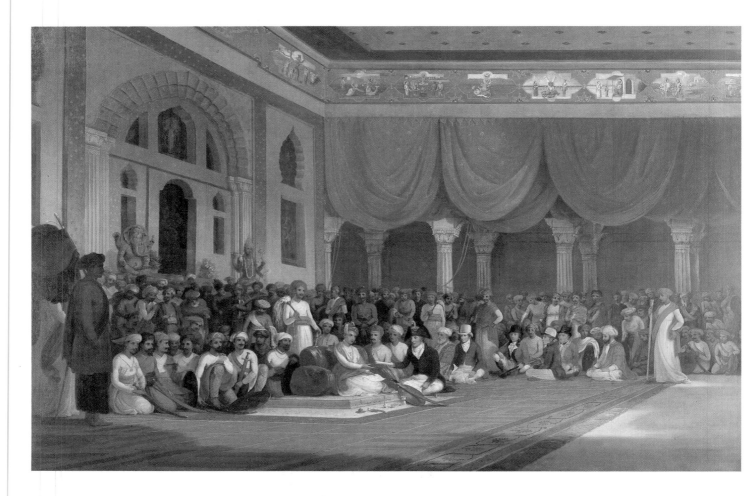

125. *Sir Charles Warre Malet, Bt., the British Resident at the Court of Poona, in 1790, concluding a Treaty in Durbar with Souae Medarow, the Peshwa of the Maratha Empire*

Thomas Daniell (1749–1840)
Oil on canvas, 71⅝ x 109¾ inches
(181.9 x 278.8 cm)
Signed and dated 1805

PROVENANCE; Commissioned by
Sir Charles Warre Malet, Bt.,
By descent to Col, Sir Edward Malet, Bt.;
his sale, Christie's (in conjunction with
Lawrence of Crewkerne)
14 April 1989 (86)

EXHIBITED: Royal Academy, 1805 (1)
Metropolitan Museum, New York,
Costumes of Royal India, 1985–86, p.9
National Portrait Gallery, London, *The*
Raj: India and the British, 1600–1947,
1990–91, pp. 162–63, no. 173

LITERATURE: Mallet, A., *Notices of an*
English Branch of the Malet Family,
London, 1885, pp.60, 141
Sutton, Thomas, *The Daniells: Artists and*
Travellers, London, 1954, p.84
Archer, Mildred, *India and British*
Portraiture, 1770–1825, London, 1975,
pp.352–54
Shellim, Maurice, *India and the Daniells,*
London, 1979, p.66, no. TD60

Thomas Daniell and his nephew William
(1796–1837) arrived in Calcutta early in
1786 and for the next seven years or so
travelled extensively in India, though
they were not present in Poona, 6
August, 1790, when Charles Malet suc-
cessfully concluded the treaty by which
Poona joined forces with Hyderabad and
the East India Company against Tipu
Sultan of Mysore. James Wales (1747–95)
arrived in Bombay in 1791 and was
patronised by Charles Malet who pre-
sumably intended him to commemorate
this important treaty, but Wales died
there in 1795 and when Malet — created
a baronet, 24 February 1791, in recogni-
tion of this services in Poona, and soon

after his appointment as acting Governor of Bombay — returned to England in 1798 he was accompanied by Wales's daughter, Susanna. She brought back many of her father's paintings, drawings and notes, and, after marrying her in 1799, Sir Charles Warre Malet turned to Thomas Daniell to produce the large painting planned by Wales, James Wales, himself, a Scot from Peterhead, had worked in London and exhibited portraits at the Royal Academy and Society of Artists, 1783–91, before coming to India.

Malet is depicted in sobre formal dress, wearing a splendid Chellink set with diamonds on his hat, and this rarely bestowed honour demonstrates the high regard for him at the Court of Poona. Behind him is Joshua Uhthaft, First Secretary of the British Embassy sent by Lord Cornwallis, and their staffs, whilst the Peshwa is seated on a low throne, accompanied by his Chief Minister, Nana Phadnis, and Bahirao Pant Mehendale, his agent for British affairs. Following Tipu Sultan's attack on the Company's ally, the Raja of Travancore, the company had already declared war, but this treaty tipped the balance and Tipu Sultan was defeated and killed at the storming of Seringapatam, 4 May, 1799. the successful conclusionof these affairs in India probably strengthened Sir Charles Warre Malet's determination to commemorate the crucial treaty and the role he had played in it. The execution of the painting occupied Thomas Daniell for several years and after completion it was exhibited at the Royal Academy in 1805.

Thomas Daniell claimed to be a late starter and told Joseph Farington (22 August 1803) that he "did not commence the practise of painting pictures till He was near 30 years of age" (Garlick, Macintyre & Cave, VI, 1979, p.2113), but he had entered the Royal Academy Schools in 1773 and exhibited there from 1774. Back from India by 1794, the Daniells subsequently published, in six parts, 1795–1808, a set of 144 coloured aquatints of *Oriental Scenery* which were a revelation to the British public.

P.C.-B.

129. *Harriet, "Help! Murder! Help Help!"*

Samuel Woodforde R.A.
(Ansford 1764 – 1817 Ferrara)
Oil on paper, Monochrome
ENGRAVED: R. Rhodes, 1808
The drawing is an illustration to *The Jealous Wife*, a play by George Colman the elder (1732–1794) which was performed in 1761. The engraving after this drawing was published as an illustration to *The British Theatre . . . a Collection of Plays . . . acted at the Theatre Royal . . . Printed from the Prompt Books with Biographical and Critical remarks by Mary Inchbald*, vol. 16, London, 1808. The poses of the characters are very similar to the

illustration to *Titus Andronicus* (Act II, Scene 3) which Woodforde painted for Boydell's Shakespeare Gallery.

Samuel Woodforde was patronised for most of his career by the Hoare family of Stourhead. He was placed at the Royal Academy Schools in 1782 thanks to the influence of Henry Hoare and in 1786 he went to Italy travelling to Rome, Florence and Venice in company with Sir Richard Colt Hoare. He first exhibited at the Royal Academy in 1784 and became A.R.A. in 1801 and R.A. in 1807. Although a considerable part of his output was portraits, he also painted subject pictures and history pieces including works for Boydell's Shakespeare Gallery and Macklin's Bible.

M.J.B.

at the Old Water-Colour Society, four at the British Institution and two at the Royal Academy (Cordingly, 1988, p.88). Between 1799 and 1813 more than sixty of his works were engraved for *The Naval Chronicle,* but he last exhibited at the Royal Academy in 1815 and undertook little during the last years of his life.

The German engraver J. C. Stadler was also responsible for engraving two of Loutherbourg's historical paintings, *The Great Fire of London* (published 1799) and *The Defeat of the Spanish Armada.*

P.C.-B.

133. *The Murder of King Henry VI in the Tower of London*

Samuel Woodforde R.A.
(Ansford 1764 – 1817 Ferrara)
Oil on paper, 5 1/2 x 6 7/8 inches
(14 x 17.5 cm)
ENGRAVED: Butler

Henry VI was murdered in the Tower of London where he had been imprisoned following the Lancastrian defeat at the Battle of Barnet. Richard of Gloucester (later Richard III) was widely believed to be responsible for the act.

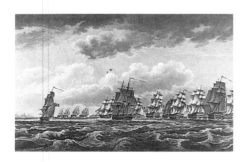

130. *The Theseus leading the Squadron near the Isle of Grouais . . . 24 Feb:y 1809*

Joseph Constantine Stadler
(active in London 1780–1812) after
Nicholas Pocock (1740–1821)
Aquatint and etching, published 23 September 1809 by Nicholas Pocock
From the collection of the Duke of Roxburgh, Floors Castle

Depicting the Fleet action to prevent the French fleet from Brest joining up with the Squadron from l'Orient, this print is representative of the large production of Nicholas Pocock during the war years. Despite celebrating his 70th birthday in 1810, he exhibited that year 18 pictures

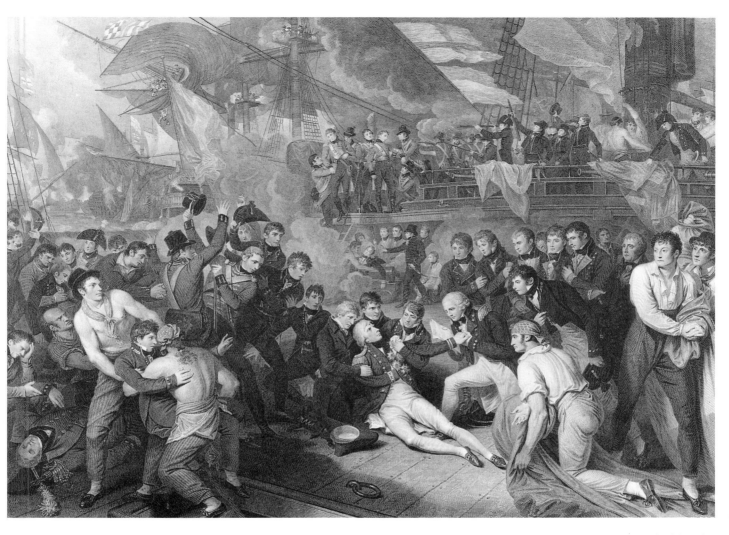

126. *The Death of Lord Nelson*

James Heath (1757–1834) after
Benjamin West (1738–1820)
Engraving, published 1 May 1811 by
Benjamin West and James Heath

As Charles Mitchell (1967, p.267) has
most succinctly observed: "West did not
represent Nelson dying, as he did, in the
cockpit of the *Victory* but on the open
deck. And around the Hero, in a single
synoptic and synchronistic vision, he dis-
played all the contributory moments and

characters of the victorious day".

The immensely detailed painting (70 x
96 inches; Walker Art Gallery, Liverpool)
had been finished by the indefatigable
West in just under six months and it was
displayed in his studio from May 1806.
However, the manipulation of history by
West is complicated by the promise he
claimed to have given Nelson, in 1804,
that he would execute a painting of his
death scene which would be a com-
panion piece to his *Death of General Wolfe*
which Nelson admired so much.

In a conversation with Joseph

Farington in 1807, West justified his de-
liberately inaccurate depiction of
Nelson's death in terms of his ideas
about Epic Composition and linked it
specifically to his earlier *Death of General
Wolfe* (cat. no. 18):

there is no other way of repre-
senting the death of a Hero but by
an Epic representation of it. It must
exhibit the event in a way to excite
awe & veneration & that which may
be required to give superior interest
to the representation must be intro-
duced, all that can shew the impor-

119

tance of the Hero. Wolfe must not die like a common soldier under a Bush, neither should Nelson be represented dying in the gloomy hold of a ship, like a sick man in a Prison Hole. To move the mind there should be a spectacle presented to raise & warm the mind, & all shd. be proportioned to the highest idea conceived of the Hero. No Boy, sd. West, wd. be animated by a representation of Nelson dying like an ordinary man, His feelings must be roused & His mind inflamed by a scene great & extraordinary. A mere matter of fact will never produce this effect.

The accuracy of West's observations were demonstrated well by the lukewarm public response to Arthur William Devis's much more accurate *Death of Nelson* (National Maritime Museum, Greenwich) which was completed in 1807 and exhibited at the British Institution in 1809.

Whereas James Heath took twelve years to complete his engraving of *The Death of Major Pierson,* four years sufficed for *The Death of Lord Nelson* which he engraved on a plate close in size to that of *The Death of General Wolfe.*

P.C.-B.

131. *Study for "Gertrude of Wyoming"*

Samuel Woodforde R.A.
(Ansford 1764–1817 Ferrara)
Oil on paper, monochrome,
9¾ x 16¼ inches 24.7 x 41.5 cm
Inscribed in pencil *Gertrude of Wyoming*

Gertrude of Wyoming is a poem by Thomas Campbell published in 1809. It was very popular and describes the destruction of the settlement of Wyoming in Pennsylvania by a force of Indians under Mohawk Brandt and of the deaths of Gertrude, the newly married wife of Sir Henry Waldegrave, and her father Albert. The characterisation of Brandt shows the ambiguity of opinion towards Indians in the eighteenth century. Brandt (also known as Thayendamage) was a real person; an educated Mohawk who served as secretary to the Superintendent

of Indian Affairs in upstate New York. When he visited England in 1775 he was fêted as a "noble savage" and painted by Romney. Campbell's later attack is therefore a curious reversal and in fact Campbell did later withdraw the slur. Gertrude is depicted seated on the ground, before Brandt and his tomohawk appear on the scene, reading her book amidst lush vegetation of the New World in a pose reminiscent of Wright's *Sir Brooke Boothby*, holding his a copy of Rousseau.

M.J.B.

128. *The Pilgrimage to Canterbury*

Luigi Schiavonetti (1765–1810)
and James Heath (1757–184) after
Thomas Stothard (1755–1834)
Etching and engraving; no publisher or publication date

Etched by Luigi Schiavonetti and engraved by James Heath in the same sense as the painting, Thomas Stothard's achievement in *The Pilgrimage to Canterbury* is remarkable, both for the antiquarian precision of the costumes worn by Chaucer and his companions, and the sensititve adaptation of the format of a 15th century Italian *cassone* panel for its emotive effect. The dresses of these medieval pilgrims follow faithfully the examples of 14th century travelling clothes made available by Joseph Strutt in his *Complete View of the Dress and Habits of the People of England* (1796–99) when he produced the first systematic documented history of dress from the earliest times down to the close

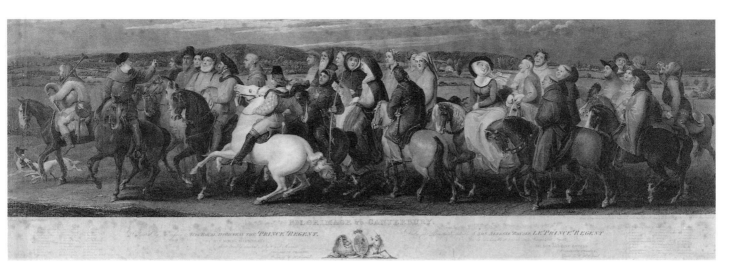

of the 15th century (Strong, 1978, p.51). The composition of Stothard's painting (1806–07; Tate Gallery) develops from Strutt's technique of bringing together costume figures from different sources into carefully constructed tableaux, but there is here an organic coherence and spontaneity which eluded Copley when he exploited the same process for his *Charles I Demanding in the House of Commons the Five Impeached Members.* Indeed, Stothard goes far beyond West and the Americans and here lays the foundations for the historical reconstuctions of Ford Maddox Brown and the Pre-Raphaelites.

William Blake's larger engraving of *Chaucer's Canterbury Pilgrims* (12¼ x 37⁹⁄₁₆ inches), was published 8 October 1810 and, pre-empted by Stothard's engraving, it was not a commercial success. Blake was very proud of the archaeological accuracy of the costumes depicted and a combination of the two engravings encouraged a new interest in cavalcade subjects.

P.C.-B.

132. *The Angel at Christ's Tomb Addressing the Holy Women*

Samuel Woodforde R.A.
(Ansford 1764 – 1817 Ferrara)
Oil on paper, 7⅝ x 12½ inches
(19.5 x 31.8 cm)

The incident is the same depicted by West in his Holy Sepulchre (cat. no. 8). the appearance of the angel at the Sepulchre is described in all four gospels but Matthew's with its descriptions of waking guards and a shining angel appealed the most to early nineteenth century artists. Woodforde has made the brilliantly shining angel the focus of his composition contrasted against the figures of Mary Magdalene, Mary the mother of James and Salome who are recorded as visiting the tomb "as it began to dawn".

M.J.B.

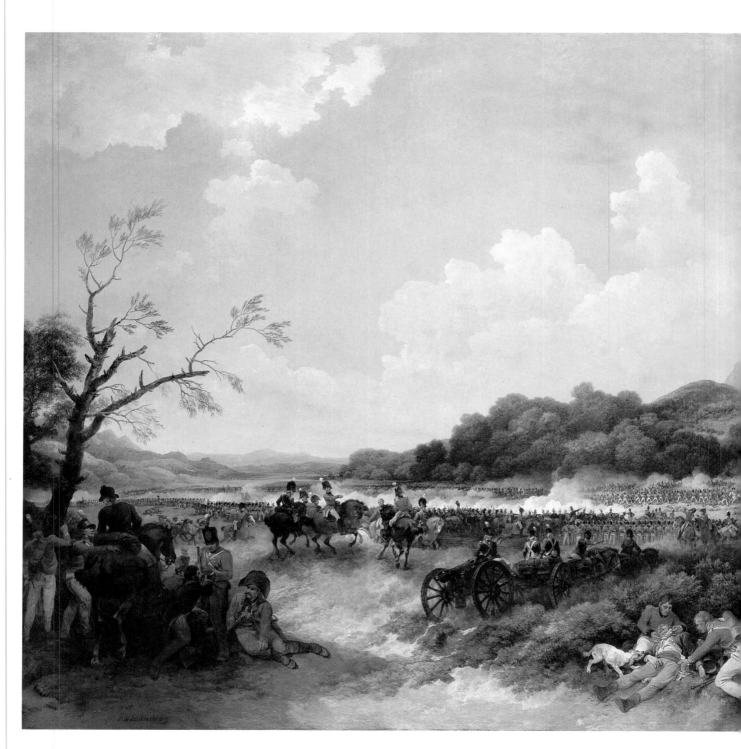

134. *The Battle of Maida*

Phillipe Jacques De Loutherbourg
(Strasbourg 1740 – 1812 Chiswick)
Oil on canvas, 60 x 84¾ inches
(152 x 214.7 cm)
Signed lower right
*LITERATURE: Philippe Jacques de
Loutherbourg, R.A., 1740–1812,* Kenwood,
2nd June–13th August 1973 (exh. cat.)
p.46 as 'untraced' Harold Acton, *The
Bourbons of Naples*
ENGRAVED: Anthony Cardon 1810
with key

The Battle of Maida, fought in southern Italy, 4 July, 1806, one of a series prior to the Peninsula War, was a famous victory won by a combined army of British and Corsican forces ranged against an army of French and Polish units. Led by Major General Sir John Stuart, the army disembarked from ships and marched to the valley of the river Amato where they engaged the enemy, commanded by General J. L. Reynier, near to the little town of Maida. Reynier and Stuart had previously faced each other at the Battle of Alexandria (see cat. no. 127).

This time the aim of the British action was to deflect the French forces from invading Sicily and they succeeded in this although dysentery amongst the troops did not allow them to push home the advantage gained by taking Naples itself.

De Loutherbourg's painting shows the period of action after the British Light Infantry had charged the left wing of the French army and routed them in a bayonet charge. It appears to be based in its essential details on the print published by W. Faden in April 1807, which shows the same moment of the battle, but the dry and schematic nature of that print is here transformed into a more dramatic and exciting depiction. By raising the viewers standpoint so that it appears that we look out over the battleground from a ridge, a better, more perspectival view of the scene shows the principal figures and regiments with greater clarity, and a sketch map by Loutherbourg in the British Museum (Album 201C5, No. 37), outlining the position of the various forces, shows some-

thing of his working method.

The groups of figures in the foreground introduce us to some of the participants in the drama. At left the group around a tree, which appears to have been invented by de Loutherbourg as an effective means of closing the composition, are a Polish prisoner and a French dragoon prisoner kneeling before a standing British Infantryman, who offers them a drink from his flask, whilst seated on the ground to the right of the group is a wounded Calabrian ally with moustache and distinctive hat. To the right, a British army surgeon dresses the wound of a French prisoner assisted by a medic, and a Calabrian friar administers the last rites to a dying soldier, while a Calabrian soldier in the centre of the group attempts to follow the battle.

Beyond this genre of human activity, the main action rages. On a knoll in the middle distance, surveying the scene of the battle are the commanders of the British force. At the centre of this group and seen side-on is Sir John Stuart, gesturing and issuing an order to Porter, his orderly dragoon (mounted messenger). Between them can be seen the heads of Captain Desade and Lieut. Nicholas, part of Stuart's suite of officers, while one of the two horsemen at the right of the group is Lieut. Colonel McLeod, commanding the 78th Highlanders. The group of three horsemen to the right, above the figures of the surgeon dressing a French prisoner's wound, are Colonel Oswald and Captain Cust, with slightly to their right and beyond them Major McCoomber, commanding the Corsican section of the Light Brigade. On the far bank of the river other notables can be picked out. At the right, in the thick of the firing, with his arm raised, is Captain Church, commanding the Corsican Rangers, and to the left of him is Lieut. Colonel Kempt, one of the brigadiers.

The reason for the depiction of so many individuals is doubtless due to the acknowledged fact that the victory of a force of just under 4,800 British troops, against 7-8,000 French, on unfavourable terrain, with only 327 British killed and wounded, was as much the result of

quick-witted and competent reactions by individual commanders, as any grand overall scheme. J. W. Fortescue (*History of the British Army*, Vol. V) has pointed out that "The Brigadiers were, taken together, a far abler lot of officers than were generally to be found in a British force; Coile, Kempt, Oswald and Ross being all men who made their mark later in the Peninsula. Any one of the four would have made a better commander than Stuart". The forthright judgement of this last sentence would not have been allowed at the time, but it seems to have been generally admitted that the victory was at least in part a corporate effort and a vindication of army training of the period.

In 1807, the year that he painted the *Battle of Maida*, Loutherbourg was at last given an official title as 'Historical Painter to the Duke of Gloucester' and in 1810 a stipple engraving after the painting was produced by Anthony Cardon, together with a key. The worn condition of some copies of this implies that the edition was large and the image popular.

<div align="right">P.C.-B.</div>

135. *Scenes from Ossian*
Robert Smirke R.A.
(Wigton 1753–1845 London)
Three sheets showing six scenes
Pencil, pen and wash on paper
2 sheets at 5 x 8⅛ inches (12.7 x 20.5 cm)
1 sheet at 3⅝ x 6¼ inches (9.2 x 8⅛ cm)

These six scenes were designed by Robert Smirke to form a frieze around the entrance hall and staircase landing of Kinmount, the Dunfriesshire house built by the 5th Marquess of Queensbury. Sir Robert Smirke, the artist's son was the architect of the house, which was designed in 1812, and it is therefore likely that he commissioned the decorations from his father.

These working sketches, in one case marked 'landing' show Smirke's method of adapting his pictorial ideas to the commission and the relative freedom with which he approached the task of designing a frieze at a time when the revered examples of the Parthenon and

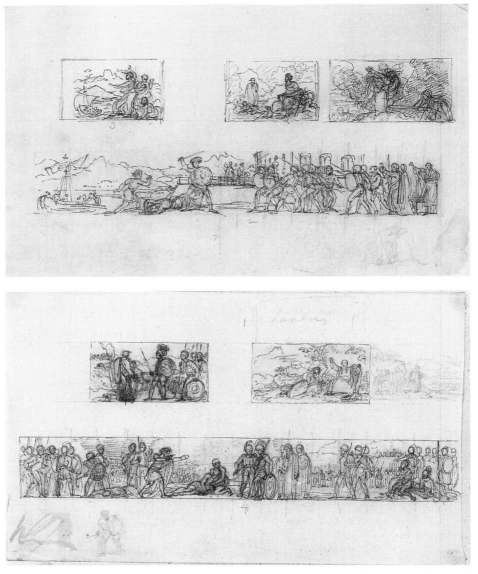

Bassae friezes must have hindered spontaneity.

Ossian, or Oisin, was a legendary Gaelic warrior and bard. A series of old ballads were interwoven by James Macpherson who added a considerable amount of his own invented poetry and passed the whole off as *An ancient Epic Poem in six Books . . . composed by Ossian, the son of Fingal*. Critics, notably Samuel Johnson, doubted their originality and they were exposed as an imposture after Macpherson's death. Nonetheless, they had considerable success. Goethe and Napoleon both admired the poem, and even as late as 1866 Matthew Arnold wrote of them saying 'You can see, even at this time of day what an apparition of newness and power such a strain must have been to the eighteenth century'.

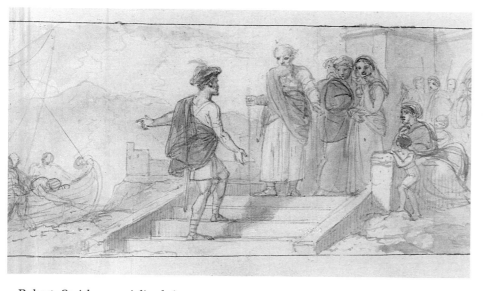

PROVENANCE: Baroness Susan North (1797–1884), Petersham Castle (sale, 14–15 July 1885, Sotheby's, London) Julius Hess, Switzerland (sale, Gutekunst und Klipstein, Bern, 1–2 December 1941, lot 938)

The episode is taken from the trilogy of plays, *The Oristeia*, by Aeschylus. Orestes was the son of Agamemnon and Clytemnestra. He was only a child when his father was murdered by his mother and her lover, Aegisthus. Fearing revenge, his mother and sister, Electra, sent Orestes to be raised at the court of Strophius. When he grew up, he returned home and revealed his identity to Electra and, with her assistance, avenged his father's murder. As a consequence of this matricide, Orestes wandered in madness around the countryside haunted by the Fates or Eumenides. In Athens he was brought to trial and acquitted, and ultimately reclaimed his father's kingdom.

Robert Smirke specialised in scenes from literature and the theatre, often with a humorous content and his work included work for Boydell's and Bowyer's galleries. Known as the Abbé Seyes of the Academy, Smirke was regarded as a determined in-fighter amongst the members of the fledgling Academy — that 'nest of vermin' as Northcote described them. He was also recorded as a man of 'strong likings and dislikings' and it was his 'radical' views that led George III to refuse, in 1804, to accept the Academy's appointment of him as Keeper.

For all this his paintings have considerable accomplishment and charm and his drawings show a brilliantly lively technique.

M.J.B.

137. *Orestes, Following the Murder of Clytemnestra and Aegisthus*

Henry Fuseli, R.A.
(Zurich 1741 – 1825 London)
Black and white chalk, 14½ x 18 inches
(37 x 45.7 cm)
Watermarks: "Strassburger Lilie mit angehangter Glocke"
"L.V.C." stamped on reverse: "Baroness North's Collection of/Drawings by H Fuselli &c" (Lugt no. 1947)

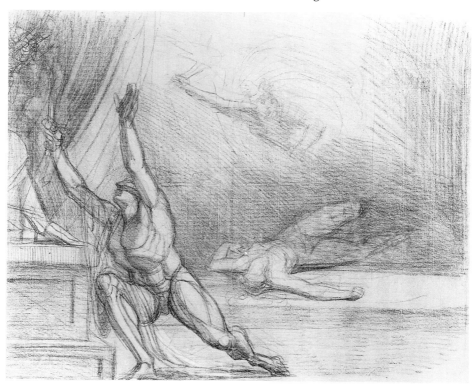

Prof. Gert Schiff has confirmed Fuseli's authorship of this drawing, dating it to around 1815–17. Baroness North and her family were friends of Fuseli. A large number of Fuseli's drawings from her collection illustrating Shakespeare, Milton, Dante, etc., appeared in the A. O. Meyer sale, Boerner, 19–20 March 1914, when most were acquired for the museums of Dresden and Basel. On the reverse of the present sheet there is a study for the figure of Orestes.

M.J.B.

136. *Horatia Nelson Kneeling before her Father's Tomb*

William Owen
(Ludlow 1769 – 1825 London)
Oil on canvas, 50 x 40 inches
(127 x 101.5 cm)

Horatia Nelson was the love child of Horatio, Viscount Nelson, and Emma, Lady Hamilton, but she lived and died in ignorance of the fact and was generally believed to have been Nelson's adopted daughter. Armed with documentary evidence in an age of kiss-and-tell we now see her life in a quite different light to that of her contemporaries. For them she was a token of the cult of sensiblity — an orphan, raised from the gutter by one of the nation's most esteemed heroes to a happy family life only to be left, cast adrift once more, after his death.

Horatia was born in great secrecy in 1801. A second child, Emma, was born some time afterwards but died in infancy. A bust of Horatia by Christopher Prosperi, exhibited at the Royal Academy in 1811, and a miniature by James Kolner painted in later life confirm her astonishing likeness to her father. Despite this, Nelson always referred to her as his adopted daughter and despite making exhaustive enquiries she was never able to discover the identity of her real parents. Nelson clearly considered the deception desirable for her sake, and the plate and smaller tokens given by him and now at the National Maritime Museum at Greenwich reveal him as a loving and

generous father. In 1822 she married the Reverend Philip Ward who changed his name to Nelson-Ward and they raised a large family. She died in 1881 and the inscription on her tomb reads "the adopted daughter of Vice-Admiral, Lord Nelson". Six years later a collection of letters between Nelson and Emma Hamilton came to light which conclusively proved the relationship between father and daughter.

A version of this picture, in inferior condition, exists in the National Maritime Museum at Greenwich (BHC 2885) Acquisition No. (1946-437.37).

William Owen came to London in 1780 and was firstly apprenticed to Catton the coach painter. He preferred figure

painting and so, in 1791, entered the Royal Academy Schools. An A.R.A. in 1804 and R.A. in 1806, he was appointed portrait Painter to the Prince of Wales in 1810, on the death of Hoppner, and Principal Painter to the Prince Regent in 1813. He eschewed the sparkle and flash of Lawrence, preferring a considered, sober approach which especially suited his depictions of children and elderly sitters.

M.J.B.

138. *The Battle of Waterloo, on the 18th of June, 1815*

John Burnet (1784–1868) after
John Augustus Atkinson
(1775–after 1831) and
Arthur William Devis (1762–1822)
Line engraving with etching, published 18 June 1819 by Hurst Robinson & Co. (late Boydells)

Following the examples set by Loutherbourg in the overall treatment of the composition, John Augustus Atkinson collaborated with Arthur

William Devis for the large number of portraits included in *The Battle of Waterloo*. The finished painting was exhibited at the Royal Academy in 1816 (517) and the drawn modello for the engraving was prepared by the engraver, John Burnet. Atkinson paid an early visit to St. Petersburg with an uncle, but he returned to England in 1801, publishing two years later *A Picturesque Representation of the Manners, Customs and Amusement of the Russians*, with 100 plates drawn and etched by him. Arthur William Devis is best known for the set of 26 paintings he executed in India,

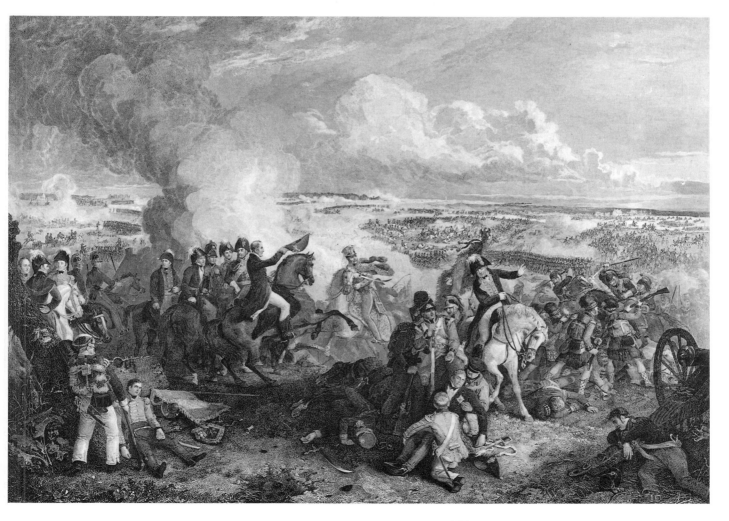

1793–95, to be engraved, illustrating 'the arts, manufactures and agriculture of Bengal', but after his return to England in 1795 he painted mainly portraits. John Burnet was born in Edinburgh and learned etching and engraving from Robert Scott. A fellow pupil with William Allen and David Wilkie, he came to London in 1806 and maintained close contact with Wilkie, executing a series of engravings after his paintings, including *the Chelsea Pensioners reading the Gazette of the Battle of Waterloo*.

P.C.-B.

139. *Combat Between Black Douglas and De Kylaw*

Henry Perlee Parker
(Davenport 1795 – 1873 London)
Oil on canvas, 70¼ x 54¾ inches
(178.5 x 139 cm)

Signed and inscribed on reverse:
"Combat between The/Black Douglas and/De Kylaw, a Northern/Borderer/ Vide Ridp/AD 1816/H.P. Parker pinxit/Newcastle on Tyne"

Sir James Douglas of Douglas was a famous hero of border history. Known as 'the Good' and also 'the Black' (the latter because of his swarthy skin) he lived from *c*.1286 to 1330. Having been dispossessed by King Edward I, he sided with Bruce after his coronation at Scone in 1306 and became his most able lieutenant. He was given control of the South of Scotland which he soon cleared of any remaining English, and launched several retaliatory raids into England, creating such havoc that several towns willingly bought immunity for fixed periods at a high rate. He was largely responsible for the retaking of Edinburgh and Roxburgh castles and was knighted after the Battle of Bannockburn.

He was dreaded throughout the north of England and numerous tales were told about his personal bravery in battle and his brilliance as an inventive tactician. Various attempts were made to destroy his stronghold at Lintalee, but all failed, and in 1319, in order to divert the

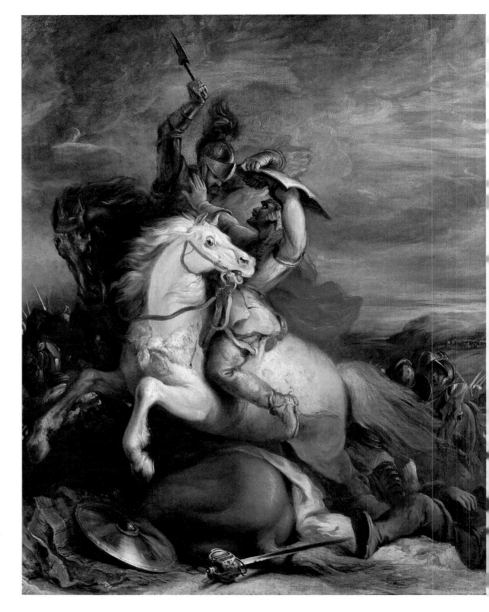

English army then besieging Berwick, he launched a counter-attack which penetrated as far as Yorkshire where between eighty and ninety towns were destroyed. Sir Walter Scott based his romance *Castle Dangerous* upon Douglas's destruction of his own castle to prevent its being cap-

tured and Douglas's exploits were widely written about in other historical romances in the early nineteenth century.

Henry Perlee Parker first set up as a portrait painter in Plymouth, but moved to Newcastle in 1815 and remained there

until 1841. His later genre scenes earned him the nickname 'Smuggler' Parker, but it is interesting to see him painting history pieces at this early stage in his career, the year before his first exhibit at the Royal Academy. Several of his paintings dealt with local subjects, the most famous being *The Rescue of the Forfarshire Steam Packet* by Grace Darling and her father, and he repeated this act of local piety after moving to Sheffield in 1841, with a picture of the locally-born sculptor, Sir Francis Chantrey, as a boy carving a walking stick handle.

The present picture shows an accomplished and complicated grouping of figures and is based in many of its details upon De Loutherbourg's *Richard the First in Palestine* and *The Battle of Bosworth Field*, two pictures engraved for Bowyer's edition of Hume's *History of England*. The diagonal grouping of the central horsemen is common to both, while the raised axe comes from the former painting and the clawing hand plucking at the shield from the latter. The style of the painting with its distinctive facial characteristics, and the fascination with gleaming metal edges against a dark background, is more typical of Henry Tresham, to whom this picture was attributed before relining revealed the inscription on the back of the canvas. *The Earl of Warwick's Vow Previous to the Battle of Towton*, by Tresham, which had been shown at the Royal Academy in 1797 and engraved, is similar in several particulars.

The age of Boydell's "noble patronage" was ended before Parker's career began but this picture shows that at the age of twenty-one he had sufficient mastery to have made a creditable contribution to any of the galleries which had flourished before the Napoleonic Wars killed them off.

M.J.B.

140. *Kriemhild and the Dead Siegfried*

Henry Fuseli, R.A.
(Zurich 1741–1825 London)
Black chalk with india ink wash on paper, 15⅛ by 19⅞ inches (38.5 by 50.5 cm)
Watermark, upper left: "J. Whatman/ 1810"
Inscribed in pencil on reserve: "Kreimhilde und der tote Siegried"
Stamped on reverse: "Baroness Norths' Collection of/Drawings by H. Fuselli &c" (Lugt no. 1947)
PROVENANCE: Baroness Susan North (1797_1884), Petersham Castle (sale, 14–15 July 1885, Sotheby's, London) Julius Hess, Switzerland (sale, Gutekunst und Klipstein, Bern, 1–2 December 1941, lot 940)

The scene is taken from *The Nibelungenlied,* a German poem of the thirteenth century that again became popular in the nineteenth century. Siegfried, the Prince of the Netherlands woos and marries Kriemhild, a Burgundian princess. One of Kriemhild's brothers, Gunther, wishes to marry Brunhild, Queen of Issland, and Siegfried offers to help him by defeating her in trials of skill and strength, which he succeeds in doing. A double marriage takes place. For Siegfried and Kriemhild it proves to be the start of a short but happy time, but Brunhild remains truculent and Gunther has again to ask Siegfried for his help. Siegfried obliges and dressed as Gunther he subdues her and takes away her ring and girdle which he gives to Kriemhild. In the course of time the two queens quarrel and Kriemhild reveals the deception to Brunhild who is furious. Gunther's servant Hager, misreading the course of events, believes that his master's honour has been hurt by Siegfried and so he kills him surreptitiously during a hunt.

The drawing shows the grief-striken Kriemhild mourning over the body of the dead Siegfried, her collapsed body emphasised by the long flowing lines of

the drapery contrasted with the rigid form of her dead husband.

Fuseli was one of the first artists to draw inspiration from the Nibelungenlied. The present compositional study which can be dated *c.*1820–1825 was seen by Prof. Gert Schiff, who noted its authenticity and connections to Fuseli's earlier Nibelungen illustrations.

The sheet bears a simpler version of the same composition on its reverse.

M.J.B.

141. *Shakespeare between Tragedy and Comedy*

Richard Westall R.A.
(Hertford 1766 – 1836 London)
Oil on panel, 44⅛ x 42⅛ inches
(112 x 107 cm)
Signed and dated: "R Westall R.A. 1825"

Shakespeare is seen seated in a golden throne, dressed in Jacobean costume. Behind him, floating on a cloud, is the character of Comedy, dressed in a diaphanous costume, her curls and dress floating in the breeze while she toys with his hand. Shakespeare, who has clearly been flirting with Comedy turns to Tragedy, dressed in a plain black cloak, trailing dark clouds of doom and commands her with a gesture to stay. Around Shakespeare's feet grow wild flowers, whilst in the middle, between Tragedy and Comedy, grows a vine whose product may promote either mood.

The most obvious prototype for this painting is Reynolds's *Garrick between Tragedy and Comedy* of 1761 which showed Garrick, in Richard Cumberland's couplet, "twixt the Tragic and the Comic muse,/courted of both, and dubious where to choose". Reynolds's painting was a burlesque of Renaissance and Baroque depictions of 'The Choice of Hercules', culminating in Paolo de Matteis's painting executed to the detailed instructions of the 3rd Earl of Shaftesbury (1671–1713) and now in the Ashmolean Museum, Oxford. In these, the hero, forced to choose between

Vice and Virtue, chooses the path of Virtue. In Reynolds's depiction, by contrast, Garrick appears considerably more inclined to take the road offered by Vice in the guise of Comedy.

Westall's picture differs in various important essentials from that of Reynolds. Here the young Shakespeare is seated in judgement, not torn between the characters who attempt physically to lead him. Psychologically, if not mythologically, the scene is closer to a Judgement of Paris than the choice of Hercules. Nonetheless, there are elements of the Hercules myth which are more fully

realised here than in Reynolds's work. Westall was an amateur poet who published a collection of his own verse illustrated by himself. Thus it is likely that he knew Joseph Spence's translation of Prodicus's *Choice of Hercules* which described Comedy or 'Pleasure' as "All soft and delicate, with airy swim/Lightly she danc'd along; her robe betray'd/Thro' the clear texture ev'ry tender limb,/Height'ing the charms/it only seem'd to shade." Westall's figure of Comedy seems to conform exactly to this description.

It was pointed out by contemporary

critics that the figures of Tragedy and
Comedy in Reynolds's work betrayed
elements of the styles of Reni and
Correggio respectively. Westall's
painting appears to show a similar use of
different painterly styles. The figure of
Tragedy is Neo-Classical in its linearity,
and its strict profile and confined gesture
are similar to John Flaxman's illustra-
tions to Homer. The figure of Comedy,
by contrast, with her pretty face, de-
picted three-quarter, and graceful
charms, is of a type comparable with the
slightly risqué pin-up girls painted by
the Revd. Matthew William Peters
(1741/42–1814). Another variant on the
theme was George Romney's picture
Shakespeare nursed by Tragedy and Comedy,
painted for Boydell's Shakespeare
Gallery which showed the infant
Shakespeare doted upon by his two com-
peting nursemaids.

M.J.B.

142. *Bertalda Frightened by Appearances*

Theodore Matthias Von Holst
(1810 – London – 1844)
Oil on canvas, 31¼ x 24¼ inches
(79.5 x 61.5 cm)

In March 1848 Dante Gabriel Rossetti
wrote his first letter to Ford Madox
Brown asking to be taken on as a pupil.
In it he referred to an outline drawing by
Brown that Rossetti had cut from an
illustrated art periodical. "The outline . . .
constitutes, together with an engraving
after that great painter Von Holst, the
sole pictorial adornment of my room".
Rossetti was obviously deeply influ-
enced by Von Holst; his early drawings
are clearly indebted to him and he wrote
a poem based on Holst's picture *The
Fortune Teller,* but others shared his high
opinion. Holman Hunt's diary of 1855
records Millais, Collins and Michael
Rossetti dining at Campbell's Skotch
Stores off Regent Street, for which choice
Michael Rossetti explained: "The PRBs
had a liking for this dining-room as it
was hung around with pictures by
Theodore Von Holst." Probably the clear

forms and unclouded colours of much of Von Holst's work pleased the Pre-Raphaelites, as did his subject matter, for Holst was very much a painter of literary subjects and, other than Goethe and Shakespeare, his source of inspiration was the contemporary Gothic and Romantic literature which looked back to a time well before the Augustan poets and "Sir Sloshua" Reynolds.

The authors whom Von Holst chose to illustrate included Hoffmann, Victor Hugo, Walter Scott and Bulwer-Lytton, the latter becoming a patron of his. He was also chosen to execute two illustrations for the 1831 edition of Mary Shelley's *Frankenstein*. The episode illustrated is taken from the fairy romance *Undine* by Baron de la Motte Fouqué (1777–1843), first published in 1811. A fisherman and his wife, having lost their daughter by drowning, adopt and bring up Undine in her place. Unknown to them she is in fact a nymph, personification of the water element, and suitably capricious in her behaviour. The Knight Huldbrand von Ringstetten shelters in their cottage and falls in love with Undine. They marry and she acquires a soul as a result. Her kinsmen, however, dislike the arrangement and cause trouble. Huldbrand neglects Undine and falls in love with Bertalda, who, though apparently well born, is in truth the fisherman's lost daughter. One day, in a boat on the Danube, Huldbrand, tormented by Undine's family of sprites, chastises his wife and she is snatched away by them into the water. Assuming her to be drowned, Huldbrand proposes to Bertalda: they are about to be married when Undine, rising from a well, goes to Huldbrand's room, kisses him and he dies.

In the incident depicted here, Bertalda, who is impossibly proud, is set upon in a passage of the castle in which she lives by sprites including Undine's uncle Kuhleborn, the evil water goblin seen at left. They humble her by telling her of her true parents.

Von Holst became a student at the Royal Academy Schools when only ten years old. There he became the favourite pupil of the Professor of Painting, Henry Fuseli, whose style had a decided influence upon him as evidenced by the figures of the sprites, yet his own treatment of these characters is idiosyncratic. Gert Schiff has pointed out the similarity between certain of Von Holst's figures and those in early Netherlandish scenes of *The Temptation of St Anthony*.

Gert Schiff also outlines three distinct periods in Von Holst's stylistic development of which this picture conforms to the third, mature, phase. In similar paintings Schiff praises "an audacious verve, a quivering nervousness, yet at the same time . . . an almost trance-like firmness".

M.J.B.

BIBLIOGRAPHY

Aitken: *A View of the Character and Public Services of the late John Howard*, London, 1792.

Alberts, Robert C.: *Benjamin West, a Biography*, Boston, 1978.

Alexander, David: "The Dublin Group': Irish Mezzotint Engravers in London', *Quarterly Bulletin of the Irish Georgian Society*, XVI, 1973, pp.72-93.

Alexander, David: '"After-Images": a review of recent studies of reproductive print-making', *The Oxford Art Journal*, VI. 1983, pp.11-17.

Alexander, David: *Affecting Moments, Prints of English Literature made in the Age of Sensibility, 1775–1800*, York (exh. cat.), 1986.

Alexander, David & Godfrey, Richard T.: *Painters and Engraving: The Reproductive Print From Hogarth to Wilkie*, New Haven (Yale Center for British Art exh. cat.), 1980.

Allen, Brian: 'Francis Hayman and the Supper-Box Paintings for Vauxhall Gardens', *The Rococo in England: A Symposium*, ed. Charles Hind, London (Victoria and Albert Museum), 1986, pp.113-33.

Allen, Brian: *Francis Hayman*, New Haven/London (exh. cat.), 1987.

Altick, Richard D.: *Paintings from Books: Art and Literature in Britain, 1760–1900*, Columbus (Ohio), 1985.

Archer, Mildred: *India and British Portraiture, 1770–1825*, London, 1979.

Archer, Mildred & Lightbown, Ronald: *India Observed; India as viewed by British Artists, 1760–1860*, London (Victoria and Albert Museum (exh. cat.), 1982.

Archibald, Edward H. H.: *Dictionary of Sea Painters*, Woodbridge (Antique Collectors Club), 1980.

Armstrong, Walter: *Sir Joshua Reynolds*, London/New York, 1900.

Ashton, Geoffrey: *Shakespeare, His life and work in paintings, prints and ephemera*, London, 1990.

Ashton, Geoffrey & Mackintosh, Iain: *The Georgian Playhouse — Actors, Artists, Audiences and Architecture, 1730–1830*, London (Hayward Gallery exh. cat.), 1975.

Bain, Ian (ed.): *Thomas Bewick: a Memoir written by Himself*, London, 1975.

Baker, W. S.: *William Sharp Engraver, with a descriptive catalogue of his works*, Philadelphia, 1875.

Barrington, Nash, E.: 'Angelica Kauffmann and her Engravers Ryland and Burke', *Magazine of Art*, X, 1887, pp.259-64.

Bayly, Christopher A. (ed.): *The Raj, India and the British, 1600–1947*, London (National Portrait Gallery exh. cat.), 1990.

Bennett, Shelley M.: *Thomas Stothard, The Mechanisms of Art Patronage in England circa 1800*, Columbia (Missouri), 1988.

Bindman, David: *The Shadow of the Guillotine, Britain and the French Revolution*, London (British Museum exh. cat.), 1989.

Boase, Thomas S. R.: 'Illustrations of Shakespeare's Plays in the Seventeenth and Eighteenth Centuries', *Journal of the Warburg and Courtauld Institutes*, X, 1947, pp.83-108.

Boase, Thomas S. R.: *English Art 1800–70*, Oxford History of Art V, Oxford, 1959.

Boase, Thomas S. R.: 'Macklin and Bowyer', *Journal of the Warburg and Courtauld Institutes*, XXVI, 1963, pp.148-77.

Boerner, C. G. (pub.): *Angelika Kauffmann und ihre Zeit, Graphik und Zeichnungenvon 1760–1810*, Düsseldorf (exh. cat.), 1979.

Booth, Joseph: *A Catalogue of Pictures Copied by a Chymical and Mechanical Process; the Invention of Mr. Joseph Booth; Exhibited with the Originals from which they have been taken . . .*, London (Polygraphic Rooms exh. cat.), 1787 (further catalogues were issued at intervals, the 10th in 1793).

Bray, Eliza Anne: *The Life of Thomas Stothard*, London, 1851.

Brayley, F. W. (ed.): *The Works of the late Edward Dayes*, London, 1805.

Bretherton, James: *James Bretherton's Catalogue of Prints for the Year 1775*, London, 1775.

Bruntjen, Hermann A.: *John Boydell (1719–1804): A Study of Art Patronage and Publishing*, Ph.D. thesis, Stanford University, 1974, Fine Arts University Microfilms, Ann Arbor, 1979.

Burke, Joseph: *English Art 1714–1800*, Oxford, 1976.

Butlin, Martin: 'William Hamilton', *Aspects of British Painting 1550–1800 from the collection of the Sarah Campbell Blaffer Foundation*, 1988, pp.171-74.

Butlin, Martin & Joll, Evelyn: *The Paintings of J. M. W. Turner*, London, 1977.

Calloway, Stephen: *English Prints for the Collector*, Guildford/London, 1980.

Chaloner Smith, J.: *British Mezzotinto Portraits*, 4 vol., London, 1878–83.

Chamberlain, Arthur B.: *George Romney*, London, 1910.

Clayton, Tim: 'The Engraving and Publication of Prints of Joseph Wright's Paintings', in Egerton, Judy: *Wright of Derby*, London (Tate Gallery exh. cat.), 1990, pp.25-29 & 231-58.

Collins Baker C. H.: *Catalogue of the Petworth Collection of Pictures in the Possession of Lord Leconfield*, London, 1920.

Cordingly, David: *Marine Painting in England 1700–1900*, London, 1974.

Cordingly, David: *Nicholas Pocock*, London, 1988.

Cotton, W.: *A Catalogue of the Portraits painted by Sir Joshua Reynolds P.R.A.*, London, 1857.

Coxhead, A. C.: *Thomas Stothard, R.A.: An Illustrated Monograph*, London, 1906.

Croft-Murray, Edward: *Decorative Painting in England 1537–1837*, II, London, 1970.

Cummings, Frederick & Staley, Allen: *Romantic Art in Britain: Paintings and Drawings 1760–1860*, Detroit/Philadelphia (Detroit Institute of Arts & Philadelphia Museum of Art exh. cat.), 1968.

Cunningham, Charles: 'Benjamin West's Picture Gallery, by John Pasmore', *Wadsworth Athenaeum Bulletin*, 2nd series, 64, April 1956, p.1 (reprinted in *Art Quarterly*, XIX, 1956, pp.210-11).

De Vesme, A. & Calabi, A.: *Francesco Bartolozzi*, Milan, 1928.

Dotson, Esther: *Shakespeare Illustrated, 1770–1820*, Ph.D. Dissertation (Institute of Fine Arts, New York University; unpublished), 1973.

Drummond, William: *Samuel Woodford Royal Academician 1763–1817*, London (William Drummond at the Kyburg Gallery, exh. cat.), 1989.

Dunlap, William: *History of the Rise and Progress of the Arts and Design in the United States*, 2 vols., New York, 1834.

Earland, Ada: *John Opie and his Circle*, London, 1911.

Edwards, Edward: *Anecdotes of Painters who have Resided or been Born in England*, London, 1808.

Erffa, Helmut von & Staley, Allen: *The Paintings of Benjamin West,* New Haven/London, 1986.

Evans, Dorinda: *Mather Brown: Early American Painter in England,* Middletown (Conn.), 1982.

Fagan, Louis: *Catalogue Raisonné of the Engraved Works of William Woollett,* London, 1885.

Farington, Joseph (ed. by Garlick, Macintyre & Cave): *The Diary of Joseph Farington,* 16 vol., London/New Haven, 1978–.

Fawcett, Trevor: *The Rise of English Provincial Art: Artists, Patrons and Institutions outside London, 1800–1830,* Oxford, 1974.

Finberg, Alexander J.: *The Life of J. M. W. Turner, R.A.,* 2nd & rev. ed., Oxford, 1961 (1st ed. Oxford, 1939).

Fletcher, E. (ed.): *Conversations of James Northcote with James Ward,* London, 1901.

Flexner, J. T.: *J. S. Copley,* Cambridge (Mass.), 1948.

Ford, John: *Ackermanns,* London, 1983.

Frankau, Julia: *John Raphael Smith, his Life and Works,* London, 1902.

Frankau, Julia: *Eighteenth Century Colour Prints* (revised ed.), London, 1906.

Frankenstein, Alfred: *The World of Copley, 1738–1815,* New York.

Friedman, Winifred H.: 'Some Commercial Aspects of the Boydell Shakespeare Gallery', *Journal of the Warburg and Courtauld Institutes,* XXXVI, 1973.

Friedman, Winifred H.: *Boydell's Shakespeare Gallery,* New York, 1976.

Galt, John: *The Life and Studies of Benjamin West, Esq., President of the Royal Academy of London, Prior to his Arrival in England: Compiled from Materials Furnished by Himself,* London, 1816.

Galt, John: *The Life and Works of Benjamin West, Esq., President of the Royal Academy of London, Subsequent to his Arrival in this Country: Composed from Materials Furnished by Himself . . . Part II,* London, 1820.

Garlick, Kenneth: *Sir Thomas Lawrence, A complete catalogue of the oil paintings,* Oxford, 1989.

Girouard, Mark: *The Return to Camelot,* New Haven/London, 1981.

Godfrey, Richard T.: *Printmaking in Britain,* London, 1978.

Goodreau, David: *Nathaniel Dance, 1735–1811,* London (Kenwood exh. cat.), 1977.

Gordon, Catherine: '"More than one handle": the Development of Sterne Illustration 1760–1820', *Words: Wai-te-Ata Studies in Literature* (Wellington, N.Z.), IV, 1974.

Graves, Algernon: *The Royal Academy of Arts: A Complete Dictionary of Contributors and their Work from its foundation in 1769 to 1904,* 8 vol., London, 1905–06.

Graves, Algernon: *The Society of Artists of Great Britain (1760–91): The Free Society of Artists (1761–83): A Complete Dictionary of Contributors and their Work from the Foundation of the Societies to 1791,* London, 1907.

Graves, Algernon & Cronin, Walter V.: *A History of the Works of Sir Joshua Reynolds, P.R.A.,* 4 vol. London, 1899.

Green, Valentine: *A Catalogue of New Plates Engraved and Published by V. Green, Mezzotinto Engraver to His Majesty and to the Elector Palatine, No. 29 Newman Street, Oxford Street,* London, [c.1780].

Griffiths, Anthony: 'Prints after Reynolds and Gainsborough', in *Gainsborough and Reynolds in the British Museum,* London, 1978.

Gwynn, Stephen L.: *Memorials of an 18th century painter (James Northcote),* London, 1898.

Hall, L. H.: *Catalogue of Dramatic Portraits in the Theatre Collection of the Harvard College Library,* Cambridge (Mass.), 1930.

Hamlyn, Robin: 'An Irish Shakespeare Gallery', *The Burlington Magazine,* CXX, 1978, pp.515-29.

Hammelmann, Hanns: 'Shakespeare's first illustrations, *Apollo,* LXXXVIII, 1968, supp. 1-4.

Hammelmann, Hanns: *Book Illustrators in Eighteenth Century England,* New Haven, 1975 (edited and completed by T. S. R. Boase).

Harvey, Francis: 'Stipple engraving in England', *Print Collectors Quarterly,* Jan. 1930. pp.59-71.

Heineken, : *Idée Genérale d'un Collection d'Estampes,* Vienna, 1771.

Holt, Elizabeth G.: *From the Classicists to the Impressionists: A Documentary History,* New York, 1966.

Holt, Elizabeth G.: *The Triumph of Art for the Public, 1785–1848, The Emerging Role of Exhibitions and Critics,* New York, 1979.

Horne, Henry P.: *An Illustrated Catalogue of the Engraved Portraits and Fancy Subjects painted by Thomas Gainsborough, R.A., Published between 1760 and 1820, and by George Romney, published between 1770 and 1830, with the Variations of the State of the Plates,* London, 1891.

Howgego, James L.: 'Copley and the Corporation of the City of London', *The Guildhall Miscellany,* IX, 1958.

Hutchinson, Sidney C.: *The History of the Royal Academy 1768–1968,* London, 1968.

Hyde, Ralph: *Panoramania! The Art and Entertainment of the 'All-Embracing' View,* London (Barbican Art Gallery exh. cat.), 1988.

Ingamells, John & Raines, Robert: 'A Catalogue of the Paintings, Drawings and Etchings of Philip Mercier', *Walpole Society,* XLVI, 1976–78, London, 1978.

Irwin, David: 'Gavin Hamilton, Archaeologist, Painter and Dealer', *The Art Bulletin,* XLIV, 1962, pp.87-102.

Irwin, David & Francina: *Scottish Painters at Home and Abroad, 1700–1900,* London, 1975.

Ivins, William M.: *Prints and Visual Communication,* Cambridge (Mass.)/London, 1969 (republication of 1st edition published in 1953 by Harvard University Press).

Jaffé, Irma B.: *John Trumbull, Patriot-Artist of the American Revolution,* New York/Boston, 1975.

Joppien, Rudiger: *Philippe Jacques de Loutherbourg, R.A.,* London (Kenwood exh. cat.), 1973.

Joubert, F. E.: *Manuel de l'Amateur d'Estampes,* 3 vol., Paris, 1821.

Kraemer, Ruth S.: *Drawings by Benjamin West and His Son Raphael Lamar West,* New York (Pierpont Morgan Library exh. cat.), 1975.

Lambert, Susan: *The Image Multiplied, Five Centuries of printed reproductions of paintings and drawings,* London (Victoria and Albert Museum exh. cat.), 1987.

Le Blanc, Charles: *Manuel de l'Amateur d'Estampes,* 4 vol. Paris, 1854–89.

Legouix, Susan: *Image of China,* London, 1980.

Lennox-Boyd, Christopher; Dixon, Rob & Clayton, Tim: *George Stubbs: The Complete Engraved Works,* Abingdon, 1989.

Leslie, Charles R. & Taylor, Tom: *Life and Times of Sir Joshua Reynolds,* 2 vol., London, 1865.

Macmillan, Duncan: *Painting in Scotland, The Golden Age,* Oxford (University of Edinburgh & Tate Gallery exh. cat.), 1986.

Manners, Lady Victoria: *Matthew William Peters R.A., His Life and Work,* London, 1913.

Manners, Lady Victoria & Williamson, G. C.: *John Zoffany: his Life and Works,* London, 1920.

Manners, Lady Victoria & Williamson, G. C.: *Angelica Kauffmann, R.A., Her Life and Works,* London, 1924.

Marshall, Roderick: *Italy in English Literature, 1755–1915: Origins of the Romantic Interest in Italy,* New York, 1934.

Merchant, W. Moelwyn: *Shakespeare and the Artist,* London, 1959.

Meyer, Jerry D.: 'Benjamin West's Chapel of Revealed Religion: A Study in Eighteenth-Century Protestant Religious Art', *Art Bulletin,* LVII, 1975, pp.247-65.

Meyer, Arline: *John Wootton, 1682–1764, Landscapes and sporting art in early Georgian England,* London (Kenwood exh. cat.), 1984.

Millar, Oliver: *Zoffany and his Tribuna,* London, 1967.

Millar, Oliver: *Pictures in the Royal Collection: Later Georgian Pictures*, London, 1969.

Mitchell, Charles: 'Benjamin West's *Death of General Wolfe* and the Popular History Piece', *Journal of the Warburg and Courtauld Institutes*, VII, 1944, pp. 20-33.

Mitchell, Charles: 'Benjamin West's *Death of Nelson*', *Essays in the History of Art presented to Rudolf Wittkower*, London/New York, 1967, pp.265-73.

Nicolson, Benedict: *John Hamilton Mortimer, ARA 1740–79*, London (Kenwood exh. cat.), 1968.

Nicolson, Benedict: *Joseph Wright of Derby*, London, 1968.

Northcote, James: *The Life of Sir Joshua Reynolds*, 2 vol., London, 1819.

Okun, Henry: 'Ossian in Painting', *Journal of the Warburg and Courtauld Institutes*, XXX, 1967, pp.327-56.

Parker, H: *Prints of Naval Battles*, London, 1911.

Parker, Barbara N. & Wheeler, Anne B.: *J. S. Copley*, 1938.

Paulson, Ronald: *Book and Painting — Shakespeare, Milton and the Bible — Literary Texts and the Emergence of English Painting*, Knoxville, 1982.

Paulson, Ronald: *Breaking and Remaking, Aesthetic Practice in England, 1700–1820*, New Brunswick/London, 1989.

Pavière, Sydney H.: *The Devis Family of Painters*, Leigh-on-Sea, 1950.

Penny, Nicholas: 'An Ambitious Man — The career and achievement of Sir Joshua Reynolds', in Nicholas Penny et al: *Reynolds*, London (Royal Academy exh. cat.), 1986, pp.17-42.

Peter Mary: *John Opie 1761–1807*, London (Arts Council travelling exhibition), 1962.

Pointon, Marcia R.: *Milton and English Art*, Manchester, 1970.

Pressly, Nancy: *The Fuseli circle in rome*, New Haven (Yale Center for British Art exh. cat.), 1979.

Pressly, William: *The Life and Art of James Barry*, New Haven and London (exh. cat.), 1981.

Pressly, William L.: *James Barry, The Artist as Hero*, London (Tate Gallery exh. cat.), 1983.

Prideaux, S T.: *Aquatint Engraving*, London, 1909.

Prown, Jules: *John Singleton Copley, 1774–1815*, 2 vol., Washington (D.C.), 1966.

Pye, John: *Patronage of Briitish Art*, London, 1845.

Redgrave, Richard & Samuel: *A Century of British Painters*, 2nd edition, London, 1890; new edition, revised, London, 1947.

Riely, John: *Henry William Bunbury, 1750–1811*, Sudbury (Gainsborough's House exh. cat.), 1983.

Roberts, W: *Sir William Beechey, R.A.*, London, 1907.

Robinson, Eric & Thompson, Keith: 'Matthew Boulton's mechanical paintings', *The Burlington Magazine*, CXII, 1970, pp.497-507.

Rogers, John J.: *Opie and his Works*, 1878.

Rosenblum, Robert: 'Gavin Hamilton's *Brutus* and its Aftermath', The Burlington Magazine, CIII, 1961, pp.8-16.

Rosenblum, Robert: *Transformations in Late Eighteenth-Century Art*, Princeton, 1967.

Rosenblum, Robert: 'Reynolds in an International Milieu', in Nicholas Penny et al: *Reynolds*, London (Royal Academy exh. cat.), 1986, pp.43-54.

Rubinstein, Gregory M.: 'Richard Earlom (1743–1822) and Boydell's *Houghton Gallery*', *Print Quarterly*, Vol. VIII, No. 1, March 1991)

Santaniello, A. E. (ed.): *The Boydell Shakespeare Prints*, New York, 1979.

Schiff, Gert: *Johann Heinrich Füssliss Milton-Galerie*, Zürich/Stuttgart, 1963.

Schiff, Gert: *Johann Heinrich Füssli, 1741–1825, Text und Oeuvrekatalogue*, 2 vol., Zürich/München, 1973.

Schiff, Gert: *Henry Fuseli, 1741–1825*, London (Tate Gallery exh. cat.), 1975.

Schiff, Gert & Viotto, Paola: *L'Opera Completa di Füssli*, Milan, 1977.

Shellim, Maurice: *India and the Daniells*, London, 1979.

Shropshire, Walter: *Walter Shropshire's Catalogue of Prints for the Year 1771*, London, 1771.

Sizer, Theodore: *The Works of Colonel John Trumbell, Artist of the American Revolution*, New Haven, 1950.

Sizer, Theodore (ed.): *The Autobiography of Colonel John Trumbull*, New Haven, 1953.

Smith, John Raphal: *A Catalogue of Prints Published by J. R. Smith*, London, n.d. [pre-1787].

Smith, J T.: *Nollekens and His Times*, 2 vol., London, 1829.

Smith, Thomas: *Recollections of the British Institution for Promoting the fine arts in the United Kingdom . . . 1805–59*, London, 1860.

Solkin, David: *Richard Wilson — The Landscape of Reaction*, London (Tate Gallery exh. cat.), 1982.

Sprague, Allen B.: *Tides in English Taste 1619–1800*, 2 vol., Cambridge (Mass.), 1937.

Staley, Allen: *Benjamin West, American painter at the English Court*, Baltimore (Museum of Art exh. cat.), 1989.

Steegman, John: *The Rule of Taste, From George I to George IV*, London, 1936.

Stevenson, Sara: *A Face for Any Occasion, some aspects of portrait engraving*, Edinburgh (Scottish National Portrait Gallery exh. cat.), 1976.

Stewart, Robert G.: *Robert Edge Pine: A British portrait painter in America 1784–88*, Washington (D.C.) (National Portrait Gallery exh. cat.), 1979.

Strange, Robert: *An Enquiry into the Rise and Establishment of the Royal Academy*, London, 1775.

Strong, Roy: *And when did you last see your father?: The Victorian Painter and British History*, London, 1978; published in the United States of America as *Recreating the Past: British History and the Victorian Painter*, New York, 1978.

Sunderland, John: 'Mortimer, Pine and Some Political Aspects of English History Painting', *The Burlington Magazine*, CXVI, 1974, pp.317-26.

Sutton, Thomas: *The Daniells: Artists and Travellers*, London, 1954.

Thane, John: *John Thane's Catalogue of Prints for the Year 1774*, London, 1774.

Thompson, J. P.: *A Catalogue of the very Extensive and highly Superior Stock of Engraved Copper Plates . . . the Property of Mr. J. P. Thompson of Gt. Newport Street who is declining this branch of the profession*, London (Thomas Dodd sale catalogue for 28 March 1810 and the next day).

Tomory, Peter: *The Life and Art of Henry Fuseli*, London, 1972.

Ward, Humphrey & Robert, W: *Romey*, 2 vol., London, 1904.

Waterhouse, Ellis K.: *Reynolds*, London, 1941.

Waterhouse, Ellis K.: *Painting in Britain, 1530 to 1790*, London, 1953.

Waterhouse, Ellis K.: 'The British Contribution to the Neo-Classical Style in Painting', *Proceedings of the British Academy*, XL, 1954, pp. 55-74.

Waterhouse, Ellis K.: *Gainsborough*, London, 1958.

Waterhouse, Ellis K.: *Reynolds*, London, 1973.

Waterhouse, Ellis K.: *The Dictionary of British 18th Century Painters in oils and crayons*, Woodbridge, 1981.

Watson, J. Steven: *The Reign of George III, 1760–1815*, Oxford, 1960.

Wax, Carol: *The Mezzotint, History and Technique*, London, 1990.

Webster, Mary: *Francis Wheatley*, London, 1970.

Weinglass, D. H.: *Henry Fuseli and the engraver's art*, exhibition catalogue, University of Missouri–Kansas City Library, 1982.

Weselly, Ignzius E.: *Richard Earlom; Verzeichnis seiner Radierungen und Schabkunstblätter*, Hamburg, 1886.

Whitley, William T.: *Artists and their Friends in England, 1700-99*, London/Boston, 1928.

Whitley, William T.: *Art in England 1800-20*, Cambridge, 1928.

Whitley, William T.: *Art in England, 1821-37*, Cambridge, 1930.

INDEX OF ARTISTS, ENGRAVERS AND PUBLISHERS